Canadians at Work

The National Automobile, Aerospace, Transportation and General Workers Union of Canada (CAW-Canada).
www.caw.ca

Concept and production by Vincenzo Pietropaolo.
Editing by Vincenzo Pietropaolo, with Schuster Gindin.
Design by Marie-José Crête.

Seeing Ourselves: Photographs as Living History copyright © 2000 by Sam Gindin.

Introduction copyright © 2000 by Vincenzo Pietropaolo.

Historical photographs in Sam Gindin's text are copyright © 2000 by respective organizations as listed on page 19.

All other photographs are copyright © 2000 by the individual photographers, as listed on page 204.

Care has been taken to ensure that all references to individuals and CAW locals are correct.
The publishers welcome any information that will enable them to rectify, in subsequent editions, any incorrect or omitted references.

Canadian Cataloguing in Publication Data

Pietropaolo, Vincenzo

 Canadians at work

Also published in French under the title: Canadiens au travail.

Includes bibliographical references.

ISBN 0-9692932-8-3

1. Blue collar workers—Canada—Pictorial works.

2. Manual work—Canada—Pictorial works.

3. Documentary photography—Canada. I. Gindin, Sam. II. CAW-Canada. III. Title.

TR681.W65P53 2000 779'.9331 C00-900950-7

This book was produced in part with the assistance of the Government of Canada's Millennium Partnership Program.
The opinions expressed in this publication are those of the authors, and do not necessarily reflect the official views of the Government of Canada.

Printed and manufactured in Canada by members of the Toronto Typographical Union, at University of Toronto Press, Toronto, Canada.

In the course of the twentieth century,

over 100,000 men, women, and children died in Canada

in industrial and other work-related accidents

tragically, comparable in magnitude to the number of Canadians who fell in WWI and WWII.

Untold others in the labour movement have devoted much of their lives

in the struggle for workers' rights and safe working conditions,

with many dying in the process.

In marking the new millennium, and in a spirit of solidarity,

this book is dedicated to the memory of those who fell in that struggle,

or who died as they were making a living.

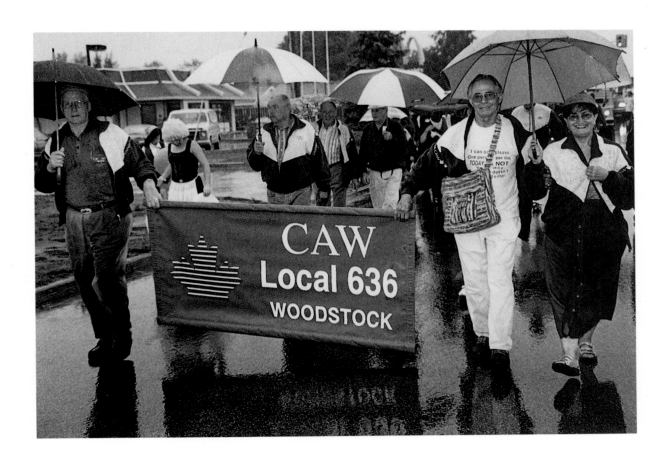

CAW retirees in the 1999 Labour Day parade in Port Elgin, Ontario

ACKNOWLEDGMENTS

From concept to realization this book took about 18 months. It would not have been possible without the dedication and effort of many people.

I would first like to acknowledge the leadership of the CAW: Buzz Hargrove, National President, Jim O'Neil, National Secretary-Treasurer, and Luc Desnoyers, Quebec Director, for their boldness of vision in embracing this unique project.

I would also like to thank the National Executive Board and its Committee: Richard Fournier, Alex Keeney, and Julie White for their support and feedback during the process.

The enthusiastic help of the staff from the almost 100 CAW locals and affiliates that were involved in the project across the country was crucial. They not only welcomed the photographers to their communities, but they also cut through red tape, shepherded them through the plants, provided logistical support, and shared a drink or two. A heartfelt thanks to all of you (too numerous to mention individually).

I would like to thank Jane Armstrong, Director of Communications at the CAW National Office, and John McClyment, CAW National Rep, for entrusting me with the book in the first place, and for their continued support throughout the process.

I am especially thankful to Angela Perri-Forder, who, in her role as the designated support staff, bore the daily brunt of the project, worked out an impossible shooting schedule, and let absolutely nothing slip through; Anne Chetwynd, CAW support staff, who lent a helping hand whenever necessary; and Lynn Brophy, CAW National Rep, for help with copy editing.

Thanks to Lana Payne and Lloyd Sullivan for introducing me to Newfoundland.

Sam Gindin has provided an admirable essay in which he presents ideas that challenge one to think about the depiction of workers in photography. Moreover, his insights and perspectives were very important to me as the book was taking shape.

I am thankful that the other photographers were there as I needed them: Denyse Gérin-Lajoie, Iva Zímová, Ursula Heller, George Webber. But I especially want to thank photographer Schuster Gindin, who assisted me in the final selection process and printing stages, and who was always available to share ideas or to rescue me whenever I needed rescuing. I am grateful to Marie-José Crête, the designer, who was able to work wonders in a very short time span, as did Reg Hunt and his staff at the University of Toronto Press. Jim Aquila offered much constructive criticism of my text.

This project required an enormous amount of travel, and I am grateful to my children, Cristina, Emily, and Adriana, for putting up with my quick arrivals and departures, and to my wife, Giuliana Colalillo, who, as always, has been helpful not only with invaluable ideas and debate, but also with the myriad day-to-day tasks that inevitably crop up in a project such as this.

I would be remiss if I did not mention all the employers who cooperated with this project, and who trusted the photographers and allowed them to move around freely in their plants.

To all the sisters and brothers who graciously honoured me and the other photographers by standing in front of our cameras, I salute you.

Vincenzo Pietropaolo
Toronto, 2000

CONTENTS

INTRODUCTION

Photography was born in 1839, at a time when a great many technological breakthroughs were coming into being. This was the peak of the industrial revolution, when the nature of work and a new class of workers were being defined. It is natural to think that the preoccupation with work and mass production would have led to the creation of many images and books about work, if not of working class culture. But this was not to be the case — neither then nor throughout the twentieth century, with only sporadic exceptions.*

Even in the 1890s when portable cameras and fast films were commonplace, and when great development projects of near mythological dimension were being built — tunnels, bridges, railways, canals, vast manufacturing plants — the subject of work and workers often seemed to be avoided or neglected by photographers and especially by book publishers.

Our society is inundated with photographs. Think of all the photographs that you saw in the last 24 hours: on billboards, in newspapers and magazines, images on television, posters in the subway and buses, in shop windows, at the airport, in your living room, and in your family's photo album perhaps. How many of these photographs depicted workers at work? In all probability, not even one. This is an astonishing fact.

Personal reflections

Working on this book has been one of the most rewarding experiences of my life. The tone of what awaited me was set early on in the project. Lloyd Sullivan, a crab harvester from Calvert, Newfoundland, invited me to join him and his two sons, Brent and Keith, on his boat to check their snow crab traps about six miles out in the North Atlantic. I met them at the wharf in St. John's in the middle of the night. It was Sunday and the weather was not ideal, but favourable enough to warrant venturing out. After they loaded ice, we set out before 5:00 a.m. in total darkness. Any romantic notion that I may have had about fishing was shattered right there and then. The boat was simply known as 131948, and it was less than 10 metres long. We travelled a few hours in very rough seas, cutting through patches of fog in the early morning. The boat tossed and turned furiously for the almost nine hours that we were out. I marvelled at the calmness of my hosts, who I am certain must have been worried sick about me, fresh from Toronto, with cameras dangling from my neck as I struggled to maintain my balance, drenched from the spray and shivering. I put on a brave smile whenever I could, and in retrospect, the fact that I had not had time for breakfast turned out to be a blessing in disguise.

What impressed me the most, however, was the courage and excruciatingly hard work required of these three men. The operation involved locating three different traplines about one hour's travel away from each other, by using longitude and latitude records kept in a log book. Once the location

of each line was identified and confirmed by the specially marked buoy, a winch was used to hoist the large cylindrical shaped steel traps from the ocean floor 175 metres below. Then the process began: Empty the trap on the deck, sort the crab, toss back into the ocean the small ones and the females, place the harvested crab in ice below deck, reset the trap with bait and set it back in position in the water. This operation was repeated 30 times, and then on to the second trapline, and the third, until 90 traps had been checked. Now the boat became very crowded, but everyone worked in practised coordination, quickly, and with determination. It was choreography on the open seas, with no breaks until the job was done.

On the way back, the wind seemed calmer, and it was time for lunch. Lloyd pulled out a plastic bag with four soft drinks, and four sandwiches on white bread — one for each man on board. I felt rather sheepish accepting the lunch, since I really had not helped with harvesting any of the crab. I mumbled something inarticulate about how I hardly deserved lunch. Lloyd promptly treated me to a dose of that quintessential Newfoundland hospitality: He stared me straight in the face, offered me the sandwich once again and said in a deadpan but authoritative voice: "Take it. It's been sent for you." My presence on the boat had been noted by his wife, Linda, when she was preparing the men's lunches.

This is the kind of warmth and hospitality that was to follow throughout the project — from the hospital workers in Sydney, Cape Breton Island, to fish packing workers in Shippagan,

*In the history of documentary photography Lewis Hine's crusading work on child labour in the United States in the early part of the twentieth century stands out as an indictment of the working conditions of the times. Sebastião Salgado's monumental book *Workers* (Aperture, New York, 1991) put a face on the diversity of manual labour across the globe at the end of the century. Milton Rogovin of Buffalo, New York, made a unique contribution by photographing workers at their plants and in their own homes in *Portraits in Steel*, (Cornell University Press, 1993). Within the Canadian context, the National Film Board of Canada's publication of *Les Ouvriers* by Pierre Gaudard in 1976, *OVO Magazine's* special issue of *The James Bay Workers* by Guy Turcot in 1979, followed by Ursula Heller's *The Shipbuilders of Collingwood* (Blue Mountain Foundation for the Arts, Collingwood, Ontario, 1981) offer singular glimpses into the work life of Canadians.

New Brunswick; from cereal factory workers in Peterborough, Ontario, to zinc miners in Campbell River on Vancouver Island; from auto workers in Windsor to shipbuilders in Halifax; from truck drivers in Winnipeg to airline workers in Inuvik, Northwest Territories; and from scientists working in aerospace technology in Ontario to Gwaii (Haida) wood carvers working in fish packing plants in the Queen Charlotte Islands.

One of the misconceptions I had about the modern workplace was that workers worked together. But despite great advances in technology, most workers end up working alone, that is, without the possibility of conversation or interaction with others, except during breaks. The nature of most work is such that one individual is merely a cog in an elaborate setup, such as the football-field-sized auto plants, where a worker's every move has been predetermined by an "efficiency" plan or the pre-set speed of the conveyor belt. In most cases, there is no time to talk to anyone, for you must concentrate on your specific task, whether it is selecting herring fillets in Marystown, Newfoundland, inspecting freshly blown glass bottles in suburban Toronto, wiring cars in Oshawa, Ontario, or mucking ore at 975 metres below ground in a nickel mine. It is usually a worker, alone, with his or her machine.

The memory that is most significant to me is how moved the workers were when they realized that I had come to photograph *them,* not the machinery they worked with, the product they made, or the building where they worked. I had come to photograph her or him, the worker, who tended to see me as an ambassador from their union. I remember the feeling of disbelief in Anthony Andrews' voice, a bus driver in the Victoria Bus Station: "He's not interested in the new bus, Peter. He wants to take pictures of us."

The look of pride at the fact that their union would go to such lengths merely to photograph them at work was unforgettable. It was as if through the

camera, they were somehow being "validated." They had always seen *others* in camera images, now it would be their turn to be witnessed by the camera. Some could not contain the glee of sheer pleasure they felt at that moment, and they often reacted in curiously bizarre ways. They would mockingly make derisive comments such as: "Good luck finding any one of us actually working here!" Or perhaps, "What makes you think we work here?"

It was very ironic, because moments later they would be back at their conveyor belt, or in their truck, or inside an airplane engine or other work station, digging, packaging, sorting, cooking, sweeping, washing, welding, painting, sewing, bolting, cutting, loading, driving forklifts, boring into bedrock, producing, working, working.

This notion of "not working" is precisely the image of workers that has been created and promoted in the popular media, especially about *unionized* workers. A quick review of mainstream newspapers, for instance, will reveal that the image of workers they promote is usually based on photographs showing workers who are not in the act of working, or several workers who may be merely watching somebody else work. (The other view is, of course, of the angry worker, portrayed as greedy and selfish, during strikes.) The irony lies in the fact that the unionized worker can afford the luxury to mock himself or his fellow workers, for that is one of the benefits of being part of a large collective power, a union of workers.

My encounter with workers, or the "photo shoot" as each of my visits was labelled (again, another concept from the advertising world or the popular media), became an opportunity to have their work experience recognized by others. Photographs confer importance, and the act of photographing a worker makes that worker feel important. The photograph becomes a vehicle for public recognition of what they do, which instills pride. Also, the experience of being photographed in a collaborative way — with the consent of

the worker, who then presents her- or himself in a certain way to the photographer — becomes an act of solidarity. If the conditions are right, and there is honest rapport between the person in front of the camera and the person behind the camera, it is not far-fetched to say that the picture already exists, as if it were a gift, and the photographer has merely to receive it.

A particularly poignant moment for me was my experience in a welding shop, at Wescast Industries in Brantford, Ontario. I had focused my camera on a welder, James Cave. He was wearing a special mask, which completely covered his face and neck. In order to permit him to breathe, the mask was connected by a flexible hose to an overhead steel pipe, which in turn was connected to a supply of oxygen. In this way, he was completely tethered to his workstation, unable to talk to anyone, or relate to anything except production. He looked rather menacing, as if he were from outer space. I managed to make eye contact with him, and he put his welding gun down, removed his gloves, then his mask, revealing a proud, youthful face. He understood the project well. With pride, he said, "You are a worker too, let me take your picture." I was momentarily speechless: No greater compliment could have been offered me. I handed him a camera; now the tables were turned, and for once I stood in front of the camera.

As I became more intensely involved in these encounters in the workplace, I began to realize that the book would provide an opportunity to counter the traditional way of representing workers in photography — as anonymous beings, without any identity. This notion of anonymity of workers has been such a widespread practice as to seem almost "natural," whereas the same cannot be said about the representation of professionals or others from the upper echelons of society. We tend to faithfully record the names of the architects or engineers who design buildings, machines, or other products, yet we do not place much importance in acknowledging the

names of the workers who actually build them. In a digression from this practice, the names of the workers portrayed in these images have also been documented.

I and the other photographers have tried to portray workers from a position of pride, dignity, and respect. This has been a voyage of photography, an exploration into the hidden landscape of workplaces and workers' faces that defines Canada as much as anything ever could.

The power of a photograph is that it outlasts the passage of time itself, though paradoxically it takes only a fraction of a second to make. It is my hope that this book will live on and become a lasting testament to the workers in its pages, and all those others who are symbolized through them.

A few words about the process

It was with great enthusiasm that I seized the opportunity when Jane Armstrong, Director of Communications at the CAW National Office, approached me and invited me to develop the *idea* of a book into a workable project. Buzz Hargrove, CAW National President, and Jim O'Neil, CAW National Secretary-Treasurer, both were very keen to see this book as the CAW's principal millennium project. Although the idea had been discussed informally among various CAW staff and leaders for some time, it had not progressed beyond the concept stage. Because of its size, the diversity of economic sectors in which its members work, and its truly national character, the CAW was the labour organization most suited to take such a bold initiative — a photographic book on workers across Canada.

The National Executive Board of the CAW formally approved my feasibility report on March 2, 1999, and created a committee to oversee it — Richard Fournier, Alex Keeney, and Julie White. Sam Gindin immediately agreed to write the introductory essay. Jane Armstrong, John McClyment, and I then set out to target the workplaces that should be photographed, ensuring

that all economic sectors of the union would be represented, as well as the 10 provinces and three territories.

The first images for this book were made on July 7, 1999, when I photographed the VIA Rail workers — members of CAW Local 4005 — at the Halifax Railway Station. I continued to photograph in Atlantic Canada until September. At the same time, I invited other photographers to join the project: Ursula Heller in British Columbia, George Webber in Alberta and Saskatchewan, Denyse Gérin-Lajoie in Quebec, Iva Zímová in Quebec and Manitoba, and Schuster Gindin in Ontario. At the peak of activity, up to five photographers were working at the same time in different parts of the country. I continued to photograph well into the winter, concentrating in Ontario, parts of British Columbia, and northern Canada. About 90 percent of the photography had been completed by the end of December, 1999. The photographs in the book cover 128 locations, represented by 87 locals and affiliated sectors.

Sorting through the contact sheets from over 575 rolls of film to select 1,500 work prints proved exhaustive. But the positive reaction of the committee who saw the work displayed on four 14-metre-long tables in a hotel meeting room in downtown Toronto was rewarding. I then reduced the initial selection to about 300 prints, which were shown once again to the committee and the board for information purposes only, and as an indicator of the progress of the project. An arm's length relationship between myself and the staff and the leadership of the CAW was established at the outset, and all artistic decisions were left entirely up to me, including the selection of images, sequencing, and editing. At this point, the designer, Marie-José Crête, joined the project, a printer was selected, and technical decisions such as paper stock, size, and binding were made.

The photographers relied on the help, advice, and support of the leadership and staff of the locals involved across

the country. Angela Perri-Forder, of the National Office, made the arrangements for the visits of the photographers to the locals, who in turn made final arrangements with the employers. Angela was the liaison between myself and the photographers, as well as between the photographers and the CAW locals throughout the country. It is a credit to the CAW that only a handful of employers declined access to their plants. The photographs were made with the consent of the workers involved, and the photographers worked with complete artistic freedom.

In travelling to all corners of the country, photographers relied on airplanes, trains, buses, and ferry boats, even a seaplane. In all instances, except the seaplane, it was CAW members who sold the tickets, handled the luggage, cleaned the trains, drove the buses, etc. In other words, the CAW members operate much of the transportation system of this country. Ours is a big country, and in all, the photographers travelled over 60,000 kilometres.

Vincenzo Pietropaolo
Whitehorse, Yukon
January 2000

I think the first condition of a good education is that the child should know that all he uses does not fall from heaven ready-made, but is produced by other people's labour.

Leo Tolstoy
Letter on Education, 1902

Seeing Ourselves:
Photographs as Living History
by Sam Gindin

Societies record themselves in different ways: through films, television, and videos; through radio, audio tapes, and CD-ROMs; through books, newspapers, and magazines; through paintings and sculptures; through photographs. What they record (and how) reflects assumptions about which lives and events are considered important. They therefore reveal what we value and what we choose, intentionally or through neglect, to leave invisible.

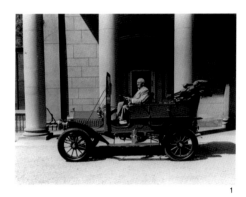

Of these various tools for communicating something about ourselves, photography stakes out a special claim to being the most true. With photographs the eye of the photographer becomes our eye and we are there. Paintings, in contrast, are more clearly interpretations of the world by others. Movies involve actors and so inhabit the world of pretend. Radio voices and audio tapes are as directly true to life as photographs, but we trust our eyes more than our ears: "Seeing is believing." Documentary films may claim to surpass photography's realism since they combine what is a series of photos, with motion and sound. But that very movement and sound creates a distance; the images and actions pass us by at their own uninterruptible pace and they are gone. It is that concreteness that gives a photograph the characteristic of seeming more real than a film.

The appreciation of art generally requires some degree of education — not necessarily formal — about ways of seeing, listening, feeling. Photographs, on the other hand, including ones that see themselves as art,

seem within our grasp even as we are developing our capacity to see more than the obvious. In part, this lack of intimidation is linked to photography's integration into our everyday lives. We see photographs on billboards, in newspapers, in magazines, in the advertising pages stuck in our mailboxes, on the desks of people we work with. We put photographs on our walls and carry them in our wallets.

Photography is accessible to us not just when we experience its images, but also when we create our own images. Anyone can take a photograph. Even if we do not consider ourselves "photographers," we know we can get an affordable camera and film, aim, click, drop the rolls at the corner drugstore, and return in a few hours for an envelope full of pictures. We cannot, in contrast, generally afford the expensive equip-

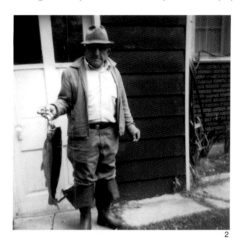

ment to make films or records. And few of us think we have the skills to paint or produce the sounds we want on the piano. This unique accessibility of photographs, their quality of being something we can both appreciate and produce, has led to photography being thought of as the most democratic of the various forms of expressing and registering our lives.

But if we can all take adequate pictures, what makes some pictures stand out in special ways? The relationship between particular kinds of photographs and their audience is one factor limiting many photographs. For example, advertisements waiting with us at bus-stop shelters, or those we browse through absent-mindedly at the doctor's office may be technically impressive, but their only link to us is through identifying us as potential buyers of products. They are not offering something to us, but trying to get something from us. The commercial role of these photographs, as art critic John Berger has emphasized, exploits and manipulates the credibility photography has as being "real." Family pictures and albums, on the other hand, are appreciated in private

rather than public spaces and aren't driven by any search for an external use or advantage. But as treasured and moving as such photos are for those familiar with the individuals, they are of limited interest to others.

When a photograph goes beyond the manipulative and the private, and resonates with a more general audience, it becomes a public photograph. Even if we look at it privately, we are sharing something with others whom we do not know. All photographs stop time, frame people or events, block out sound. Great photographs do this not only to the subject being photographed, but also to the audience looking at the final result. They draw us in, focus our attention and concentration, invite us to silently discover details about a time and place, raise questions, suggest connections, perhaps even hint at new meanings relevant to our lives.

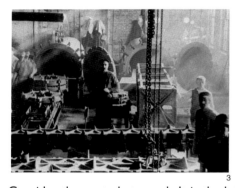

Consider the next photograph. It is the late sixties and a policeman with a billy club is pushing a young man away from some kind of demonstration. But in spite of his youth, the man doesn't look like a flower child or (our image of) an anti-war protester or civil rights marcher. There is a cool James Dean–like resistance in the posture and pace of the man; he is not going to be hurried by anyone. He has an Elvis haircut, a cigarette dangling defiantly from his lips, his jeans rolled up in cuffs, and he is wearing fifty-ish white socks. The protester is a worker, and the event isn't a demonstration but a confrontation on an auto parts picket line.

This is a photo of the "other sixties." The youth rebellion of that period took a particular form within the working class. The rebel-without-a-cause of the fifties is here a worker on strike, a rebel with a cause.

The student radical so prominent in how popular culture remembers the sixties, is here a less-remembered young union activist. In Canada the work force grew faster during the sixties than in virtually any other developed country, and this was especially evident in the auto industry. The Canadian industry doubled in size over that decade, and tens of thousands of young workers, influenced by and part of the reac-

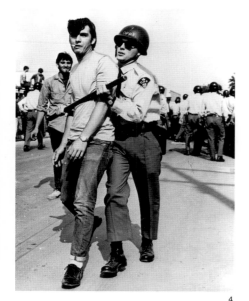

tions around them, brought a new militancy into the workplace.

Flash back for a moment, another 30 years in time to the days of the formation of the auto workers' union. We are at a union meeting in Oshawa during the famous 1937 GM strike. If there is a rebellion here, it is not in the style of dress. The angle and framing of the photograph emphasizes the well-arranged rows and neat black-and-white contrasts of the jackets, shirts, and ties. We are left with a strong sense of order and respectability and intriguing questions of what this means. Are they in their "Sunday best" because this is an important public event? Is it because of the union's roots amongst the skilled trades and the trades' earlier traditions of seeing themselves as "gentlemen craftsmen"? Or is it perhaps that the goal of the union in its early days was driven by a determination — through militancy and solidarity — to simply gain a measure of that respectability so generally denied working people?

How does this, if at all, relate to the rebel in the earlier picture? The worker we see in the sixties belongs, consciously or not, to a movement defined by its distrust of authority structures (including those in the unions). That movement was a reaction against society's values. It didn't want the

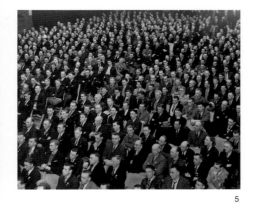

respectability its parents had fought for; it didn't want "in." Yet that very readiness to rebel could not be so easily separated from the struggles and achievements of the previous, apparently more respectable, generation. Those past gains and the resultant confidence that came with living through an era of material security no doubt contributed to the impatient demands made by the new generation of working class youth.

The workplace of the sixties was a meeting place for the tensions between these two generations. The interaction of those who had built the union since the thirties and the energy of those who now threatened to turn it upside down led, in Canada, to the union's "re-generation." Out of this came much of the present leadership — locally and nationally — of the present CAW.

The photograph of the other sixties is itself now 30 some years old and so, as we look at it today, it raises another generational question. With the sixties generation now moving towards retirement, what can we expect of their replacements? Unlike the sixties, those now coming into the workforce have lived through a long (and continuing) period of conservative times. How will this affect the character of the union? Will the union's past culture be passed on? Will the union once more be rejuvenated?

A photograph can be worth a thousand words, but words remain essential. Words can connect one photograph to others, and put them together in some context of time and place. That context changes how we look at photographs. The photographic "still" of the other sixties now has motion across time. It links the building of the union to its continuous renewal, connecting not just the past to the present, but also — in the eyes of current viewers — to questions about the future.

This talk of "generations" and the continuity of the union as if it is a "family" may seem to take us back to thinking of these photographs as part of a family album. But there is a crucial difference. The family album is about biography — the private chronicles of people tied together biologically. The photographs of union meetings and union struggles include biographies, but they move beyond them to the social stage. These photographs speak to people who may not know each other, but are united by class and joint struggles for social change. They are about the experience and making of history.

When photographs tell stories, they tell them differently than the written word. The set of photographs below involve three events separated by time and place but part

of the same story: the winning of union security. The principle of union security is straightforward. Once a union has been democratically chosen, the company must bargain with it and, since all workers in a workplace benefit from the union's presence, every worker should pay union dues. The three events referred to are the Ford strike and blockade in Windsor in 1945, the United Aircraft (then Pratt & Whitney) strike of 1974–5, and the Fleck confrontation of 1978.

The spirit of the Ford strike is captured in photographs of its most dramatic moment: the massive blockade of the plant with cars, buses, and trucks. The Ontario Provincial Police and the Royal Canadian Mounted Police had been called on to launch a surprise attack on the Ford plant to break up the pickets and undermine the strike. The blockade was the workers' response; the strike had to be protected and the blockade

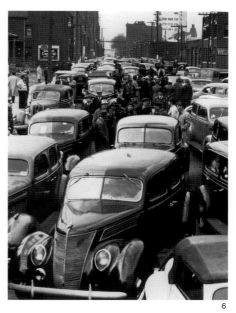

was the way to do it without bloodshed. Instead of photos of lonely picketers shivering in the cold, we see workers milling about the most productive traffic jam in Canadian history. Aerial photographs show the scale of the organized chaos. There is something deliciously ironic about using the vehicles the workers built for Ford as a strike weapon against Ford.

The photographs do not tell us how workers knew about the planned attack on their strike and their union. The mayor of Windsor had opposed the OPP and the RCMP intervention. The assumption at the time was that he went so far as to tip off the strikers — something most of us would find hard to imagine in any of our cities and communities today. What kind of social climate could have made this possible in Windsor in 1945?

The Ford strike reflected not just the determination, but also the confidence and sense of social leadership that was brewing within the Canadian labour movement after the War. The Second World War, fought against Nazism and Fascism, had mobilized people for democracy. Together with the rhetoric of "we're all in this together," this created expectations of a particular kind of peace. Workers demanded material gains after the deprivation of the depression and the controls on consumption during the war. Union security, they understood, was critical to making sure that those gains, along with workplace rights, would really last. Furthermore, with the end of the war-time economic stimulus, it was clear that a national commitment to jobs was fundamental. But given the failures of business during the thirties, this political demand could only be led by organized workers who were making the two-way connection between decent incomes and the creation of jobs, and pushing for a measure of economic planning.

Opposition to the union came from the expected quarters, and in spite of the mayor's sympathies, city council included enough opponents to block welfare for strikers feeling particular hardships. The strike nevertheless had strong community support. Returning soldiers joined picket lines and marches. Church leaders spoke in favour of the strikers, and some local businesses took out supportive ads. Farmers provided food. The members of Local 195, conscious of the generalized importance of the strike, remarkably shut down their own workplaces — with no strike pay — for over three weeks in solidarity with the Ford workers (Local 195 then included, along

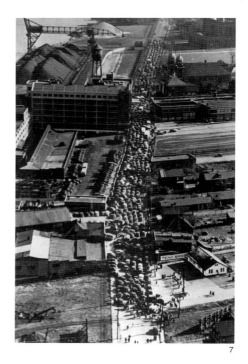

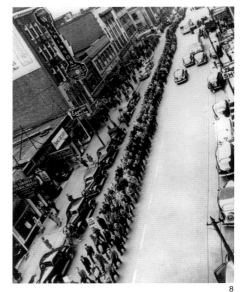

with parts suppliers, the large Chrysler facility and a smaller GM operation). Photographs of this period suggest and reinforce the sense that this was a community strike, and that Windsor was a "union town." The Windsor strike lasted 99 days, and the workers subsequently won, by way of an arbitrator, union security. That victory quickly spread to other organized plants within and beyond Windsor.

Three decades after the Ford strike, a 20-month strike at an aircraft plant in Quebec was fought over the same issue, this time leading to union security being enshrined not just in particular collective agreements, but in legislation for all Quebec workers. The dominant image of this strike was not, as at Ford, a photograph but a fleur-de-lis made from the bent nails and wire that workers found around them — Quebec workers symbolically responding to and shaping Quebec nationalism.

The United Aircraft strike was a war of attrition between a company set on rejecting unionization and workers refusing to be treated as colonials. United Aircraft had long ago accepted unionization at its American plants. Its refusal to do the same in Quebec 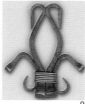 grated on Quebecois sensitivity to this second-class status within an English-dominated continent and especially in their own home. The strike that began early in 1974 consequently had, like the Ford strike earlier, significant public support. That support extended, by way of the union, beyond Quebec.

A few years earlier, Trudeau had tried to destroy the separatist movement by exploiting the powers in the War Measures Act, but the root causes of separatism persisted. The labour movement played, at that

time, a particularly prominent role within the nationalist movement. Separatism was then both a nationalist and a class issue. For many Quebec workers, it was an integral part of their vision of a different, more progressive society emerging in their province. Nobody had planned it that way, but the United Aircraft strike became an expression of the existing frustrations in Quebec and contributed to the emotional tide that brought René Lévesque and the Parti Québécois to government in 1976.

It is an interesting historical note that in the seventies, nationalism was not confined to Quebec, but was also very alive in English Canada. At one point during the Quebec strike, the UAW head office in Detroit unilaterally cut off strike pay. This was eventually resolved, but not before a mini-crisis erupted in the relationship between the Canadian section of the union and their American parent. And so one of the early truly serious signs of such nationalist tensions between the Canadian and American UAW actually first emerged in Quebec.

The strike was especially violent as might be expected given the company's determination to break the union, the length of the strike, and the mood in Quebec. Sixteen weeks into the strike, a group of workers broke into the plant and occupied it. Quebec's dreaded provincial police stormed the plant, beat up the workers, and reclaimed the plant for the company. That high-profile action led to a resolution of the strike. Though United Aircraft never accepted the principle of union security, the

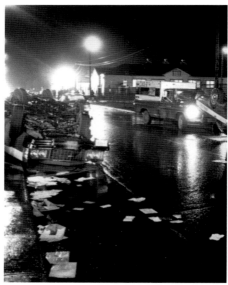

provincial Liberals made a commitment to bring it in through legislation. (It was actually brought in after the Liberals were replaced by the Parti Québécois).

In the inflamed climate of the Quebec of the early to mid-seventies, photographs of the United Aircraft strike are documents as much as images. Such documentation can, in certain circumstances, act as powerful political weapons to expose events or issues "before our very eyes." In this case, they display the pent-up anger, verify the bashed heads and bruises, and record the link between the treatment of the workers and the movement for Quebec sovereignty.

11

Turn now to a photograph from the strike at Fleck. It seems oddly out of place with any of the earlier photographs. It is a sunny day and three women are strolling together. One is pushing a baby carriage and talking casually to another. A third woman is smiling to herself and, though not part of the conversation, is clearly part of the trio. We would never know that this has something to do with the Fleck strike were it not for the picket signs: one showing support from the NDP, the other from the CCU (a small labour central outside of, and in those days as often as not in conflict with, the mainstream of Canadian labour). That the women seem so relaxed on the picket line suggests, though it is not shown in the picture, that they are enjoying the safety in

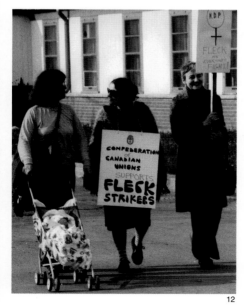

12

numbers of many other women being there with them.

This photograph does not capture the fact that the Fleck strike involved the greatest show of police force ever at a strike in Ontario. It doesn't give any indication of the uncertainty and intimidation faced by the predominantly young and female workforce when management brought police into the plant to "talk" to them even before the

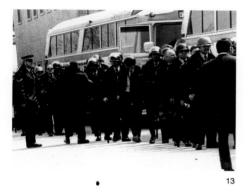

13

strike began. It doesn't tell us that the attempt to unionize was undermining a provincial strategy of attracting investment in an increasingly competitive world, with industrial parks full of low-paid workers. Nor that the owner of this auto parts plant was the deputy minister of industry and that this conflict, which began so innocently as another strike for a first contract, was therefore soon to be highly politicized. And there is no indication that the strike lasted 163 days.

What this photograph does, however, suggest — by putting before us one particular dimension of this confrontation — is that something different was happening here and that it would affect the future style and content of the labour movement. It is important to recall that in the late seventies, the women's movement in Canada was still at a relatively early stage. The expansion of the public sector in the sixties had increased the number of women in the trade union movement, and Canadian feminists, unlike feminists in most other countries, saw their future as intimately tied to these working class women. In the sixties, women in manufacturing were still fighting against separate seniority lists by gender. It was a fight led by a group of women from GM's Oshawa plant, working with other feminists, that finally ended such discrimination in 1970 through a change in the law. As late as 1977, Ford was hiring the first women in any of their assembly plants.

The strike was transformed into a high-profile crusade by the excessive show of force that the owner's position allowed him to muster, the committed and militant support

the strike received from CAW brothers and sisters across southern Ontario, and the broad support this confrontation received from the women's movement. The workers who reluctantly went on strike at Fleck in the hope of simply getting their first collective agreement ended up, like the workers at United Aircraft, unexpectedly winning union security for all workers in their province (and from a conservative government no less!). That they were young women leading a general struggle gave a tremendous impetus to the confidence of women in the movement.

As union activists, we quickly affirm that these photographs and the history behind them are not only interesting, but relevant to what actually happens today. They remind workers, we argue, that what we now have did not drop from the sky or come from the goodwill of companies but from the struggles and sacrifices of those who came before us. They connect us to those struggles and therefore inspire us to be as creative and determined today. All of this is, of course, true. But, like speeches from one generation to the other that concentrate on how hard things used to be, these positive lessons often seem remote and unconvincing. Gratitude to others for what they have done for us unfortunately gets, like old photographs, frayed with repetition. Invocations to be inspired by distant events are constricted by that very distance: "But things were so different then!" It is too easy, even after we have enjoyed and discussed these photographs, to put them back in their slip covers and boxes. They become history in the sense of being the remaining records of something past (something that has truly "passed away," something now dead).

There is another less comfortable but ultimately more useful way to view these photographs. It is to see them as a lament. They are about something lost, something we once achieved: not a particular material gain, but a sense of being on the move. When, for example, we look at photographs from the fifties through to the mid-nineties,

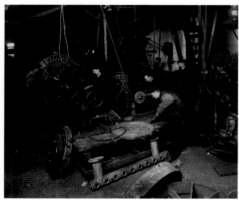

14

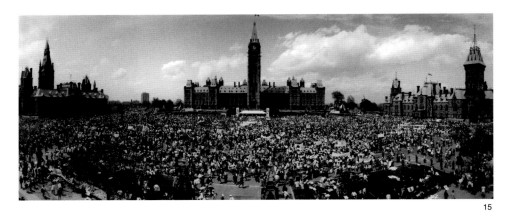

15

we can't help but notice that the mass demonstrations in these later photographs are now generally taking place outside working class communities: at provincial capitals or in Ottawa. In part, this may reflect the politicized, as opposed to company-based, nature of the issues involved. And it is certainly an indicator of the extent to which economic restructuring has disrupted and dislocated our communities over the years, converting us from community members to commuters. But it is also something more. As impressive as the photographs of mass demonstrations in Ottawa are, they also seem to say that the strength and support we once had "at home" has eroded, and we can only reproduce that show of strength by collecting it from a range of communities and concentrating it at political centres. (The Days of Action series of protests against the Harris government in Ontario and their focus on community-by-community mobilization were, perhaps, a historic return to rebuilding that past strength).

What happened to that sense of working class community and union legitimacy that we saw in Windsor in 1945, and that once sustained workers across the land? How do we restore it? How did the sovereignty movement in Quebec lose its class roots and therefore its vision? What does it mean to fight for sovereignty when the party leading that fight sounds more and more, on basic working class issues, like other parties in Quebec (and English Canada)? How was it, in the light of the current Harris government in Ontario, that once even conservative provincial governments could be forced by workers — and low-paid women at that — to introduce union security by law?

Such questions are a more difficult response to the historical photographs because they challenge us, rather than comfort us. But asking them is the only way to ensure that history really remains something alive. As singer Patricia O'Callaghan remarked about the songs of Leonard Cohen, "although they seem dark, they offer real hope because it is only in honestly examining something that change can occur."

The CAW Millennium Project

In the spring of 1999, the CAW decided on a millennium project. It commissioned Vincenzo (Vince) Pietropaolo to lead a team that would create a collection of photographs of CAW members in their workplaces.

Photographs confer status. The factories we cannot see into, the beds that get magically made when we stay at a hotel, the clerks, waiters, and waitresses we absent-mindedly ignore, the trains that seem to run on their own — all of this involves work we casually take for granted. Out of sight, out of mind. Workers themselves internalize such attitudes. When a photographer arrives in a workplace to take photographs, the common reaction is, "A picture of me?" Photographs of family rituals, like weddings, are one thing and photographs of movie stars, athletes, or famous leaders are another. But "a picture of an ordinary person at work"? The very fact of taking photographs of working people is a

16

way of overcoming that denigration and asserting the social worth of the work being done and the dignity of those doing it.

The issue is not, however, just whether to photograph working people; there are also choices to be made about how to take these photographs, and that depends very much on what the particular photographers bring to their work. Photographers arrive as outsiders. They are visitors who come, prepare, take the photographs and leave. But this does not block them from being insiders in the overall movement, from identifying with the people whose images they

are trying to capture. Each photographer involved in this project sees his/her role as being "to march and to photograph, not as a distanced observer, but as a participant" (Vincenzo Pietropaolo in the introduction to *Celebration of Resistance*, his collection of photographs of the Ontario Days of

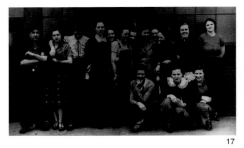

17

Action). The photographs they have compiled aren't just *of* workers but *for* workers. They aren't just about individuals who happen to work, but about workers' special — and ambivalent — relationship to their work.

We see photographs of workers who probably would have preferred, that morning, to flop their heads back on their pillows. And photographs of workers who, as retirement nears, cannot imagine being anywhere else but at work. There is the angry worker who is convinced that the word "alienation" was invented specifically to describe his work and the worker who will not let her picture be taken as long as the foreman is around. There are photographs of workers who couldn't survive without the escape into daydreams — that freedom, as one put it to his photographer, to float away to "somewhere else." And there are photographs of workers who are instantly animated by any show of interest in the details of what they do and how. There are photographs of workers who count the minutes and seconds so they can get on with their "real" life, and there are photos of workers who marvel that they are turning handfuls of gritty sand into transparent panes of glass or finishing an engine that is as beautiful as it is powerful. More than anything, as we go from photograph to photograph, there is a growing awareness that for so many workers and for so much of the time, their relationship to their work is not simple but some combination of such contradictory emotions.

A great photograph can capture something that we have in common or it can capture something that seems foreign, strange. What a single photograph cannot capture, however, is the diversity within us, amongst us, and in what we do. As we browse through the 190 photographs that make up this collection, that diversity declares itself. Seen together, the photographs proudly proclaim that "we are everywhere. " When we first broke away from the UAW, we didn't by that

act alone become a truly "Canadian" union. Rather, we became a non-American union in the heavy manufacturing sector of Ontario and Quebec. After the split, mergers became both more attractive and more possible, and as a result of those mergers and further organizing, the union soon had a solid foundation in every province and represented workers in every sector of the economy. It was then that the CAW became Canadian in more than name.

The remarkable diversity these photographs reveal includes our collective role as providers of the goods and services society uses. The invisibility of work in our society, the fact that work is so taken for granted is not new. Over 100 years ago, the Russian novelist Leo Tolstoy, observing early industrialization, remarked: "I think the first condition of a good education is that the child should know that all he uses does not fall from heaven ready-made, but is produced by other people's labour." Here again, one picture of work is just that — a single photograph. But a collection of such photographs documents the central role of workers in our society. And that can't help but suggest our potential role in social change.

When we first look at these photographs they are, as the title of the book suggests, photos of Canadians at work. There is, at first, no reason to identify these workers as being CAW members; they can be workers in other unions or workers without unions. At one level, this reminds us that we are part of a broader class and of the need for a broader solidarity within Canadian labour. But just within the CAW, the stunning diversity across regions and sectors forces us to think about our own unity. How can one union possibly accommodate all this diversity?

Unions have their own specific culture. When the UAW was formed in the thirties, the cement that built the union and held it together was "industrial unionism." Industrial unionism had three main characteristics: workplace democracy based on elected union representatives; the equality of all workers independent of their skills, colour, or gender; and the organization of workers across an entire sector (auto). As the CAW merged and diversified, it began to develop another kind of unionism dependent on a different kind of glue: "ideological unionism."

This new unionism didn't give up on the crucial strengths of industrial unionism. It didn't reject its past, but built on it and expanded it. The workers and unions who came to the CAW were coming because of the appeal of a culture that emphasized resistance ("fighting back makes a differ-

ence"). They were identifying with a perspective that insisted on the necessary oppositional role of unions in a capitalist society (which included criticism of its social democratic allies when they retreated from the fight). They were joining a union that recognized the crucial importance of playing a leading role within our communities (as an added defence against the growing power of the corporate sector). They were looking to become part of an organization that was accelerating the expansion of internal educationals and forums for linking its activists, developing new leadership, and coping with new problems (always in the context of engagement in ongoing struggles).

Can looking at ourselves contribute to seeing and appreciating our potential? Photographs have no independent life. The best photographs cannot by themselves move us to action. They cannot tell us what to do. The links they make are inevitably tenuous. The CAW culture, for example, cannot be identified from any one photograph in this book. But once we know more about the history and culture of the CAW and also of the labour movement, we can go back and look at each photograph and this overall collection of photographs in a new way. These photographs can then perhaps clarify our lives as workers: help us get a handle, however incomplete, on what we do and who we are, on our ties to each other, and on our relationship to society. History is influenced and ideals maintained by people like ourselves — the people who live in the photographs of this book.

November 5, 1999

Captions and Photo Credits

Photographs used with permission, and copyright is retained by the owners and custodians.

1. R. S. McLaughlin, the founder of what became General Motors of Canada, poses in Oshawa, Ontario, with a 1908 McLaughlin Model F, one of the first automobiles made in Canada. Courtesy of General Motors of Canada Ltd., Oshawa, Ontario.

2. The fishing trip — the quintessential photograph in the family photo album. Courtesy of Schuster Gindin, Toronto, Ontario.

3. Interior of tire factory, circa 1910. Courtesy of Walter P. Reuther Library, Wayne State University, Detroit, Michigan.

4. SKD striker, Amherstburg, Ontario, August 13, 1969. Photo by Bill Bishop. Courtesy of The Windsor Star, Windsor, Ontario.

5. Meeting of CAW Local 222 during the General Motors of Canada strike, Oshawa, Ontario, 1937. Courtesy of Walter P. Reuther Library, Wayne State University, Detroit, Michigan.

6. The Ford of Canada strike and blockade, Windsor, Ontario, November 5, 1945. Courtesy of Walter P. Reuther Library, Wayne State University, Detroit, Michigan.

7. Aerial view of the Ford of Canada blockade, Windsor, Ontario, November 1945. Courtesy of National Archives of Canada C107288, Ottawa, Ontario.

8. Strikers and World War I and World War II veterans parade through downtown Windsor, Ontario, during the Ford of Canada strike, November 9, 1945. Courtesy of Walter P. Reuther Library, Wayne State University, Detroit, Michigan.

9. Fleur-de-lis pendant made from bent nails and wire during the United Aircraft strike, Montreal, 1974. Direct scan. Pendant courtesy of Schuster Gindin, Toronto, Ontario.

10. Police cars overturned during the United Aircraft strike, Montreal, Quebec, May 1975. Courtesy of La Presse, Montreal, Quebec.

11. Evidence of violence against striking workers during the United Aircraft strike, Montreal, 1974. Courtesy of Fédération des travailleurs et travailleuses du Québec, Montreal, Quebec.

12. Women on the picket line during the Fleck strike, Huron Park, Ontario, 1978. Courtesy of Schuster Gindin, Toronto, Ontario.

13. Ontario Provincial Police being loaded onto buses at the Fleck strike, Huron Park, Ontario, April 1978. Courtesy of London Free Press, Collection of Photographic Negatives, D.B. Weldon Library, University of Western Ontario, London, Ontario.

14. Workers in the Steel and Radiation factory, Toronto, Ontario, circa 1905. Courtesy of City of Toronto Archives, Toronto, Ontario.

15. Demonstration for jobs in front of Canada's Parliament Buildings, May 15, 1993. Photo by Murray Mosher. Courtesy of Photo Features, Ottawa, Ontario.

16. Buzz Hargrove, then assistant to CAW National President Bob White, talking to workers at the Kelsey-Hayes Canada plant, Windsor, Ontario, June 27, 1990. Photo by Nick Brancaccio. Courtesy of The Windsor Star, Windsor, Ontario.

17. Workers at Motor Products, Windsor, Ontario, a manufacturer of auto components, circa 1938. Courtesy of CAW collection, Port Elgin, Ontario.

The Photographs

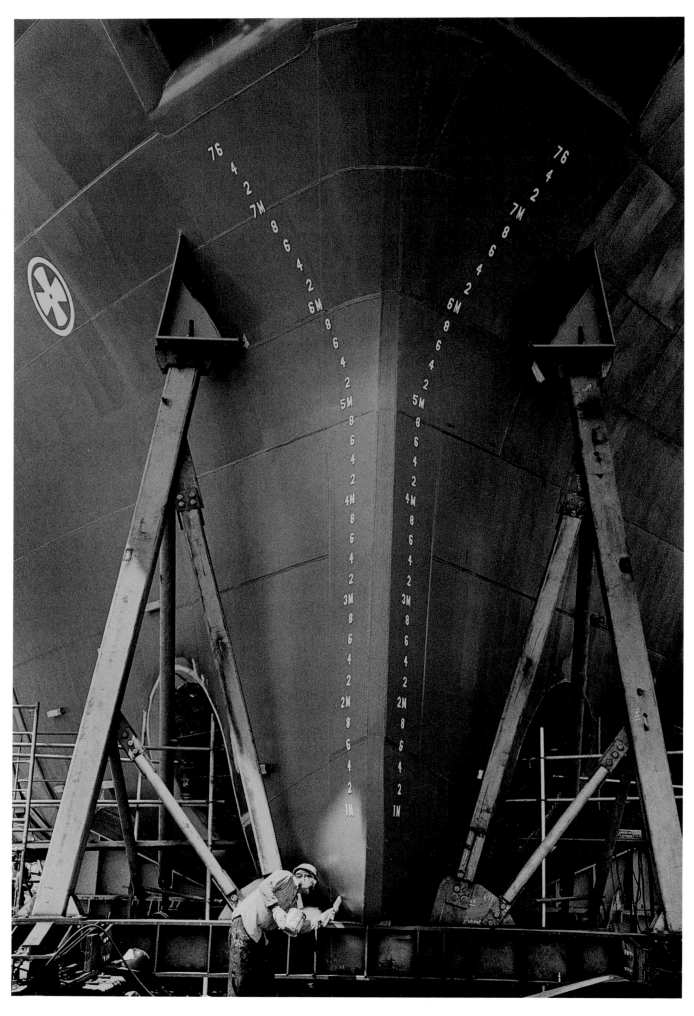

Painter in a shipyard, Halifax, Nova Scotia
Previous page: Autoworker, Windsor, Ontario

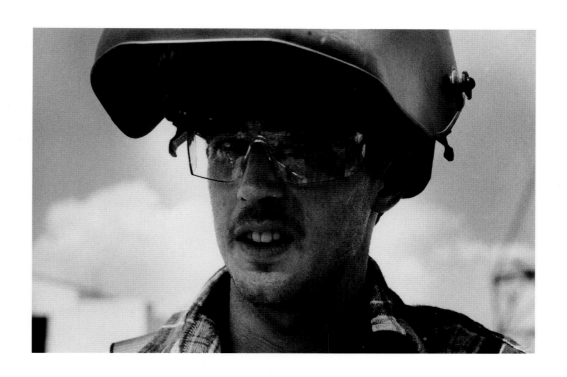

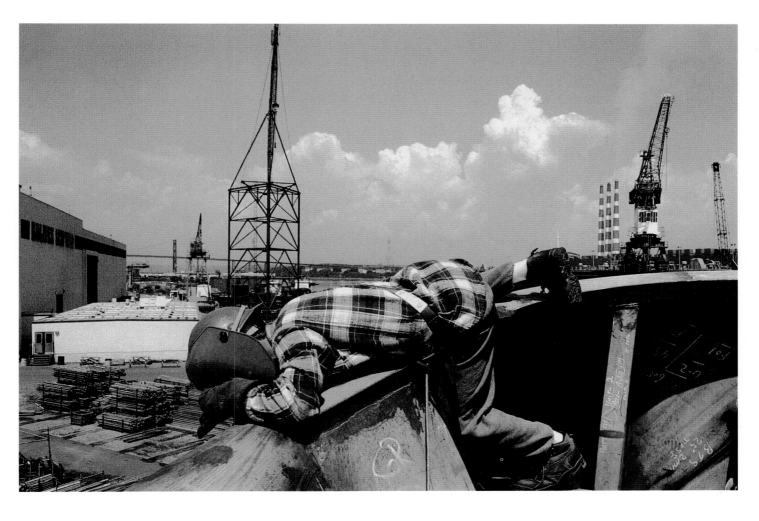

Both: Shipyard welder, Halifax, Nova Scotia

25

Autoworker, Oakville, Ontario

Assembly line workers in auto parts plant, Whitby, Ontario

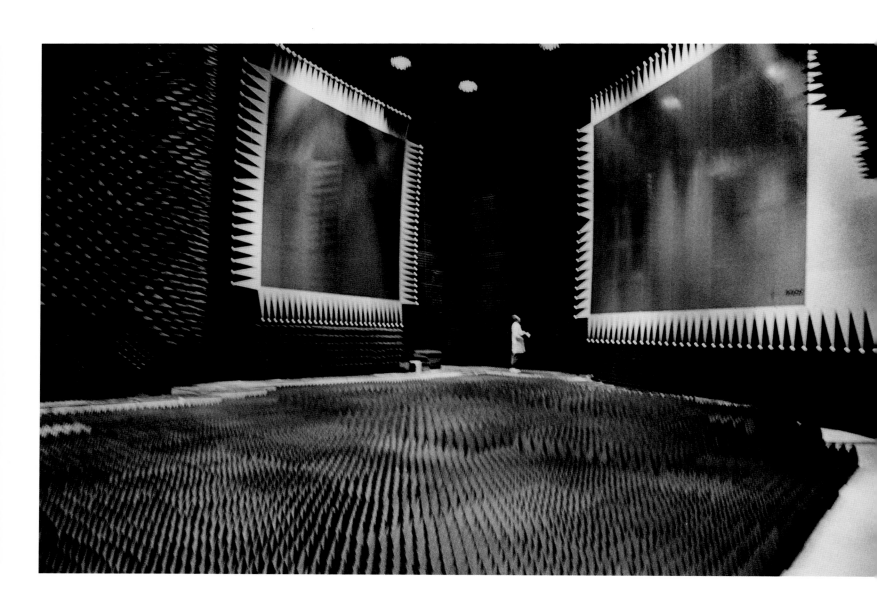

Electromagnetic test facility, Ste-Anne-de-Bellevue, Quebec

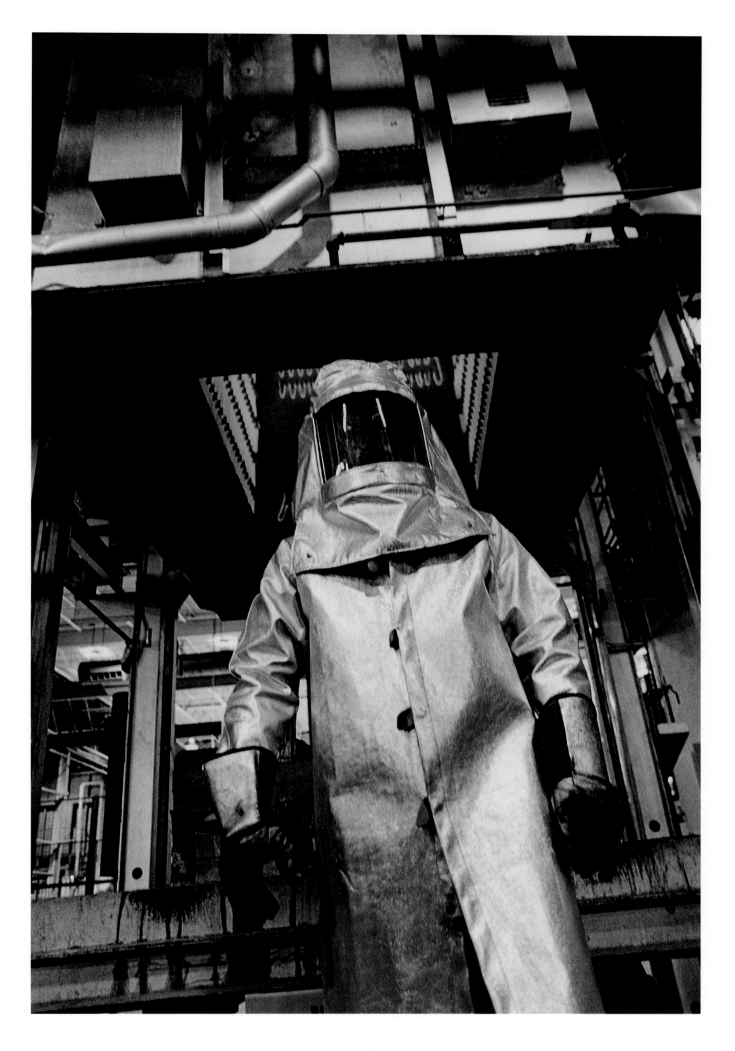

Aerospace worker, Winnipeg, Manitoba

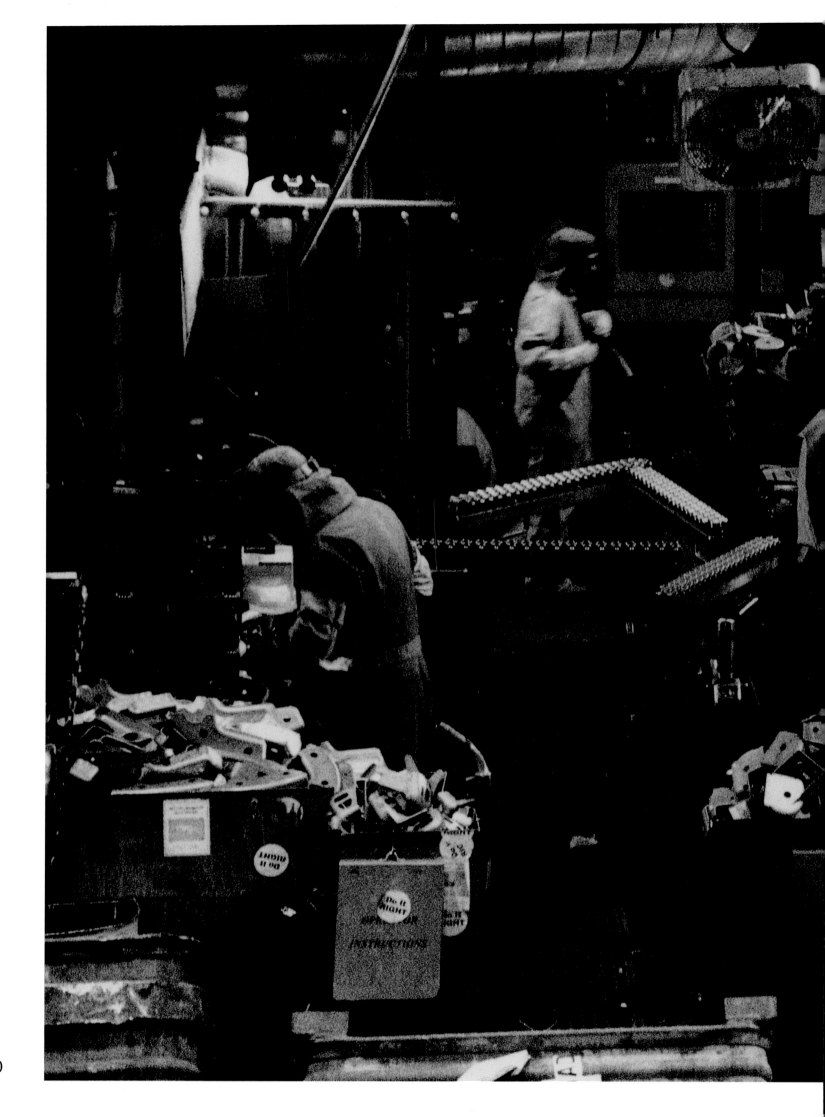

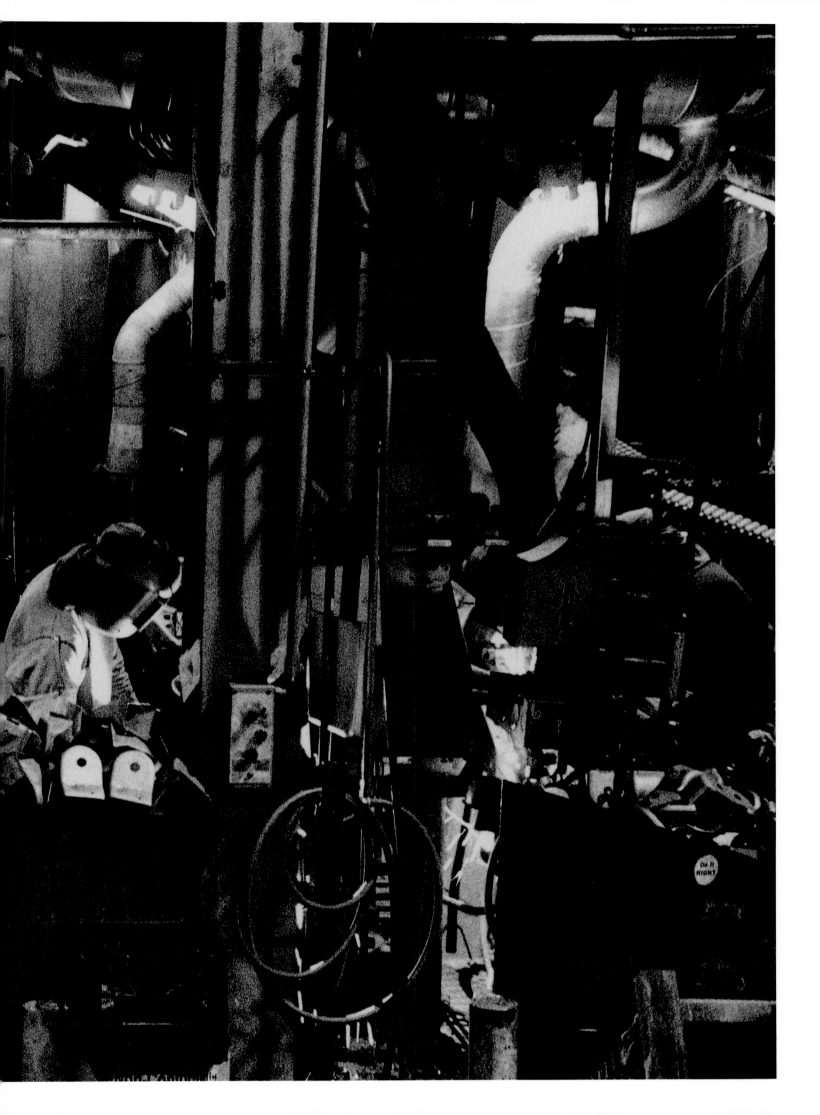

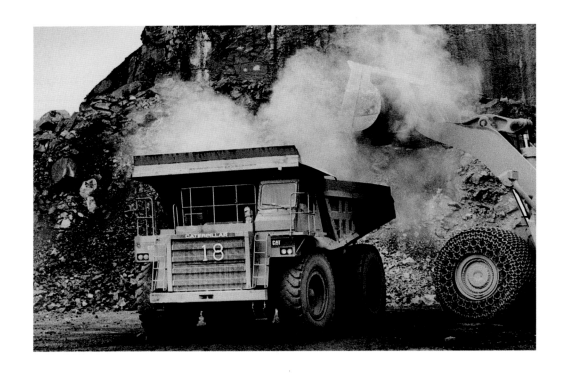

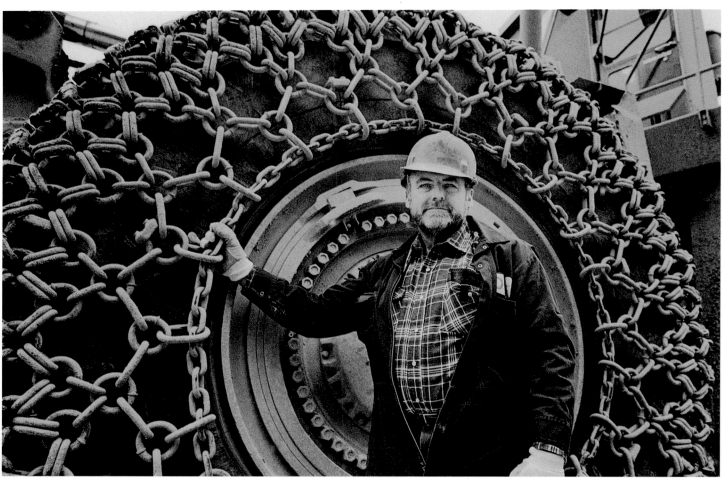

Top: Eighty-five ton truck in a cement plant, Bowmanville, Ontario
Bottom: Heavy equipment operator, Bowmanville, Ontario
Previous page: Welders in an auto parts plant, Kitchener, Ontario

Shipping canal, Brossard, Quebec

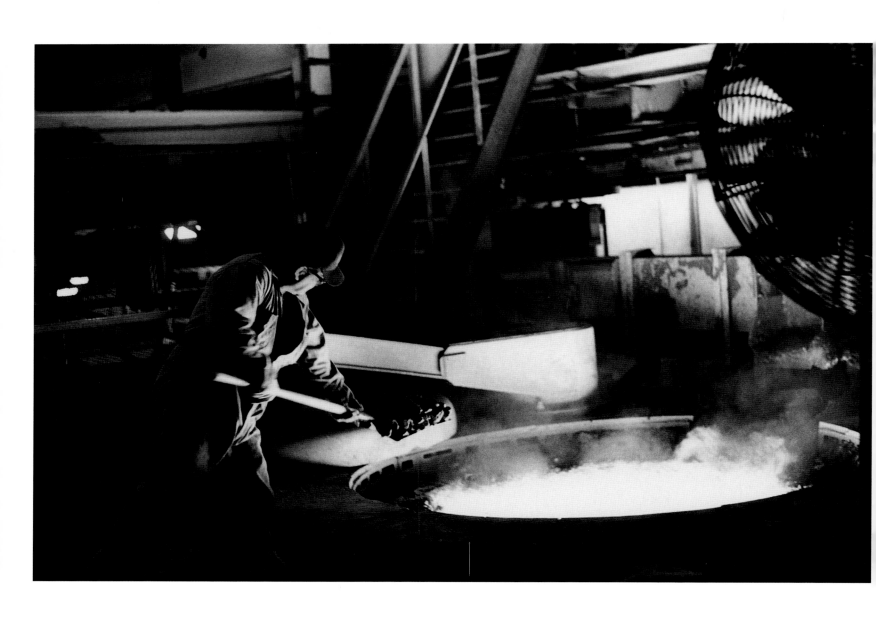

Steel shoveller in a casting plant, Windsor, Ontario

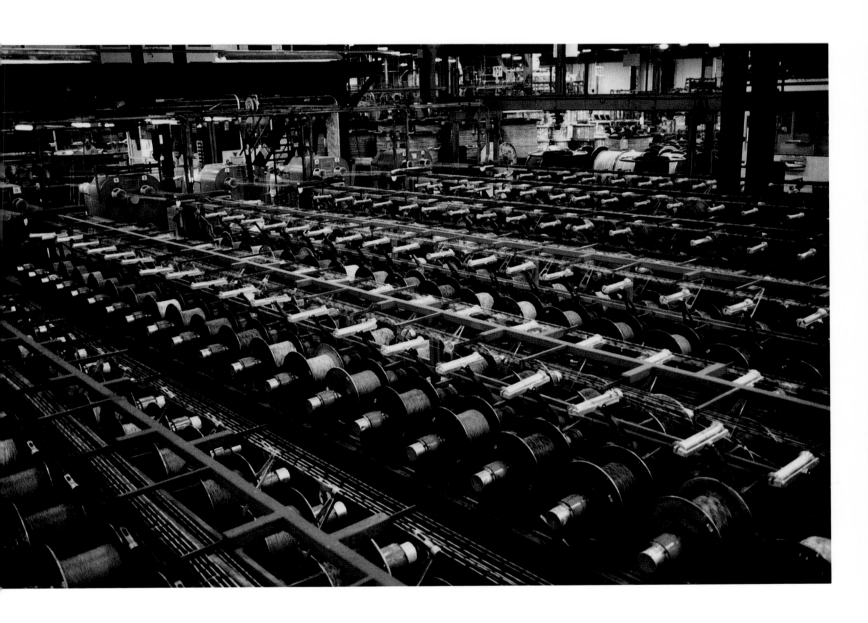

Cable manufacturing plant, Kingston, Ontario

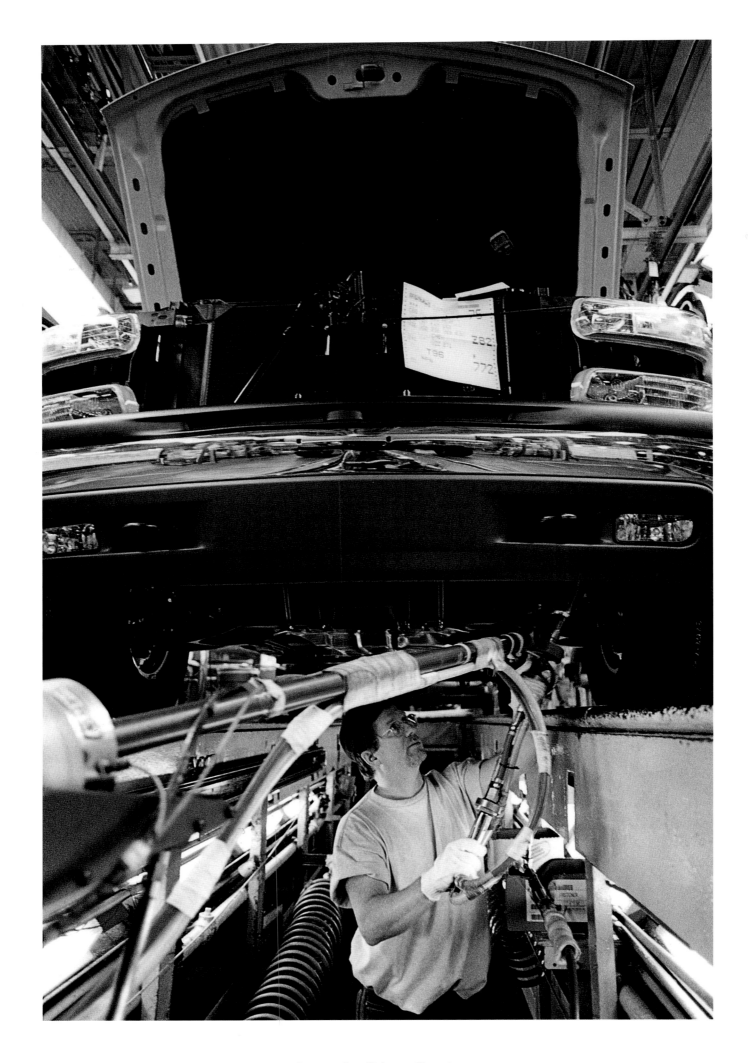

Autoworker, Oshawa, Ontario

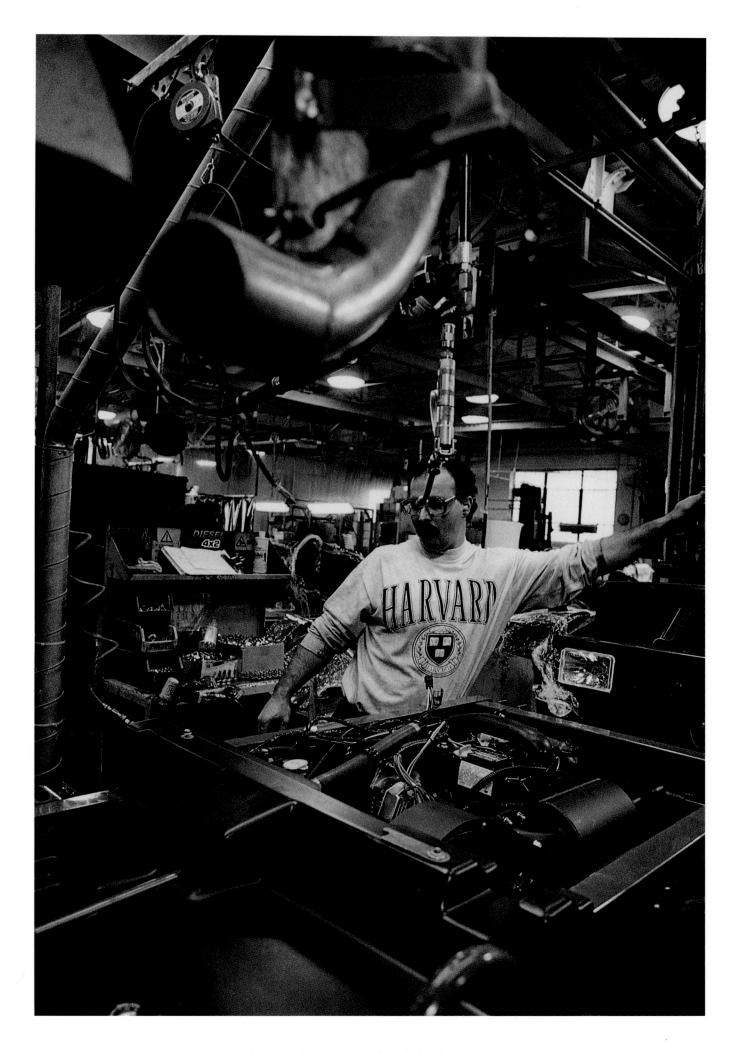

Farm machinery assembler, Welland, Ontario

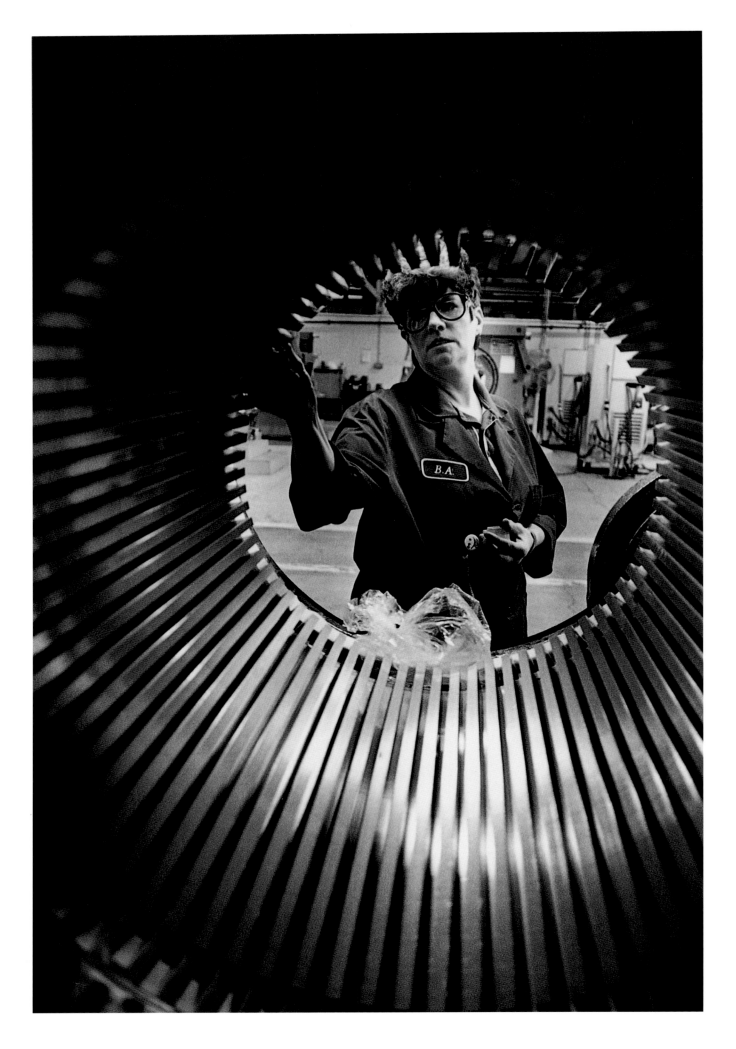

Worker in a motor manufacturing plant, Peterborough, Ontario

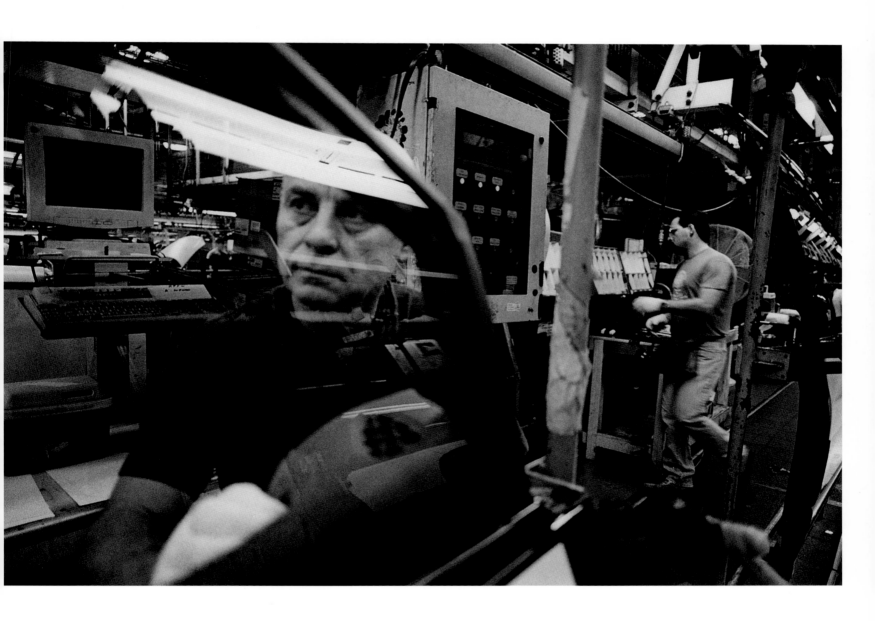

Autoworkers, Windsor, Ontario

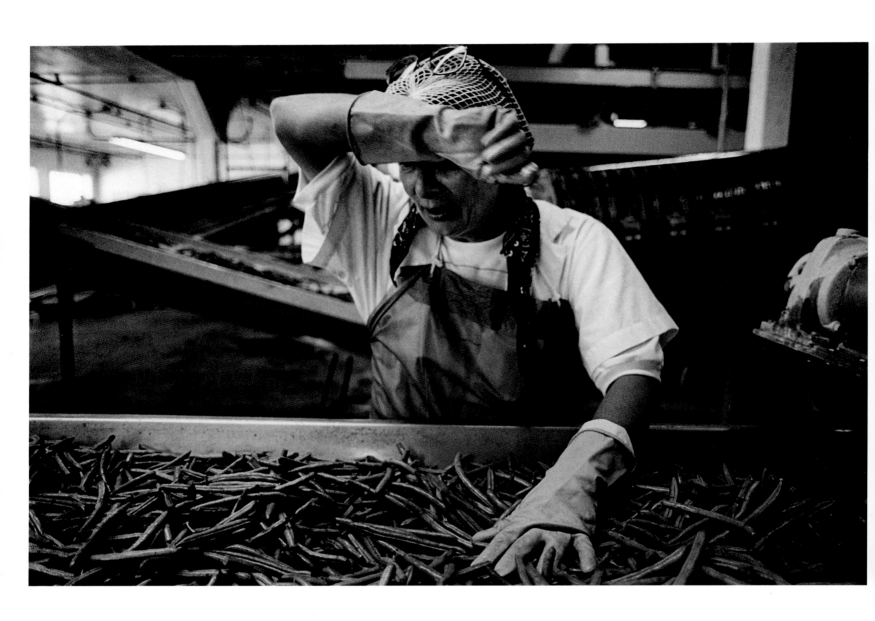

Worker in a vegetable processing plant, Chambly, Quebec

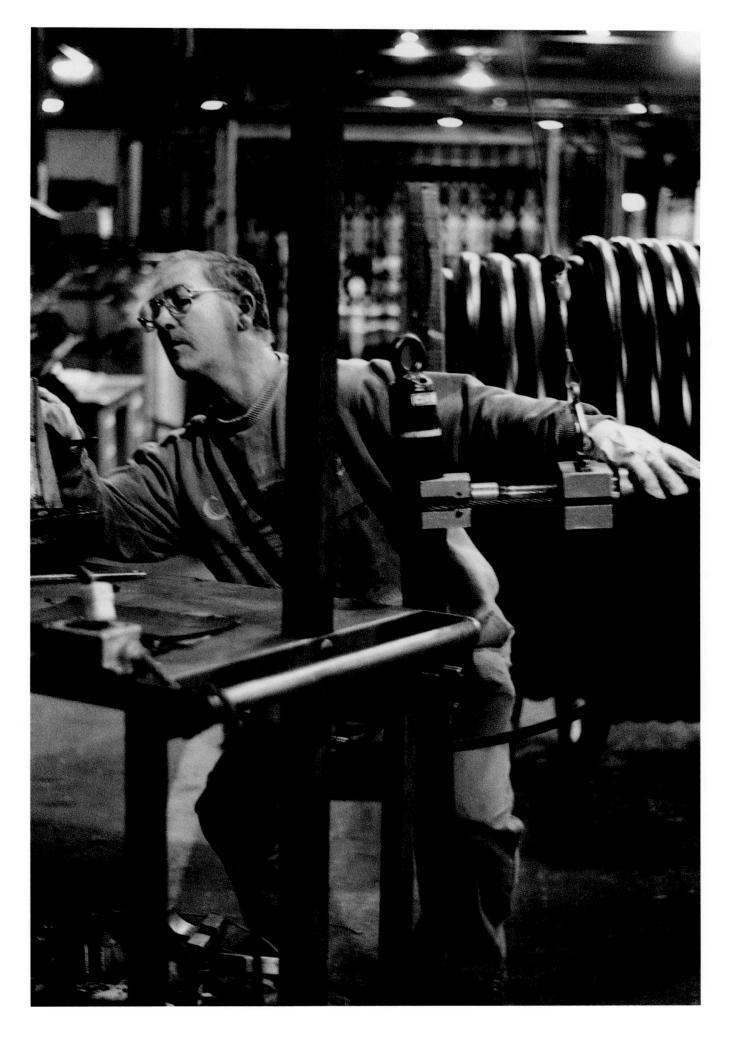

Worker in a cable manufacturing plant, Kingston, Ontario

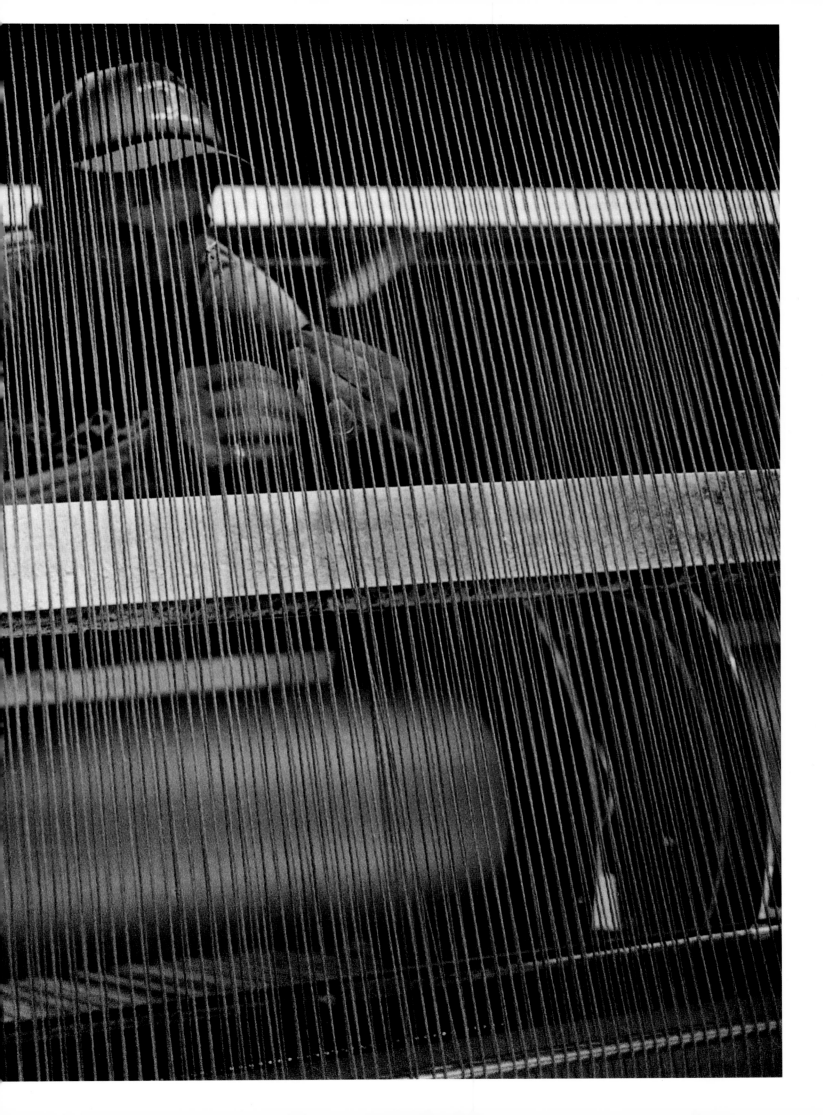

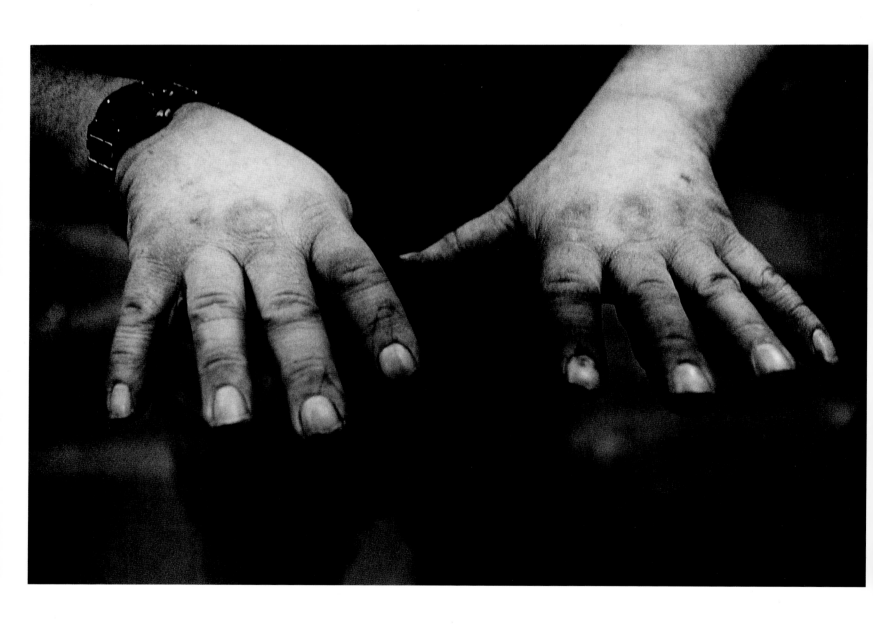

Worker's hands (thumb lost in childhood farm accident), Thunder Bay, Ontario
Previous page: Loom operator in a carpet factory, Truro, Nova Scotia

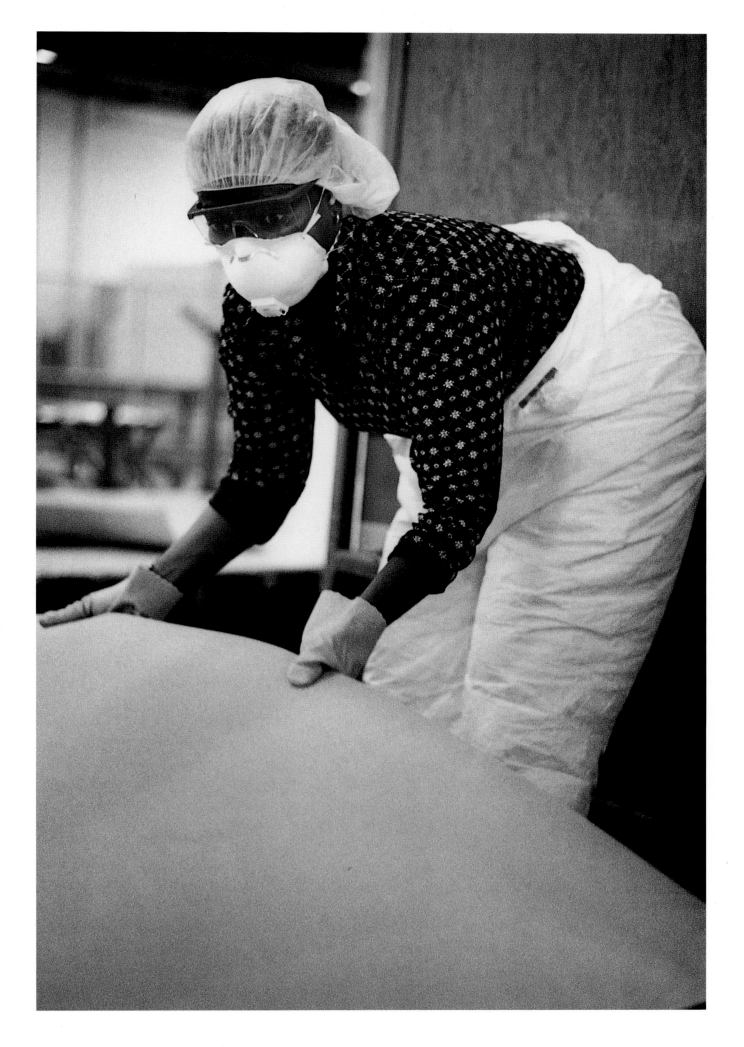

Working with foam in the auto parts industry, Woodbridge, Ontario

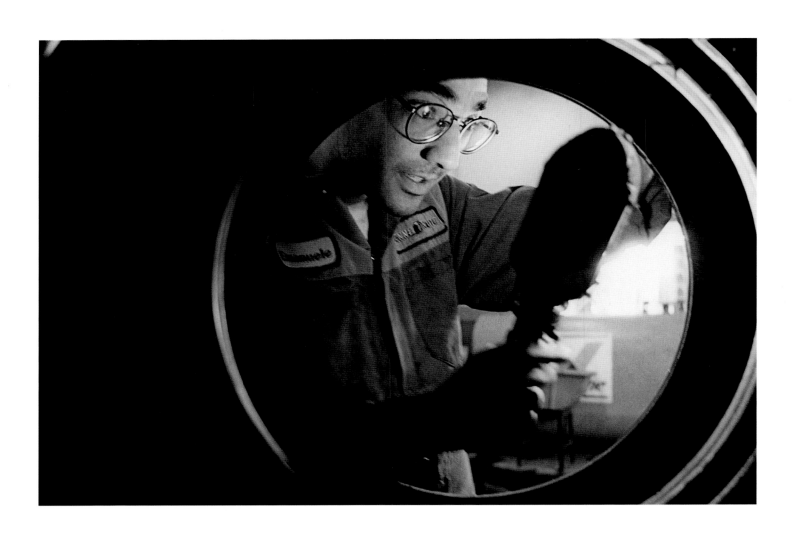

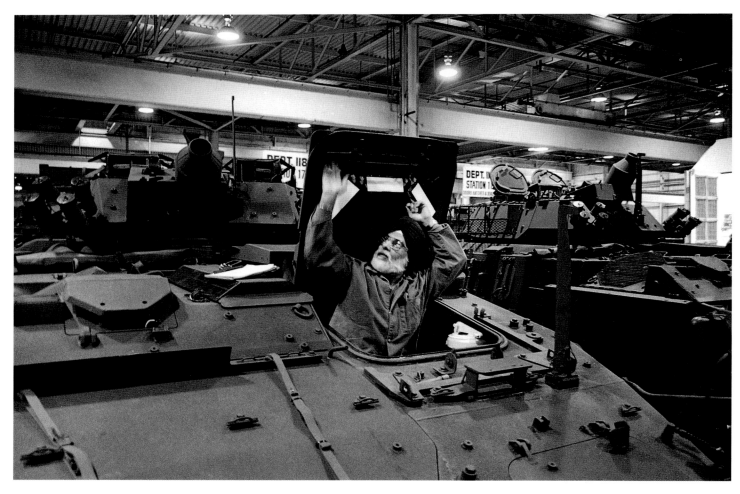

Top: Tire factory worker, St-Laurent, Quebec
Bottom: Armoured vehicle assembly worker, London, Ontario

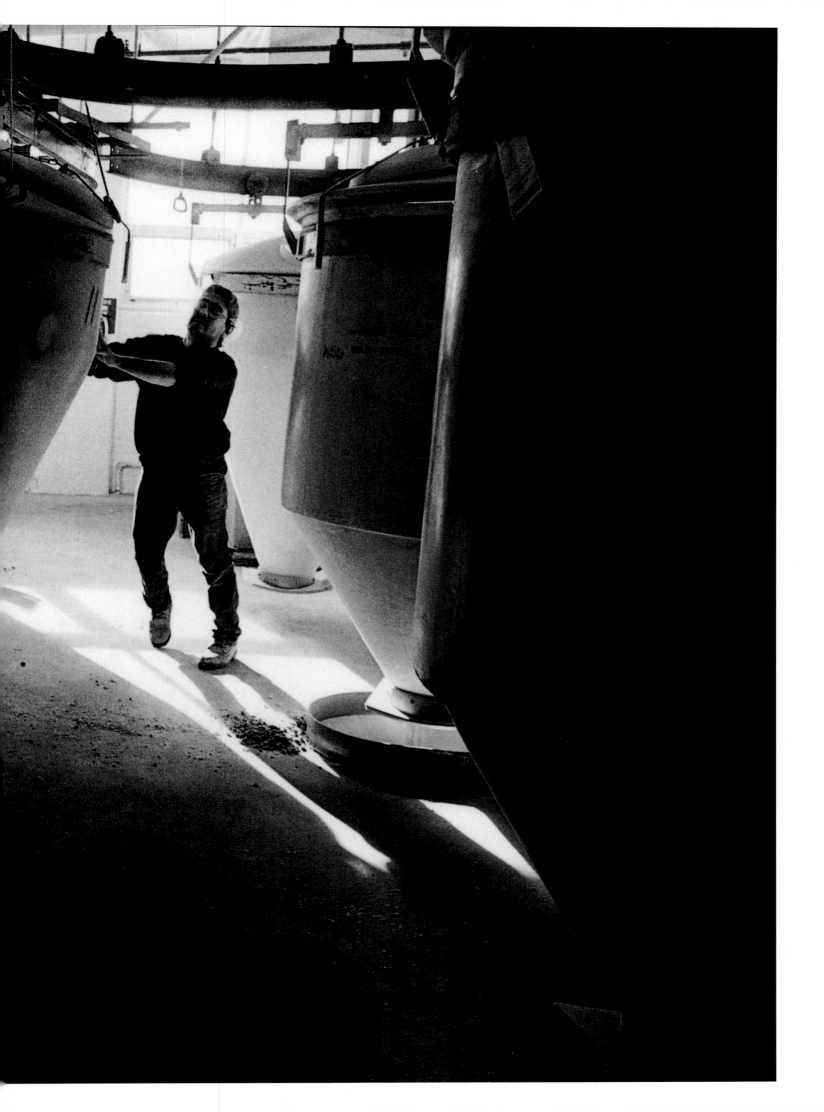

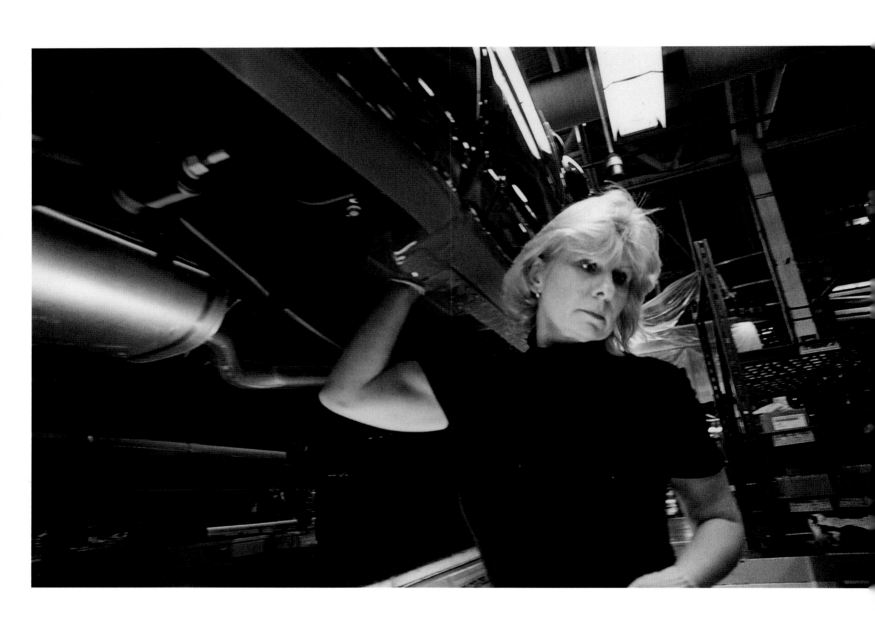

Autoworker, Oshawa, Ontario
Previous page: Cereal factory worker, Peterborough, Ontario

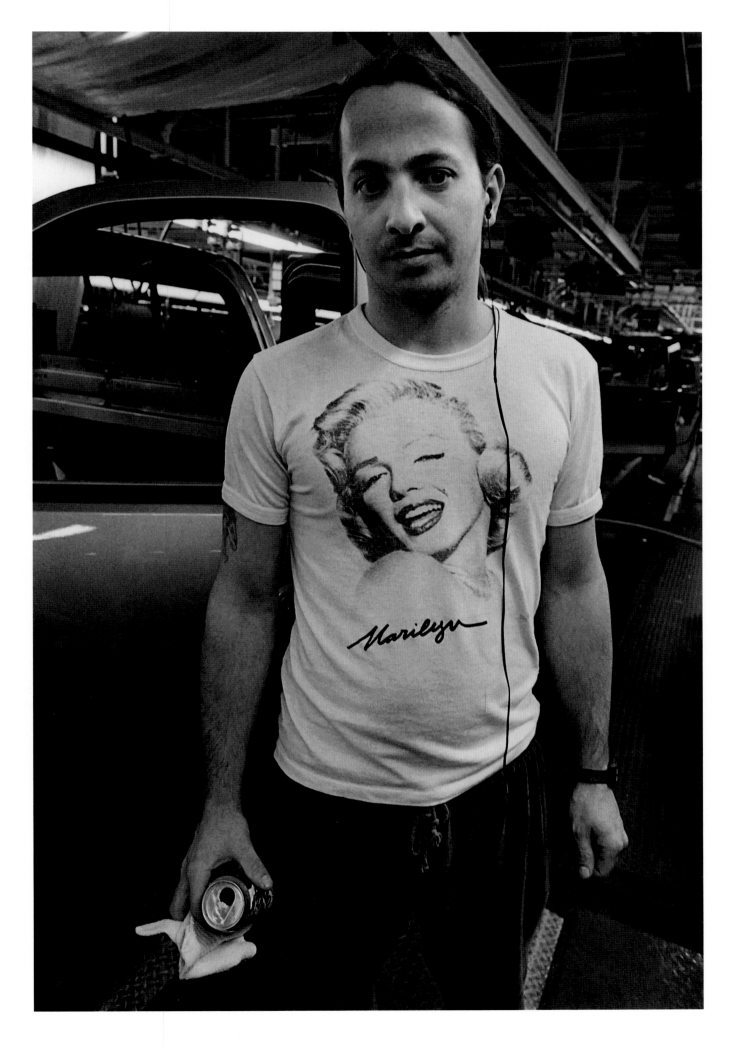

Autoworker, Oakville, Ontario

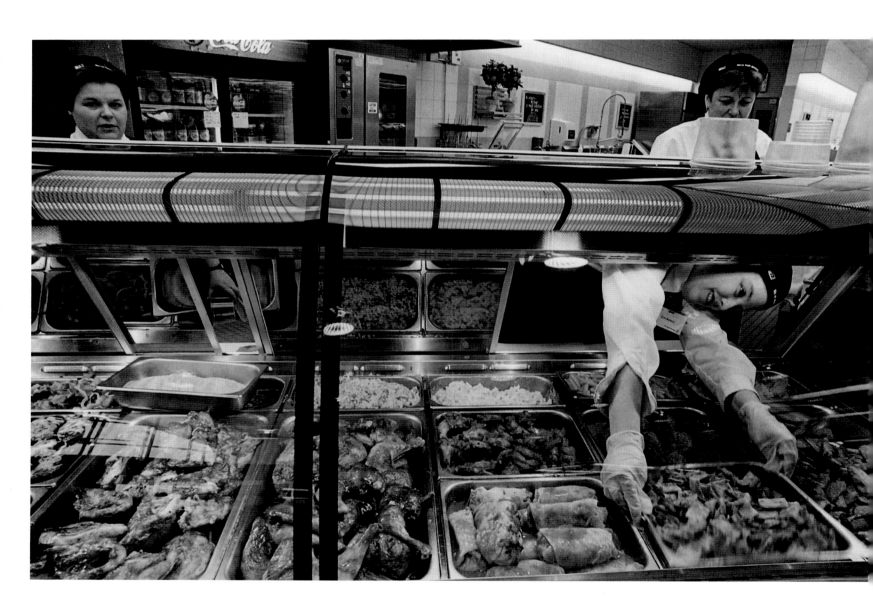

Supermarket clerks, Toronto, Ontario

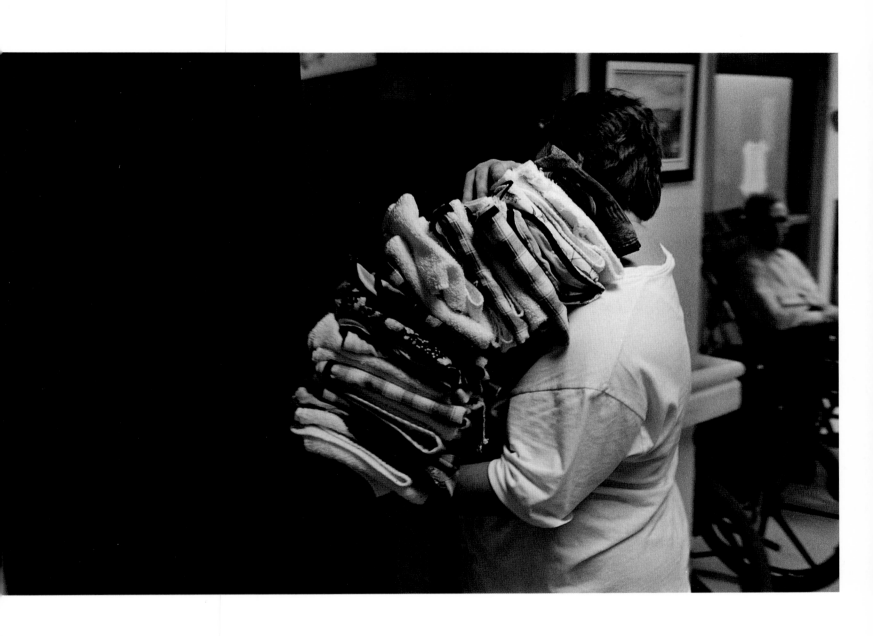

Housekeeper in a nursing home, Mahone Bay, Nova Scotia

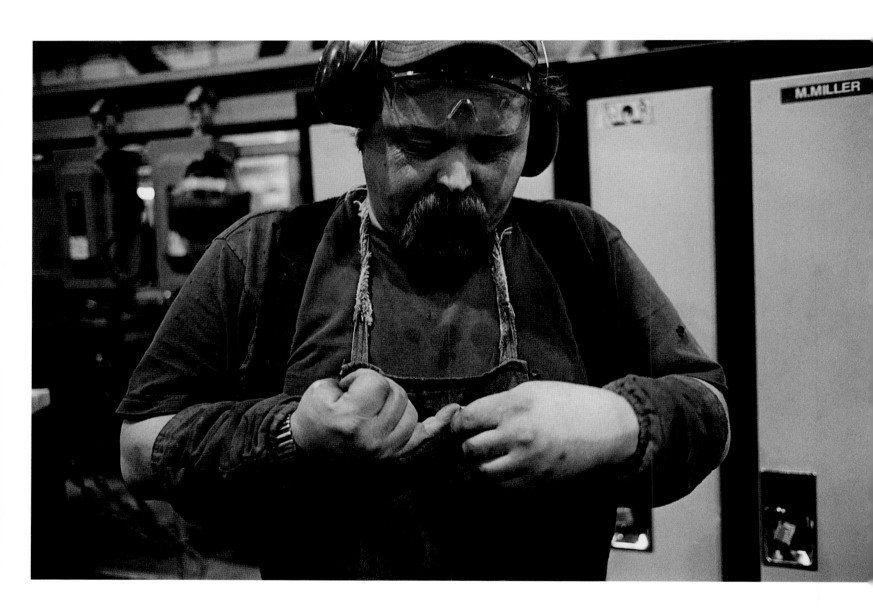

Subway car assembler, Thunder Bay, Ontario

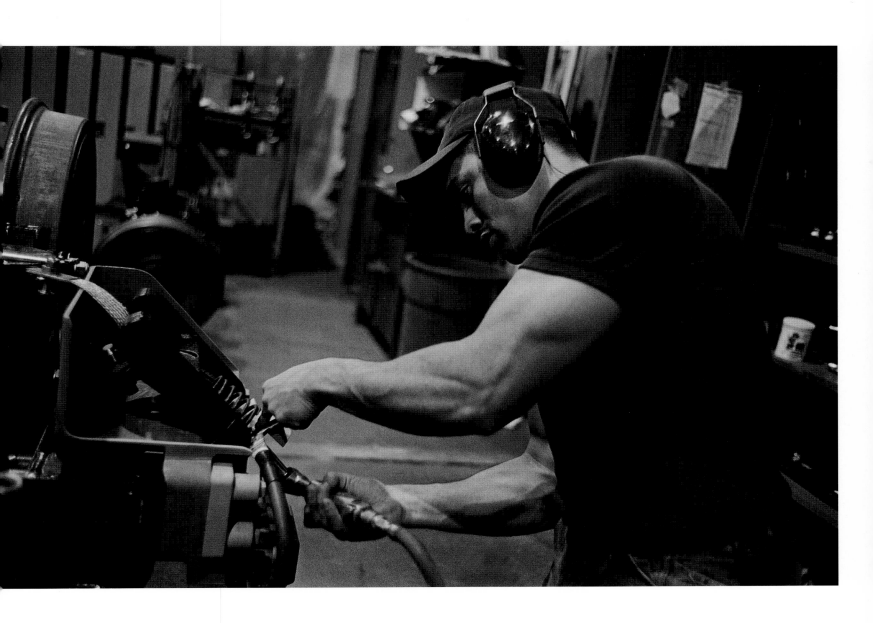

Subway car assembler, Thunder Bay, Ontario

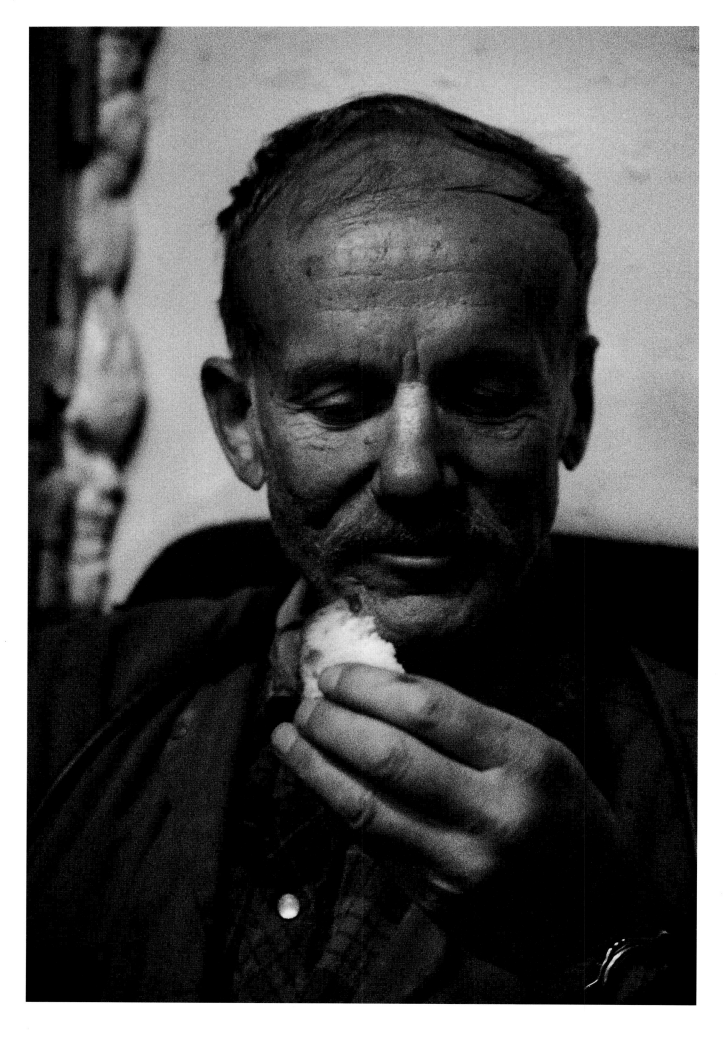

Zinc miner, Campbell River (Vancouver Island), British Columbia

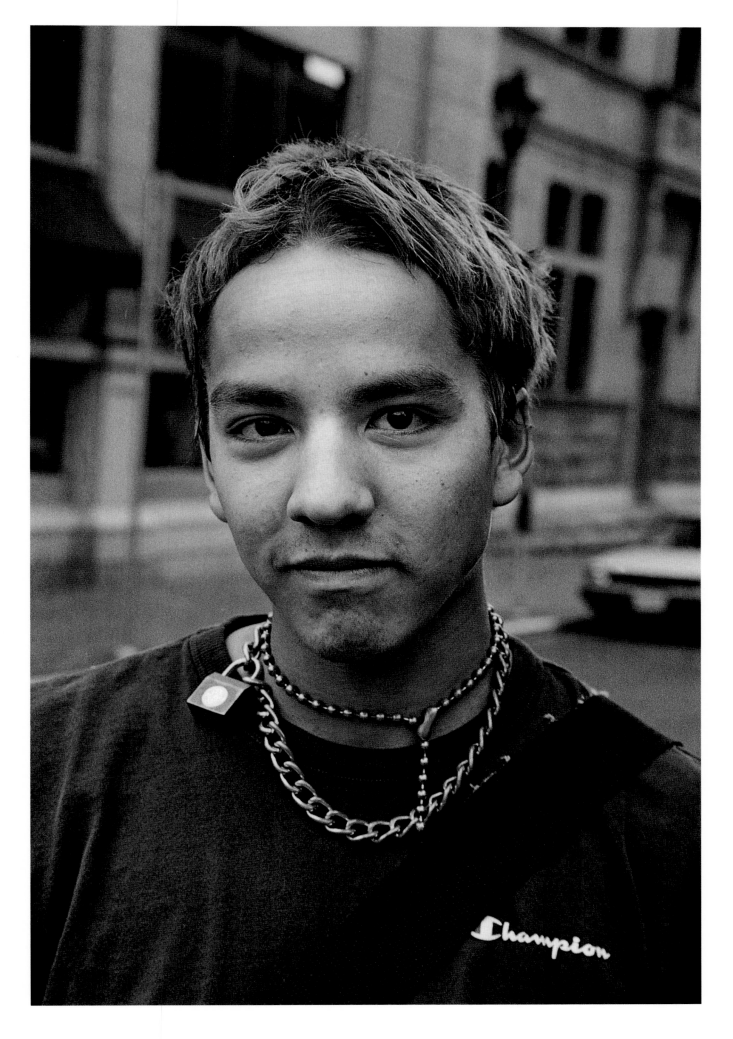

Restaurant worker after his shift, Victoria, British Columbia

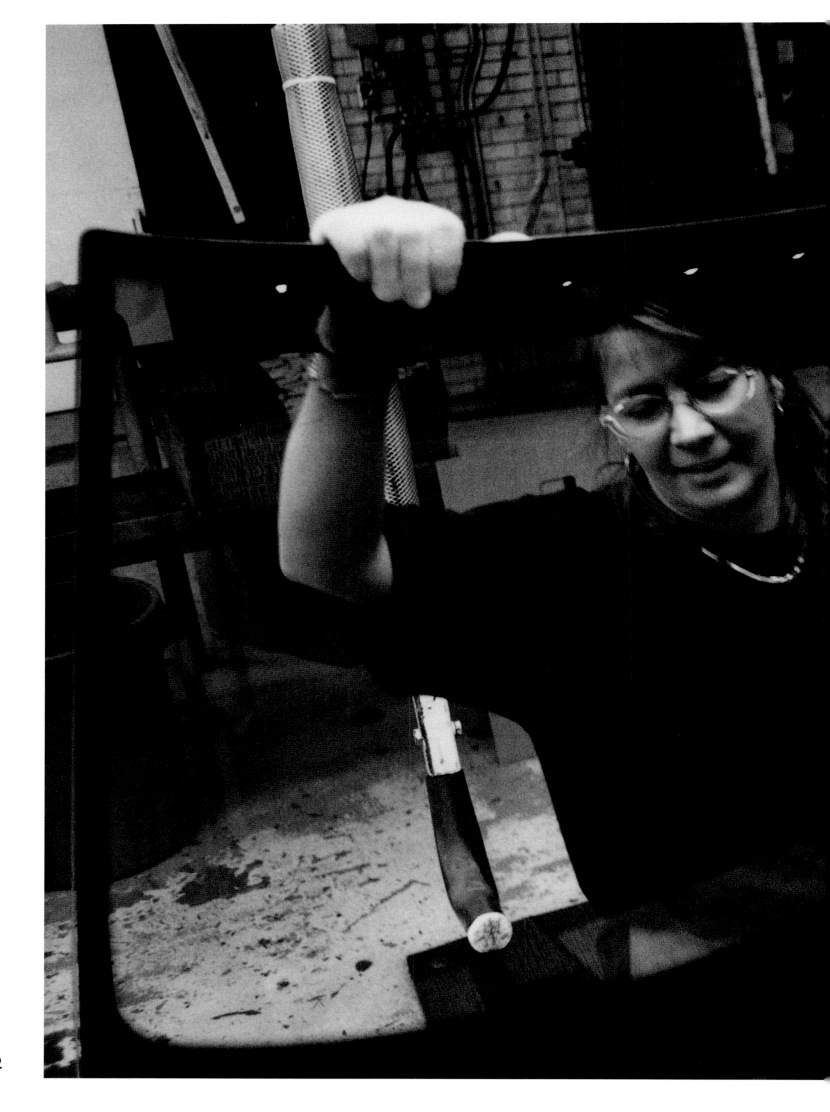

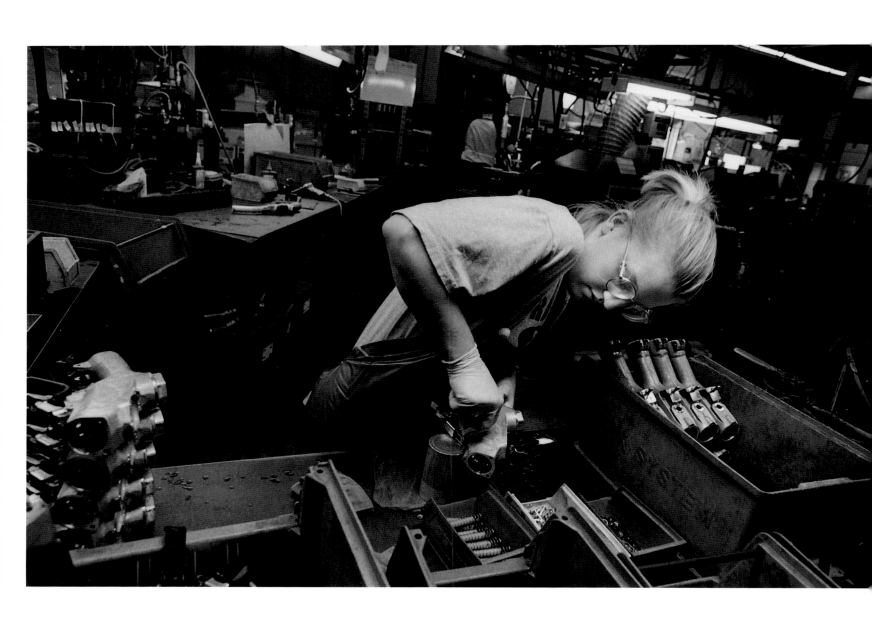

Gasoline nozzle assembly worker, Strathroy, Ontario
Previous page: Worker in a windshield plant, Hawkesbury, Ontario

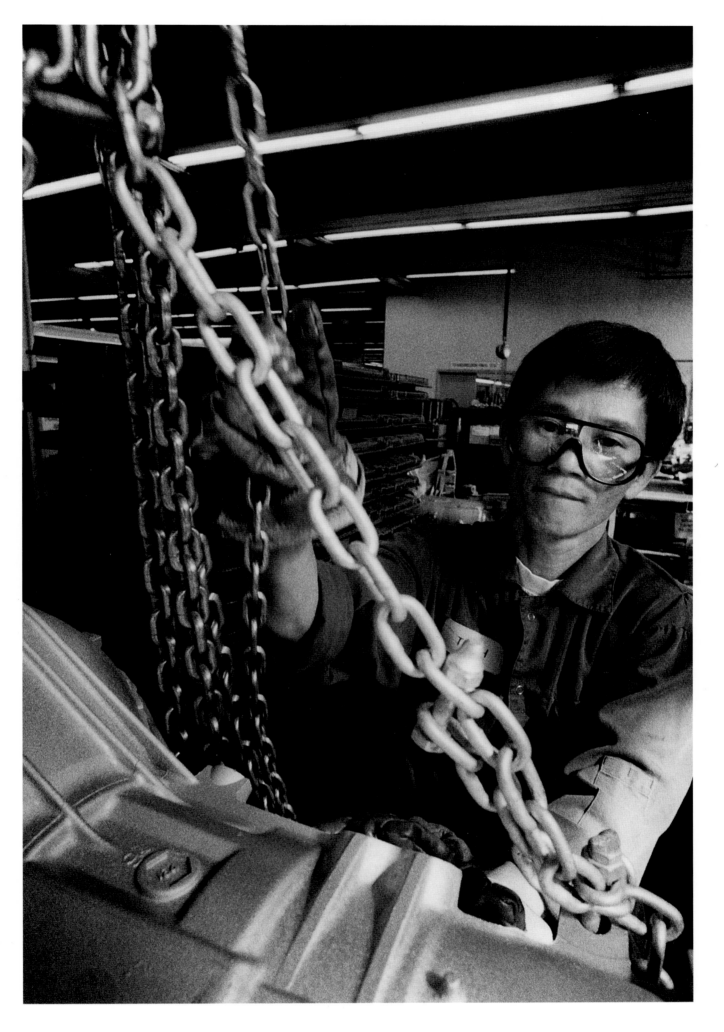

Engine rebuilder, Edmonton, Alberta

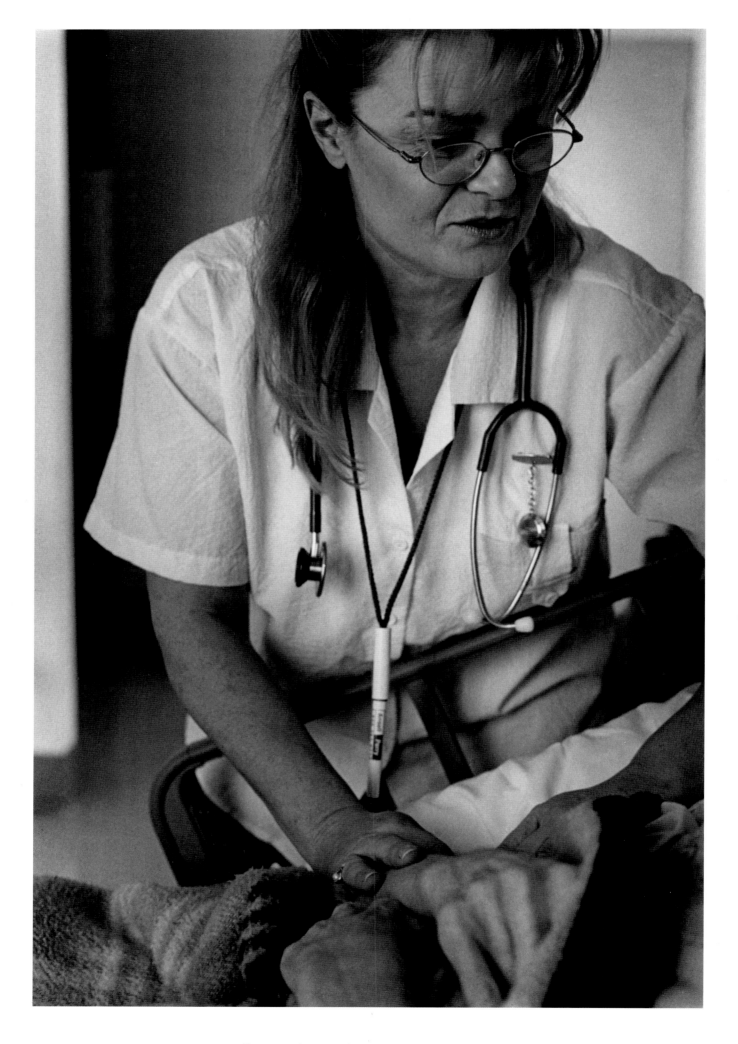

Registered practical nurse, Kitchener, Ontario

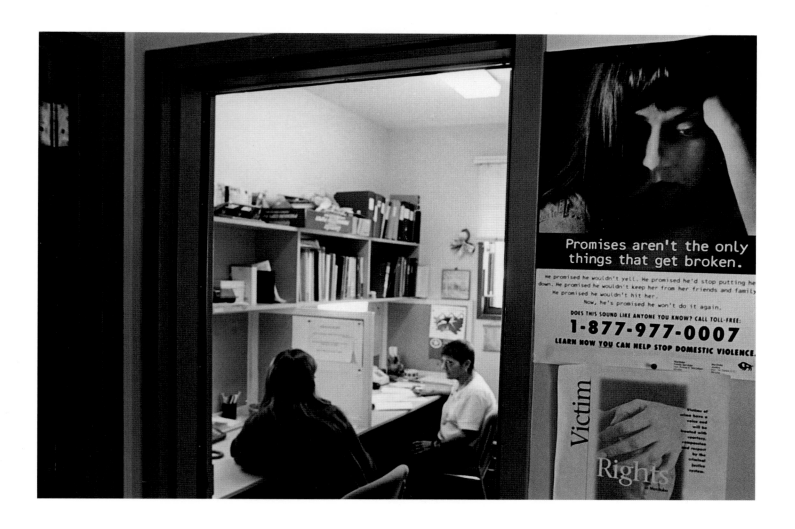

Top: Women's shelter, Selkirk, Manitoba
Bottom: Old photograph of workers in the carpentry shop of an aluminum smelter, Kitimat, British Columbia

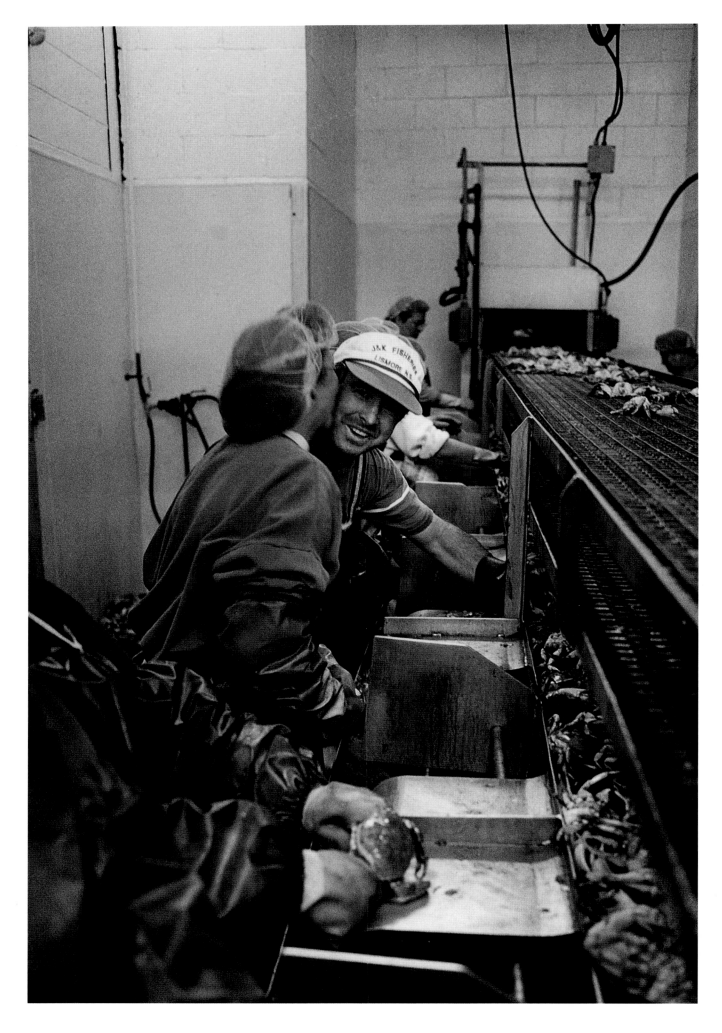

Stolen kiss on crab packing line, Lamèque, New Brunswick

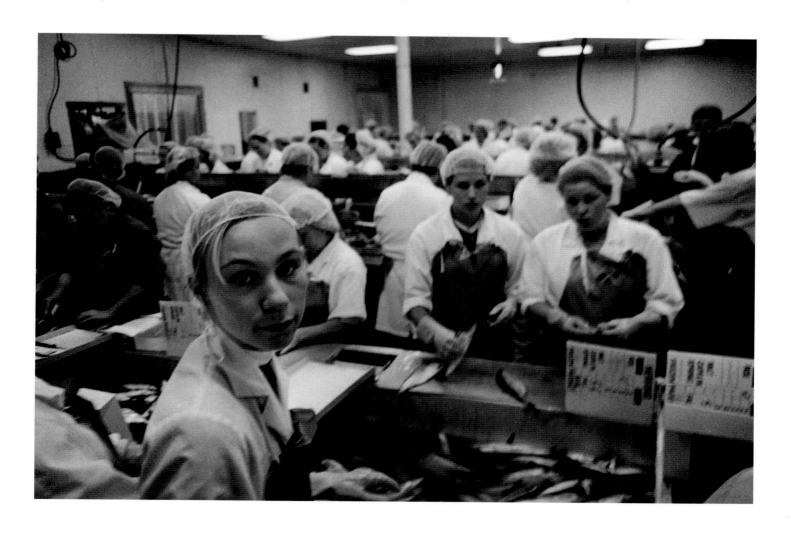

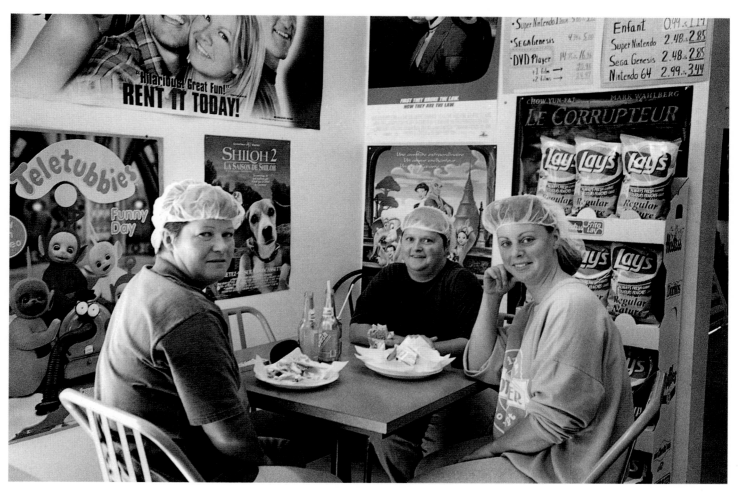

Top: Herring processing plant, Lamèque, New Brunswick
Bottom: Fish plant workers at lunch break, Lamèque, New Brunswick

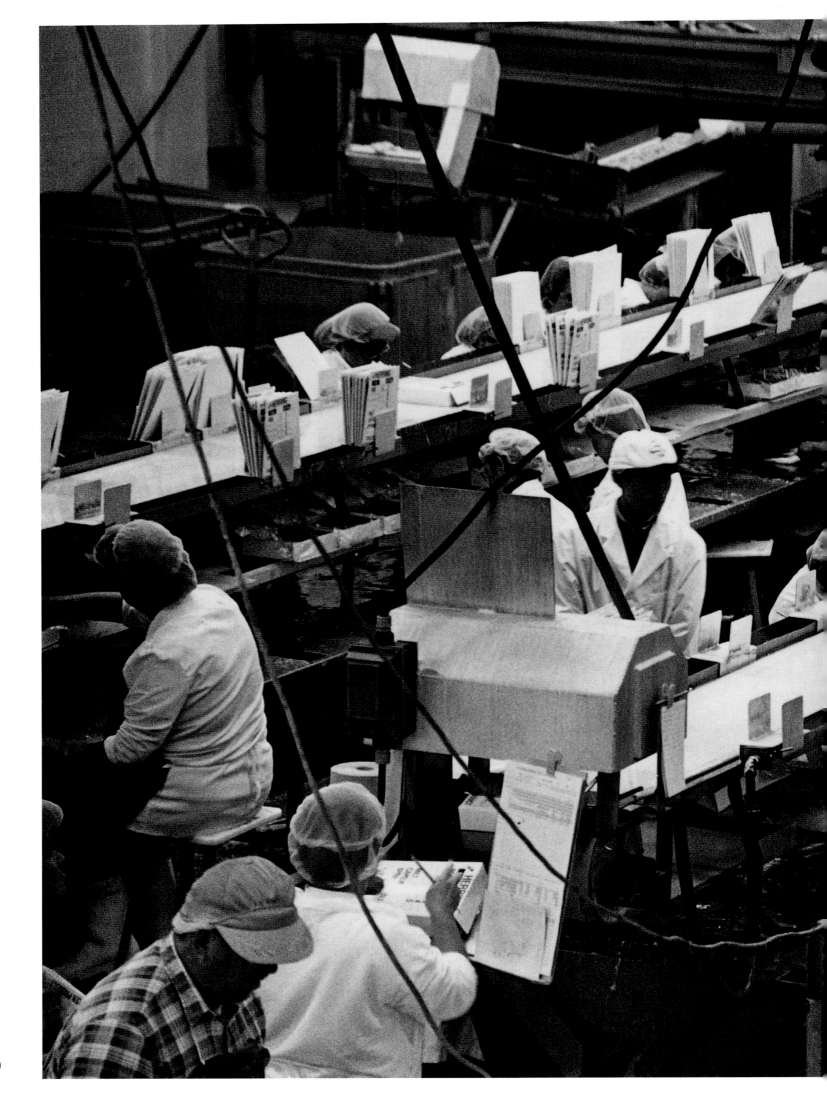

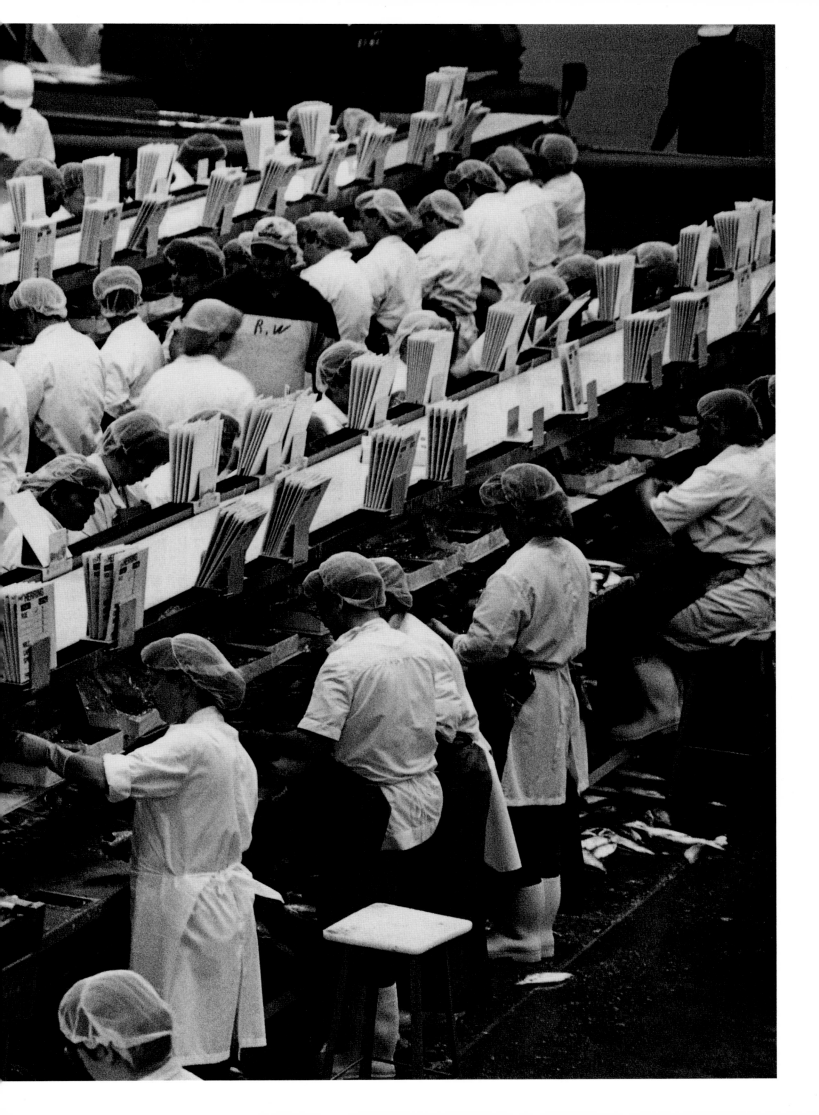

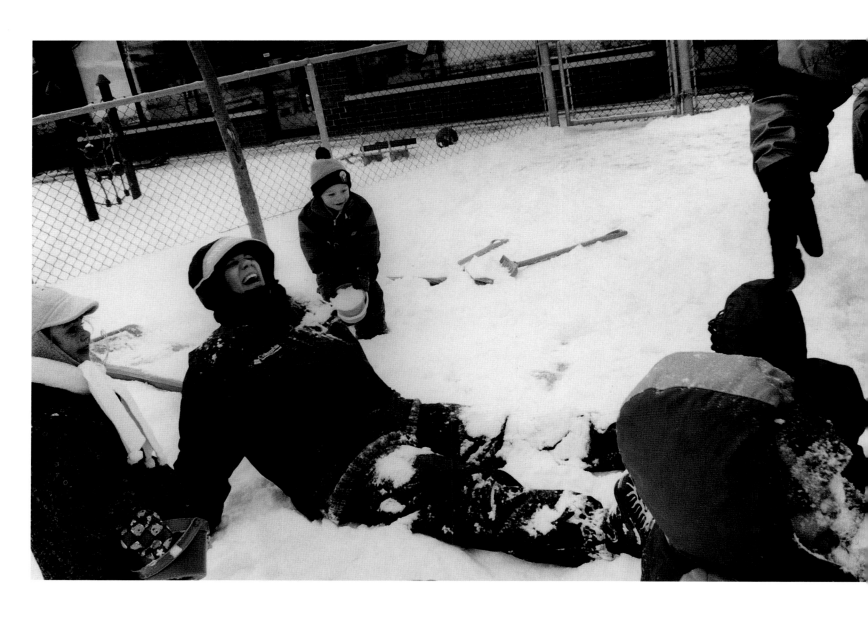

Child care worker, Oshawa, Ontario

Previous page: Fish packing plant, Lamèque, New Brunswick

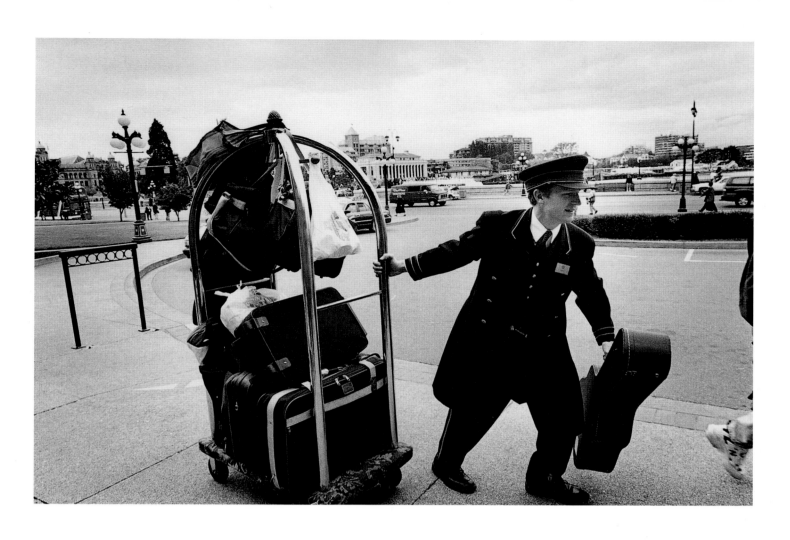

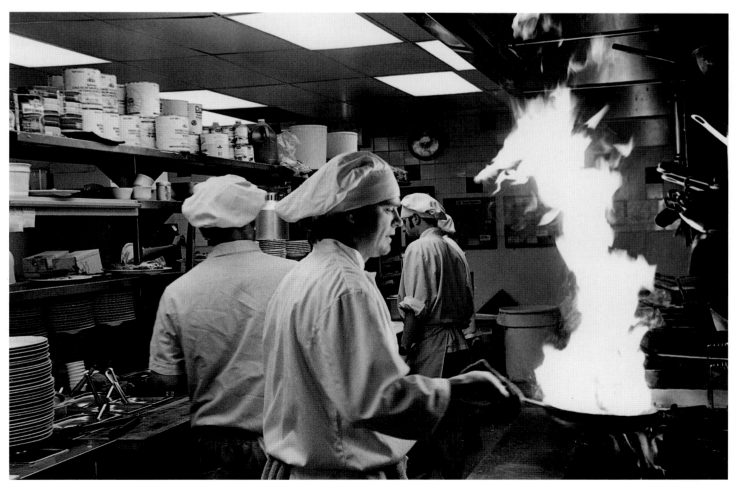

Top: Hotel worker, Victoria, British Columbia
Bottom: Restaurant cook, Victoria, British Columbia

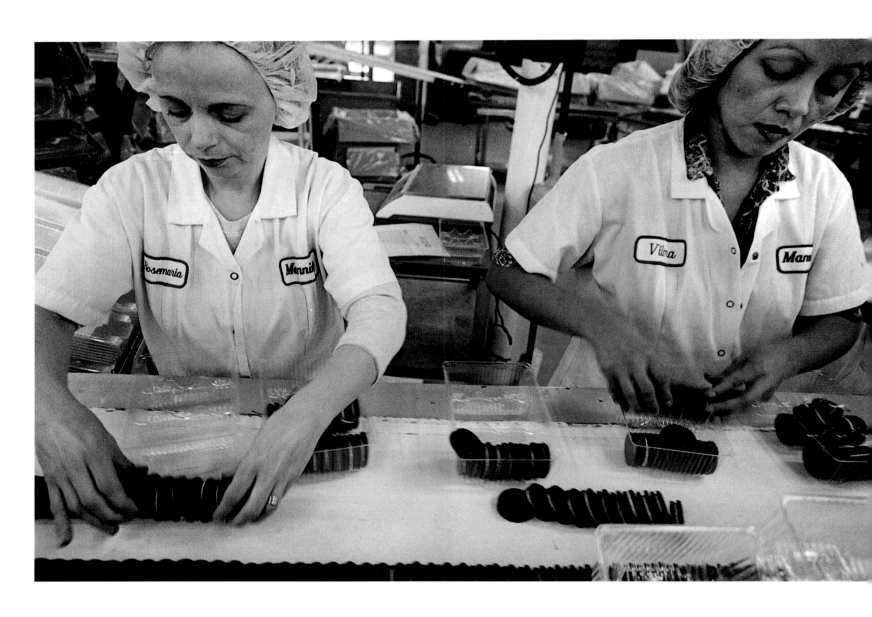

Cookie packers, Toronto, Ontario

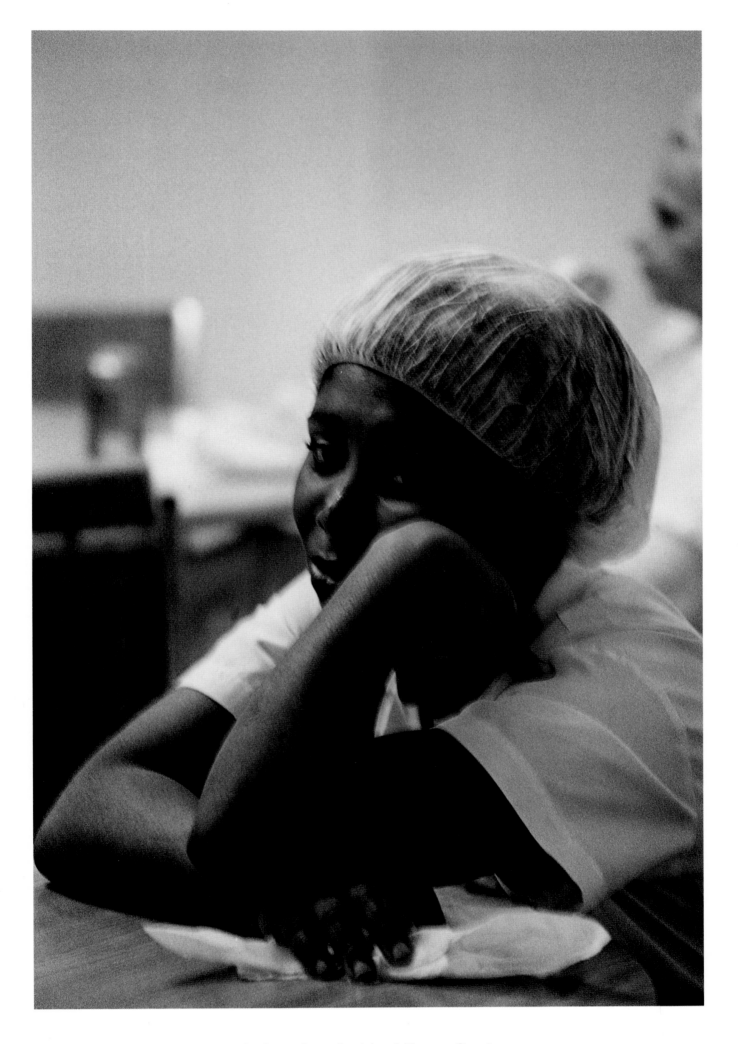

Cookie packer at lunch break, Toronto, Ontario

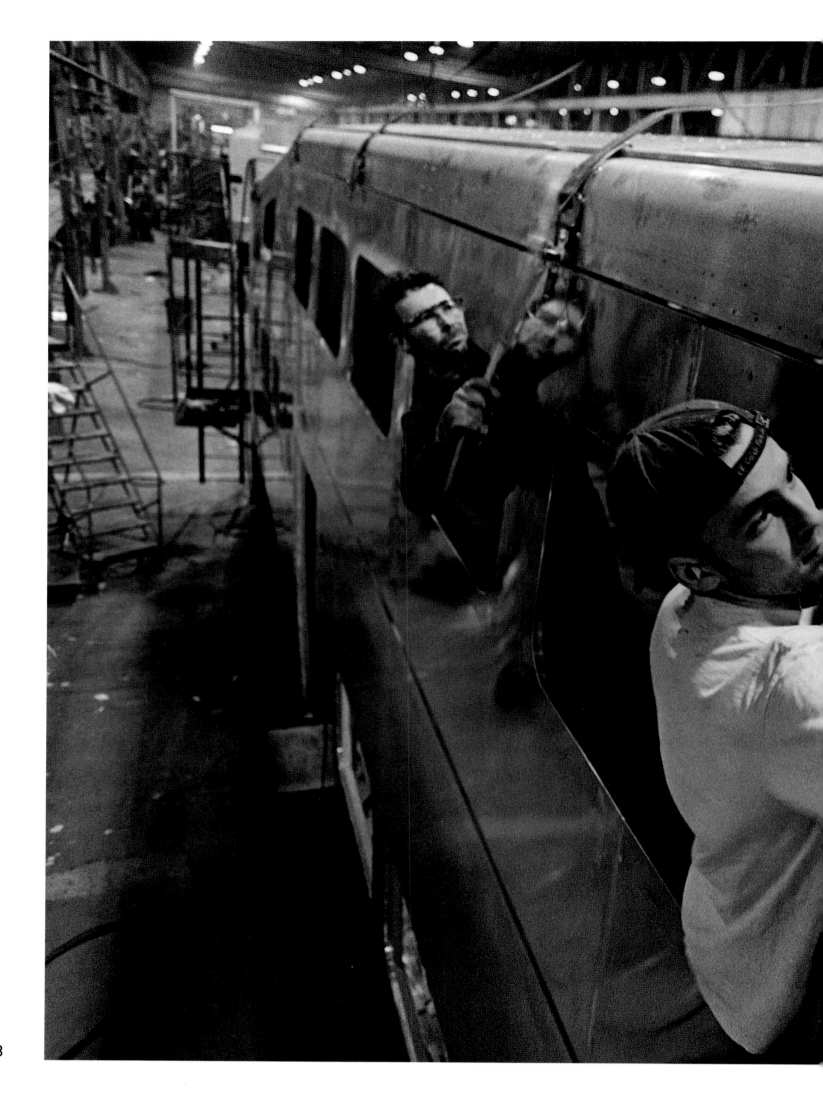

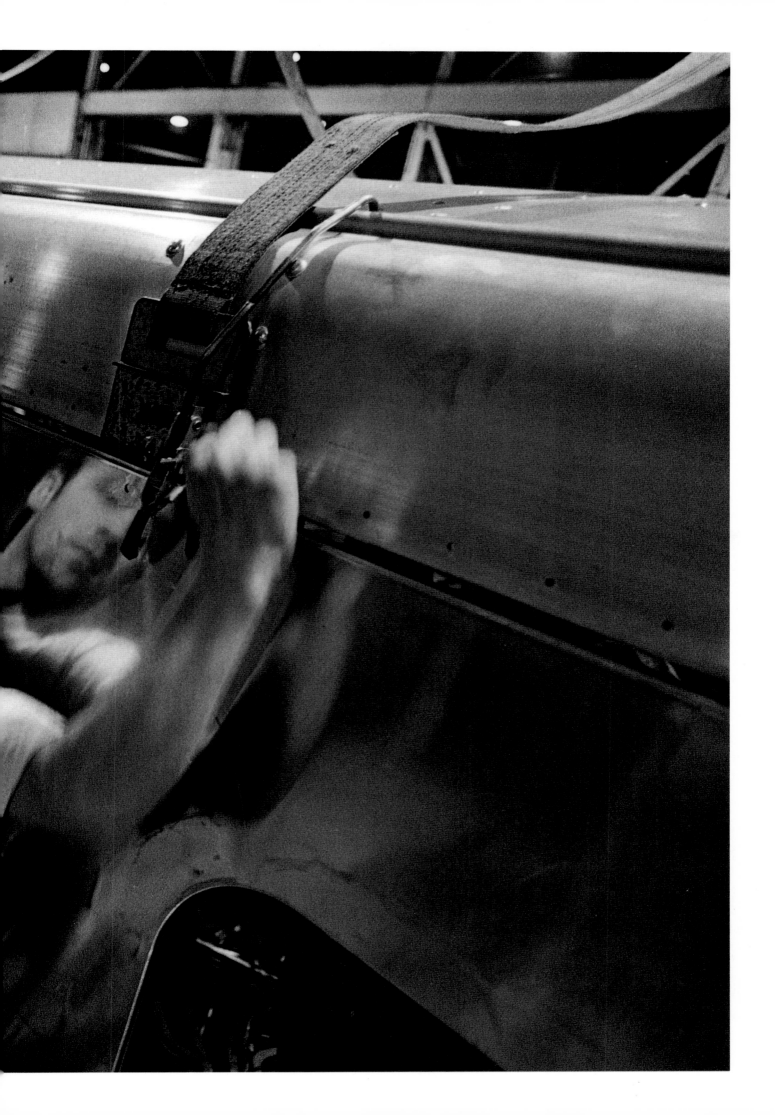

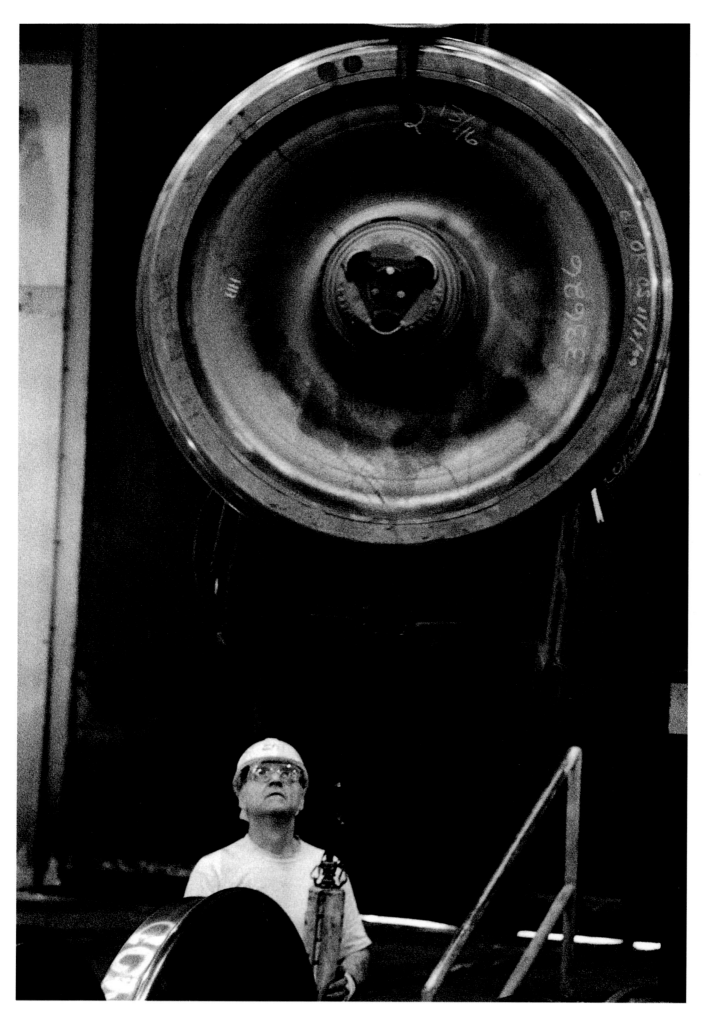

Railway worker, Concord, Ontario,
Previous page: Subway car assemblers, Thunder Bay, Ontario

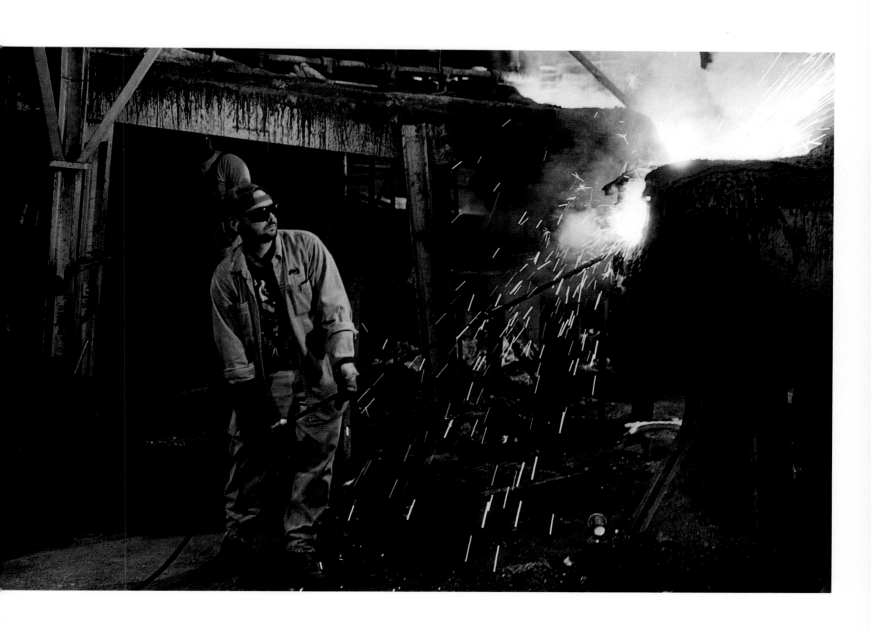

Cupola tender in a foundry, Woodstock, Ontario

Hotel chef, St. John's, Newfoundland

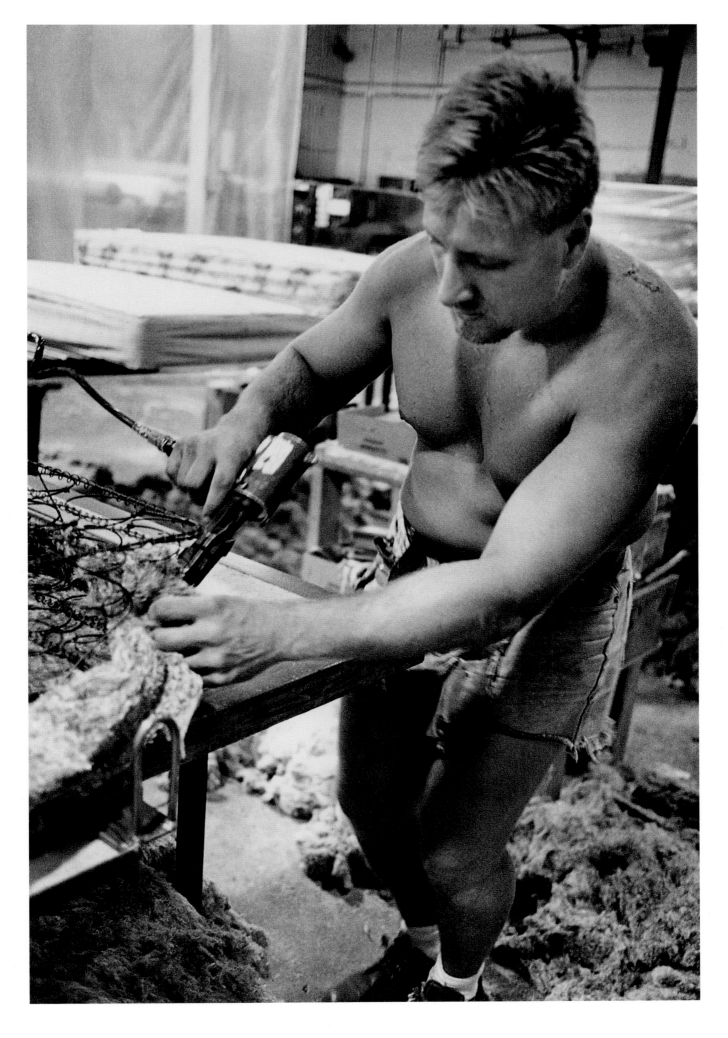

Mattress builder, Scoudouc, New Brunswick

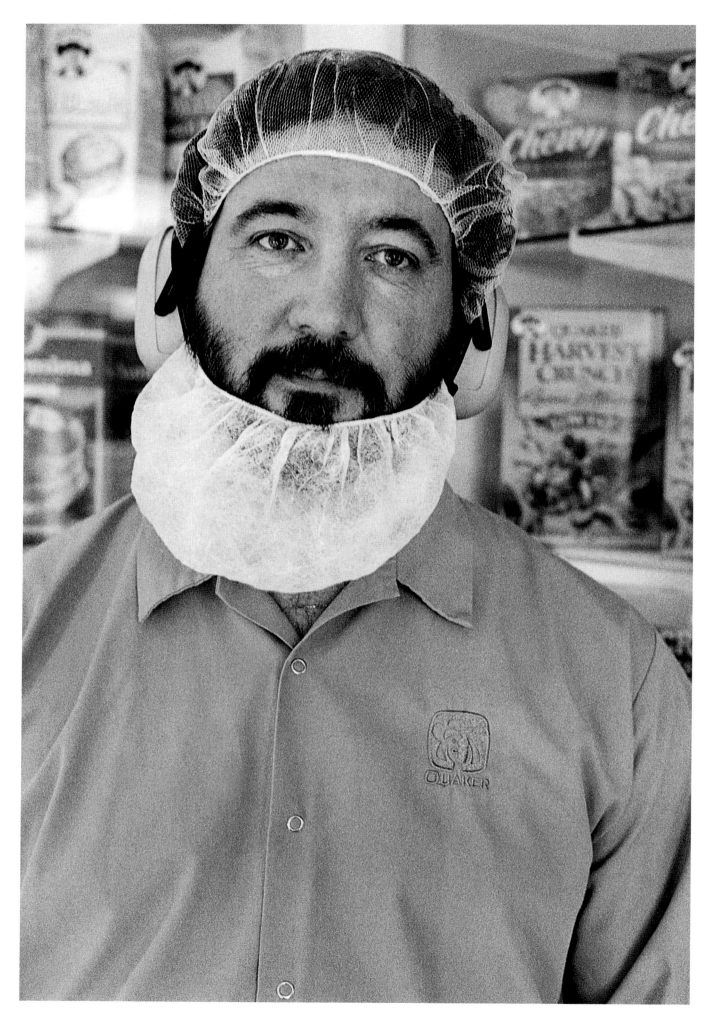

Cereal factory worker, Peterborough, Ontario

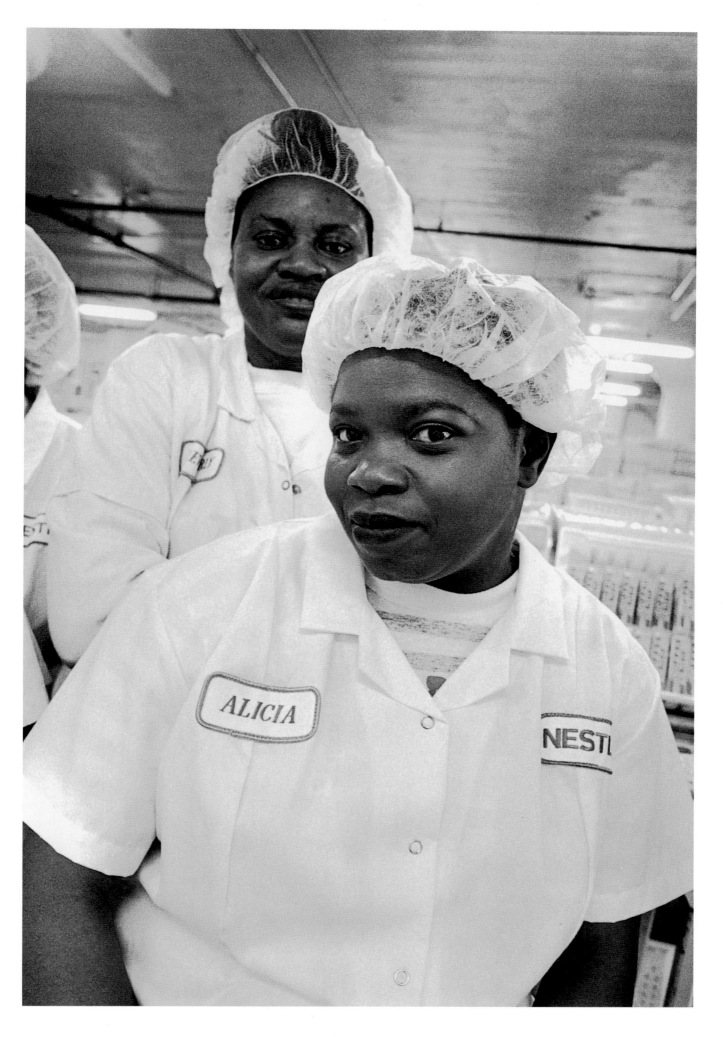

Candy bar workers, Toronto, Ontario

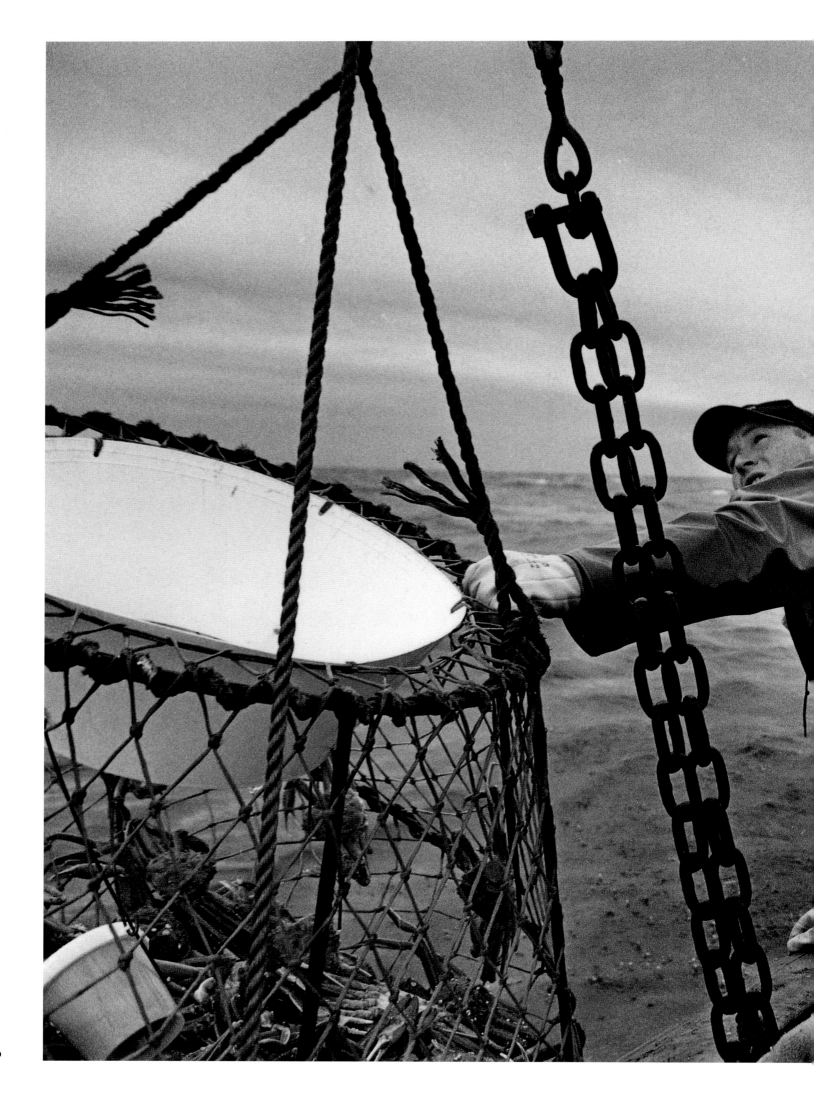

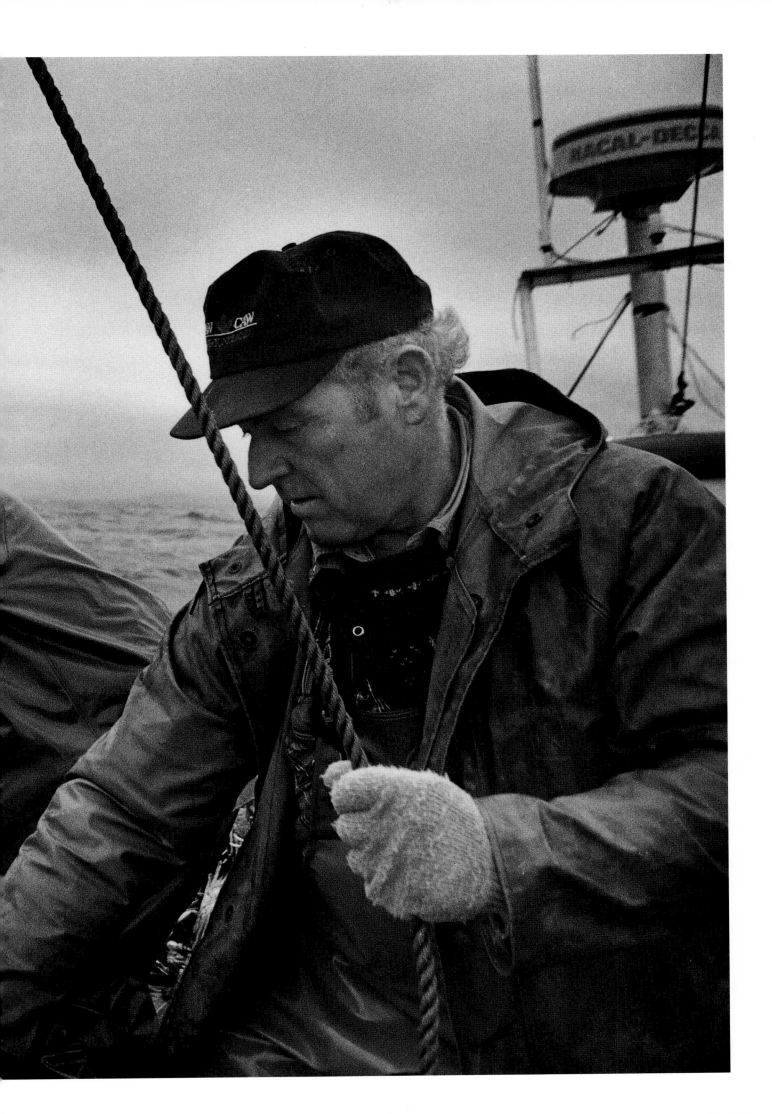

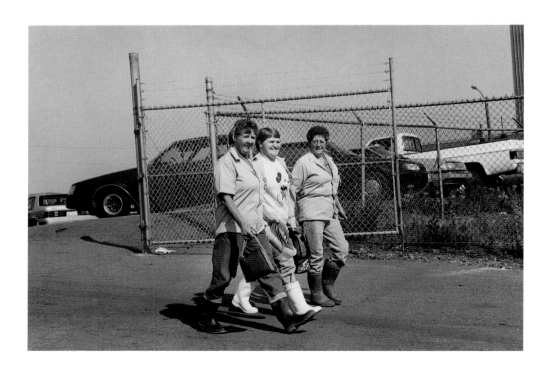

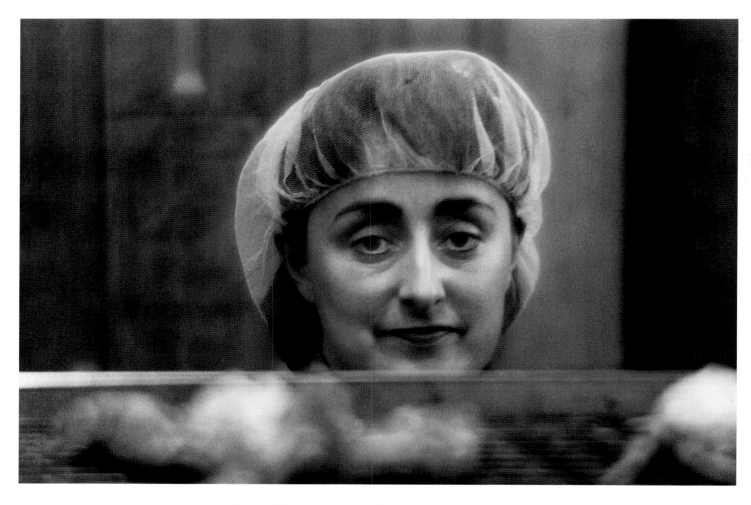

Top: Fish plant workers, Marystown, Newfoundland
Bottom: Crab plant worker, Shippagan, New Brunswick
Previous Page: Crab harvesters, off St. John's, Newfoundland

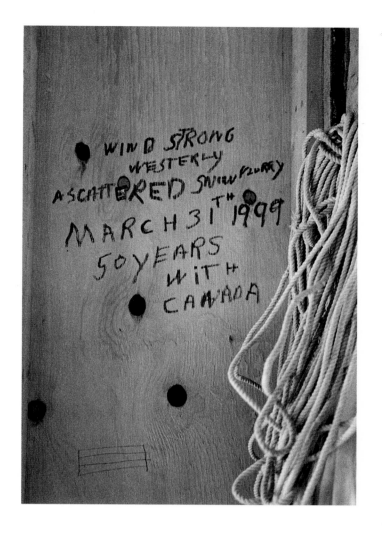

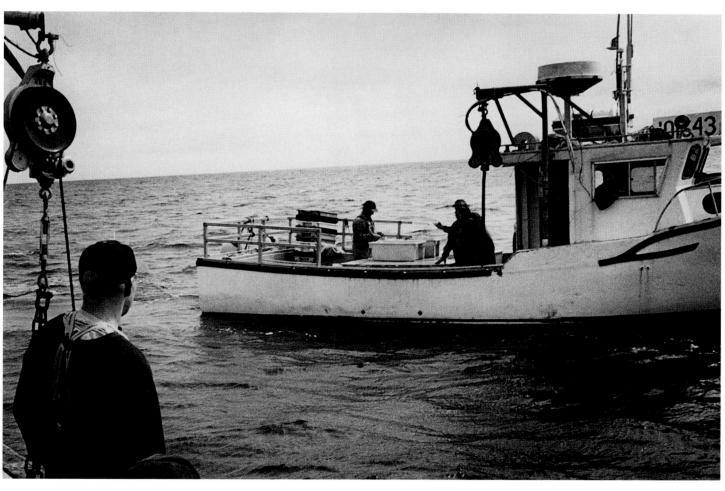

Top: Inside a fishing gear storage shed, Calvert, Newfoundland
Bottom: Fishing boats, off St. John's, Newfoundland

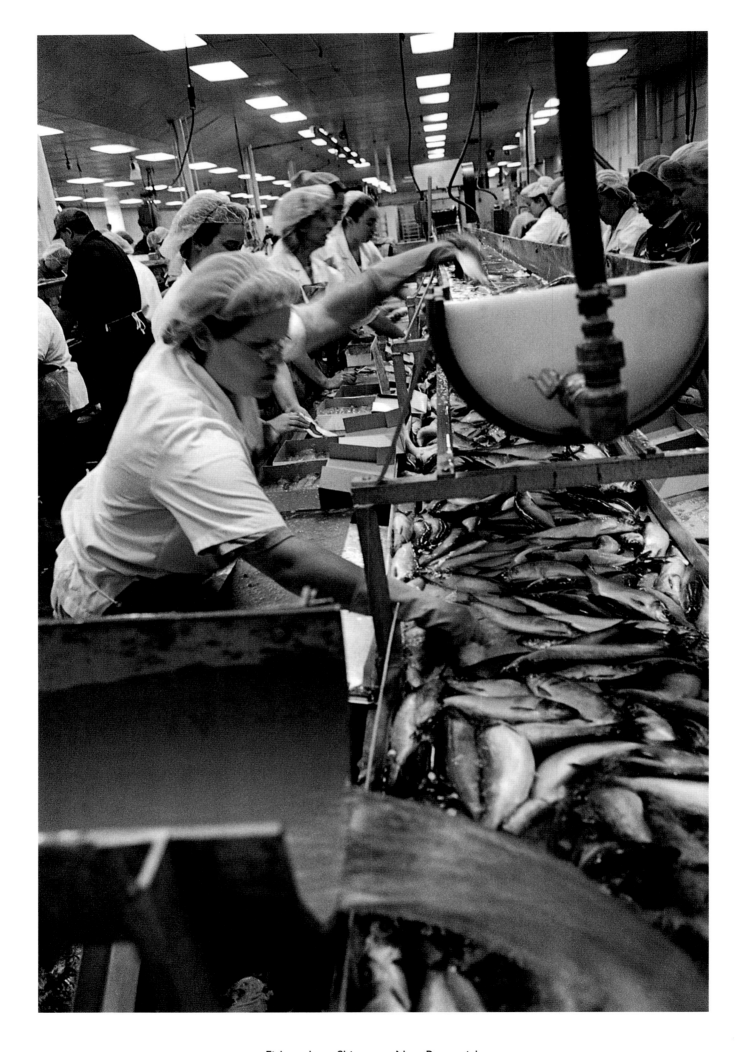

Fish packers, Shippagan, New Brunswick

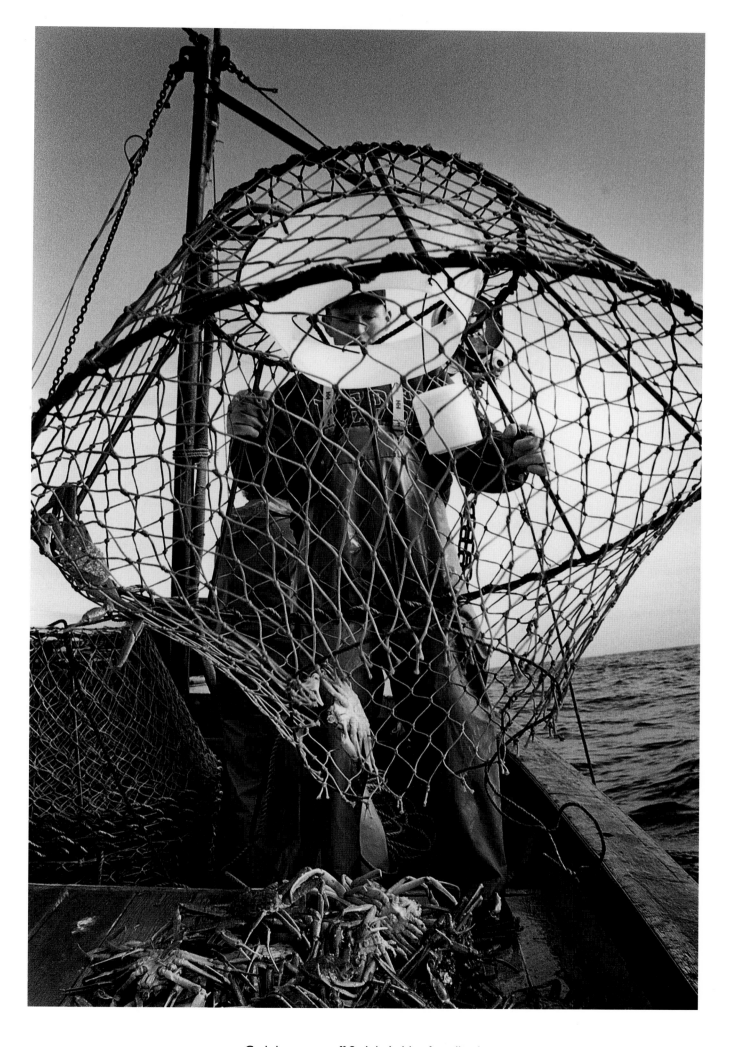

Crab harvester, off St. John's, Newfoundland

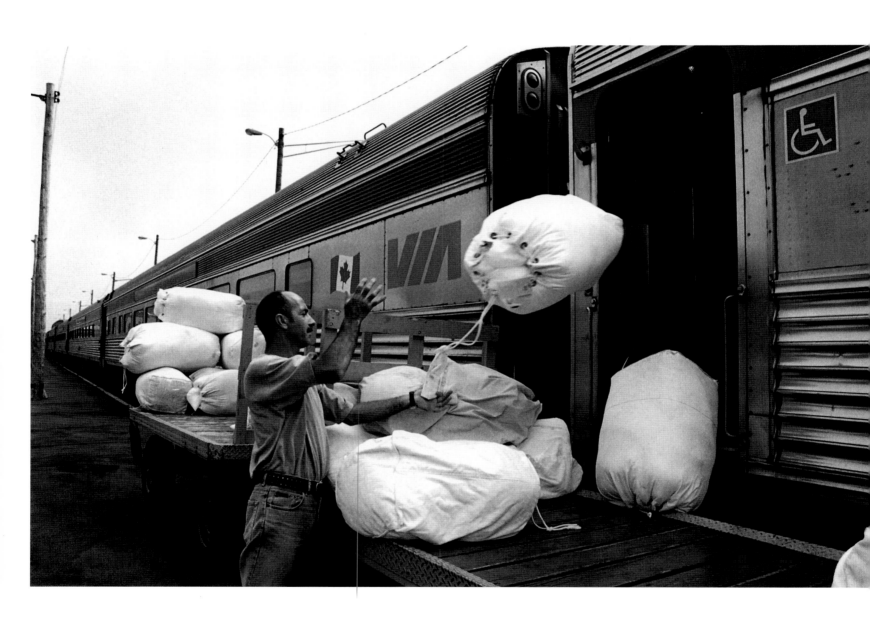

Railway worker, Halifax, Nova Scotia

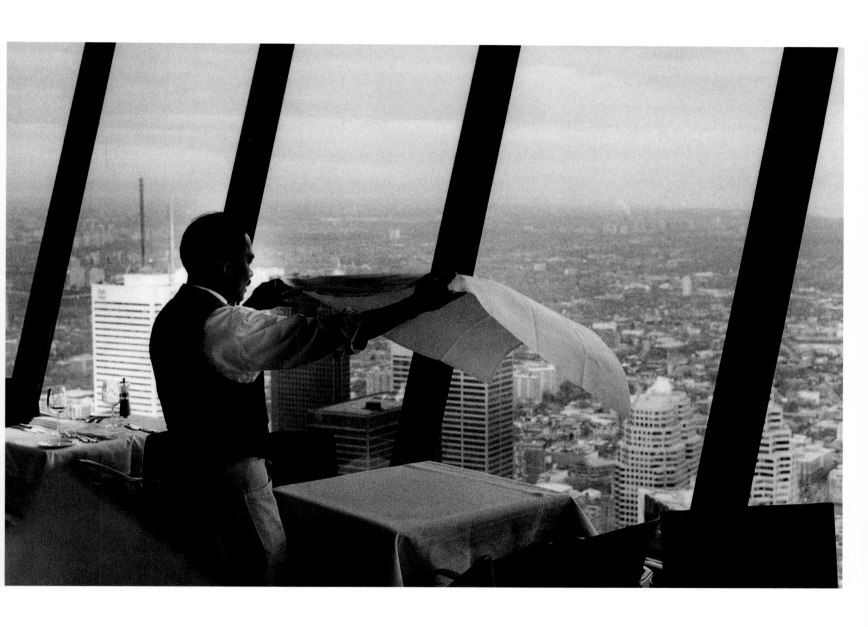

Waiter, Toronto, Ontario

Top: Newspaper office workers, Windsor, Ontario
Bottom: Call centre operator, Toronto, Ontario

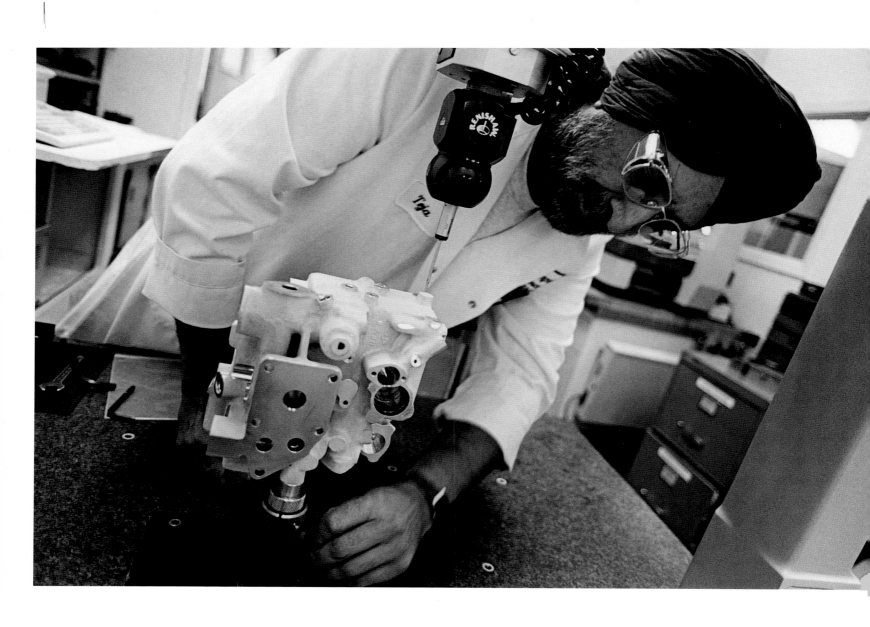

Aerospace worker, Montreal, Quebec
Previous page: Casino worker, Windsor, Ontario

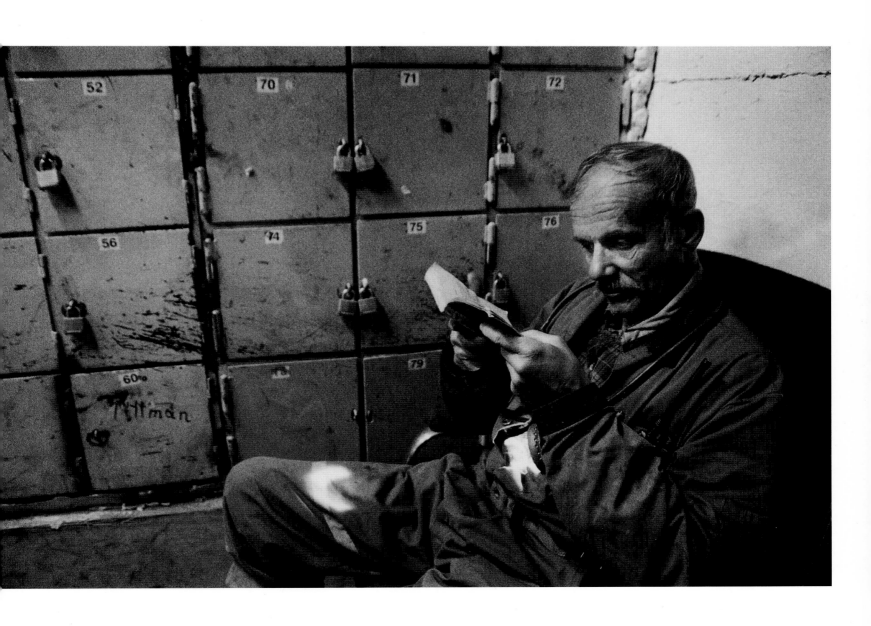

Zinc miner at lunch break, Campbell River (Vancouver Island), British Columbia

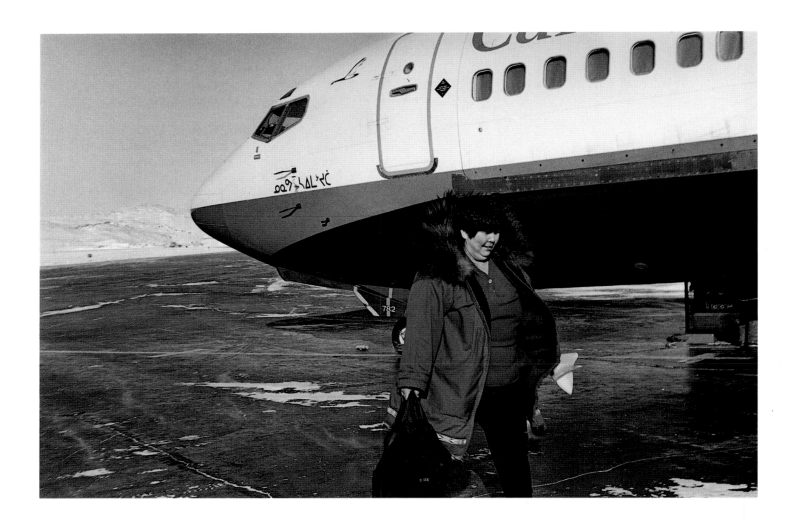

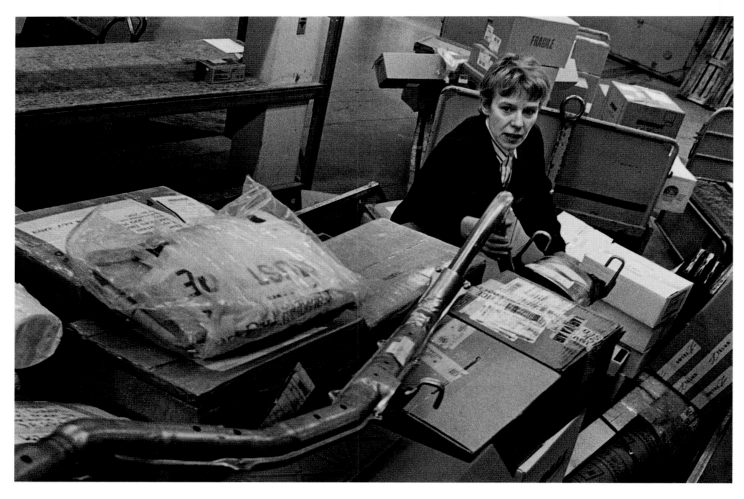

Top: Airline worker, Iqaluit, Nunavut
Bottom: Airline worker, Whitehorse, Yukon

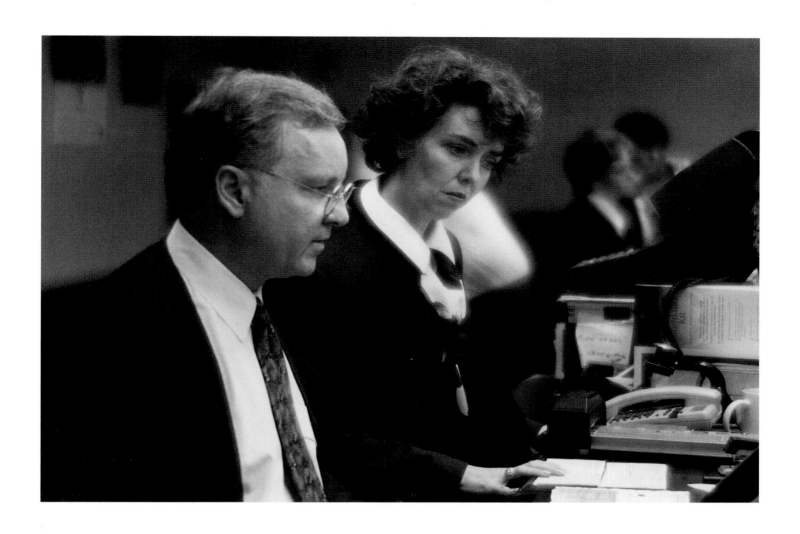

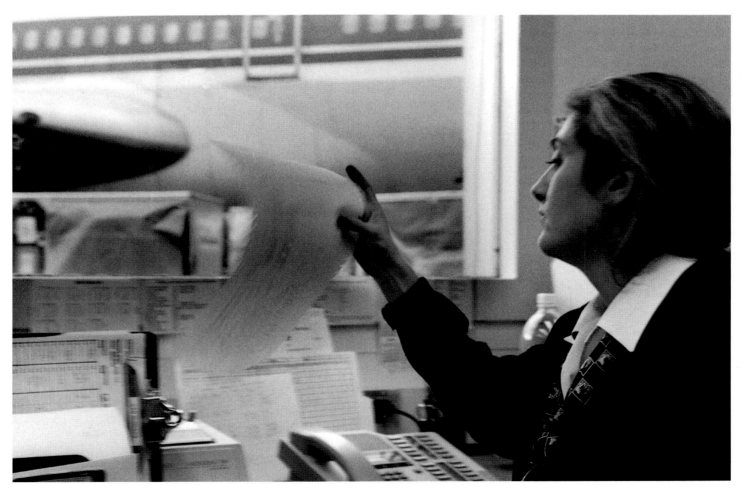

Top: Airline workers, Charlottetown, Prince Edward Island
Bottom: Airline worker, Toronto, Ontario

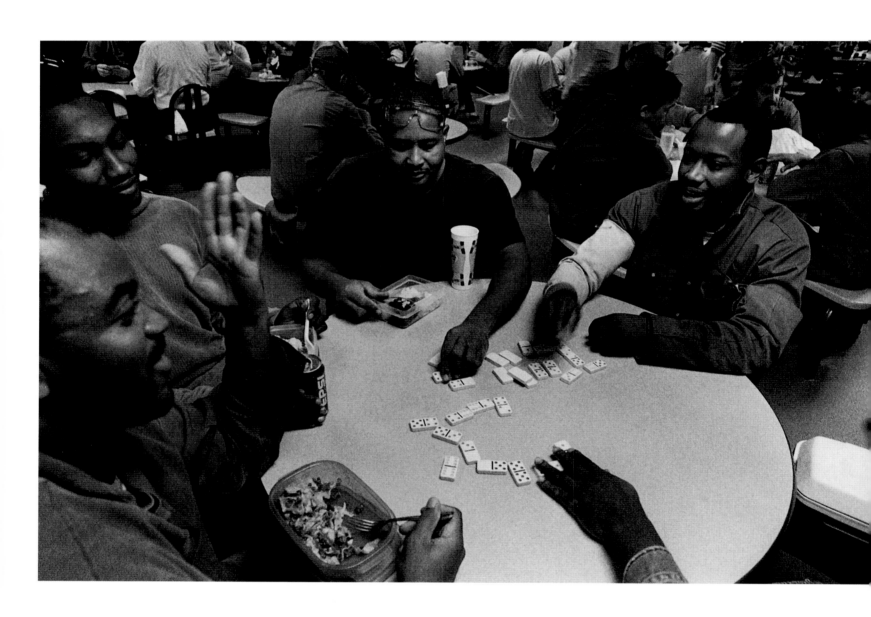

102 Auto parts workers at lunch, Kitchener, Ontario

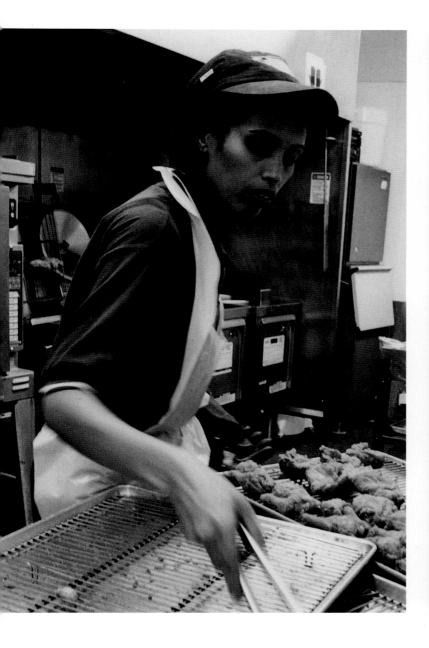

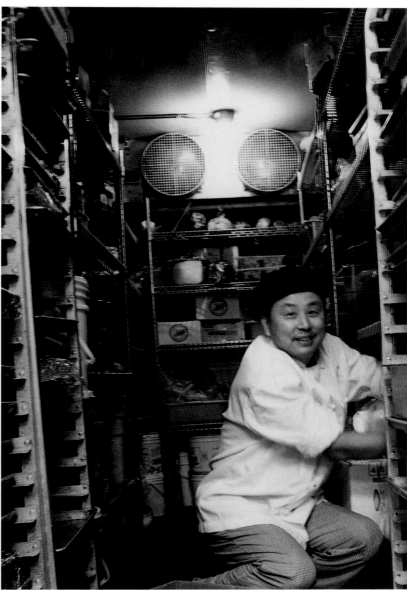

Left: Fast food restaurant worker, Vancouver, British Columbia
Right: Restaurant worker, Vancouver, British Columbia

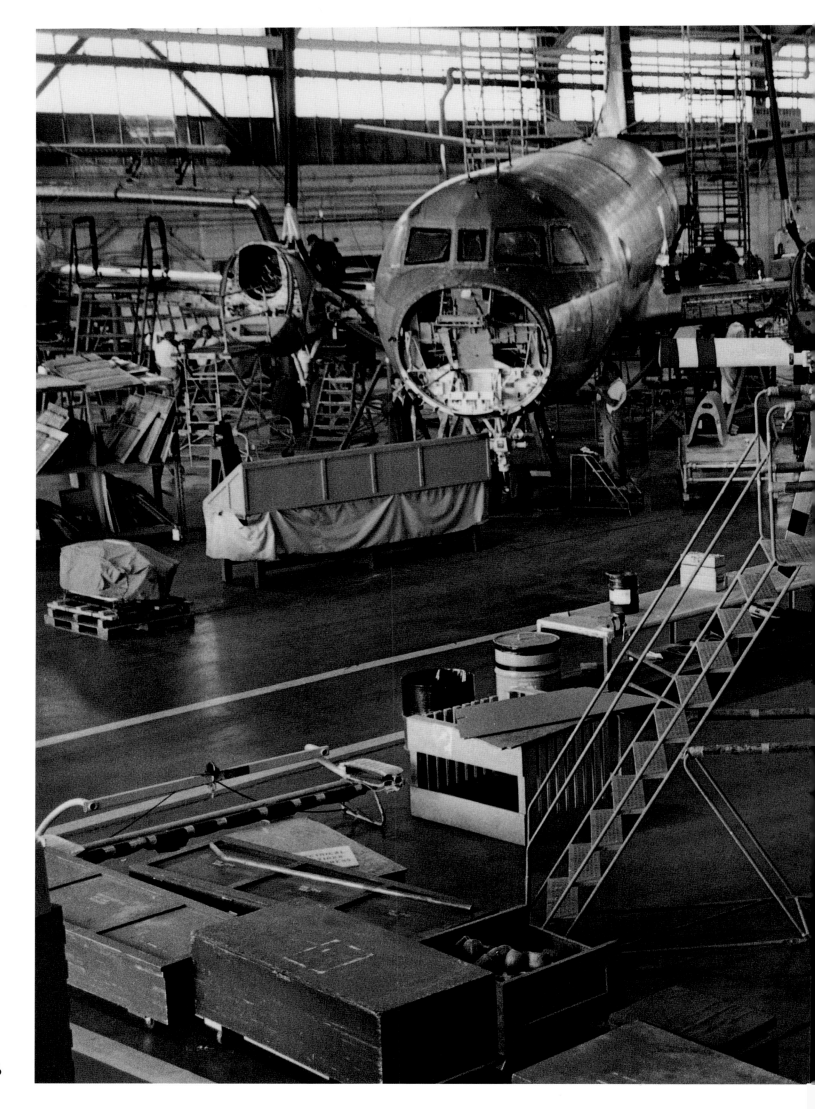

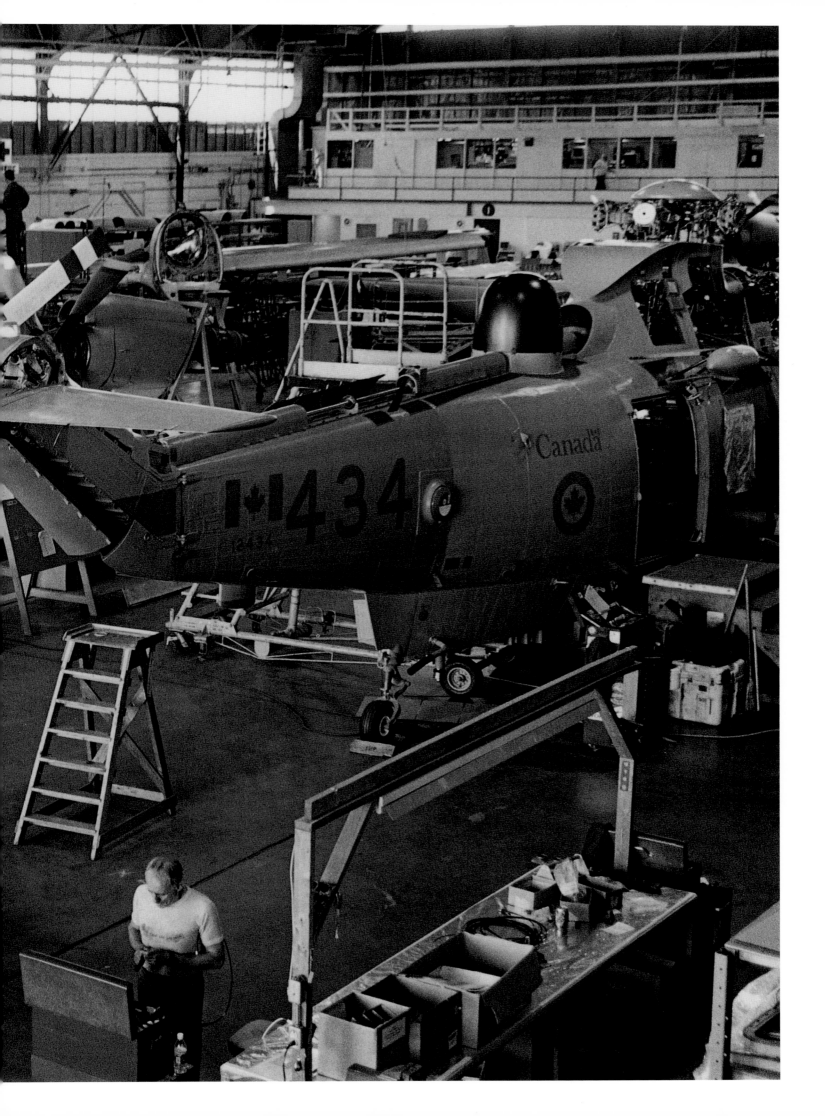

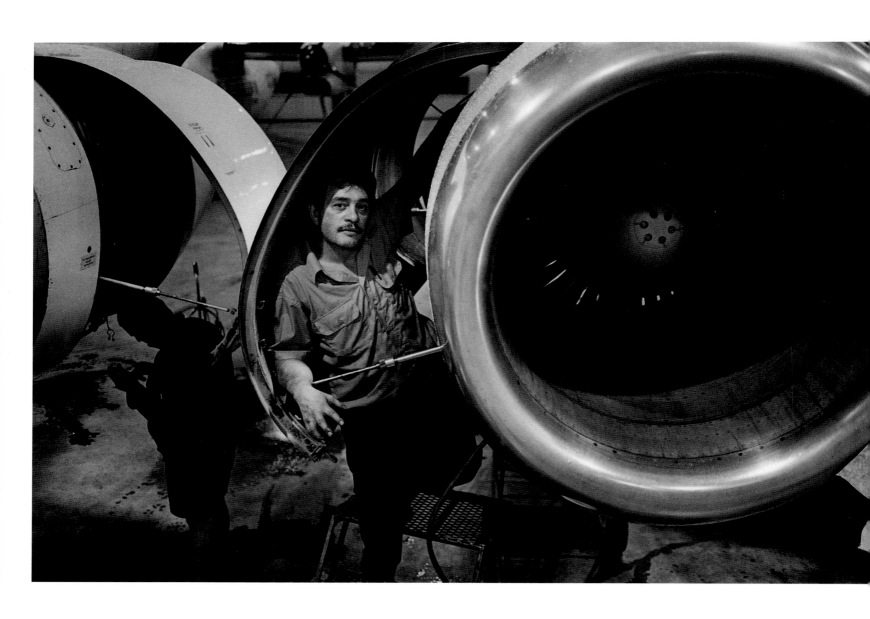

Aircraft mechanic, night shift, Halifax, Nova Scotia
Previous page: Aurora plane and Sea King helicopter maintenance plant, Halifax, Nova Scotia

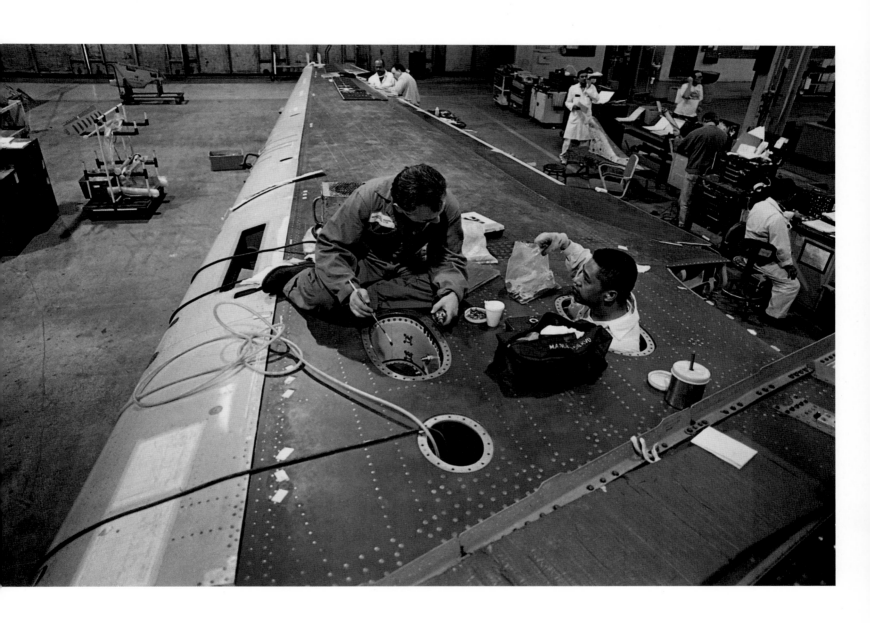

Airplane wing assemblers, Toronto, Ontario

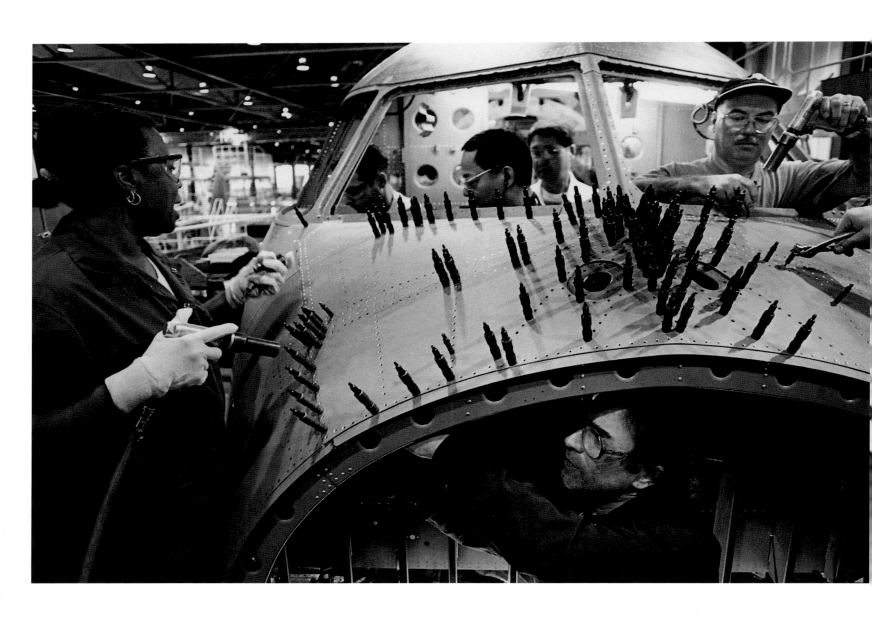

Aircraft workers, Toronto, Ontario

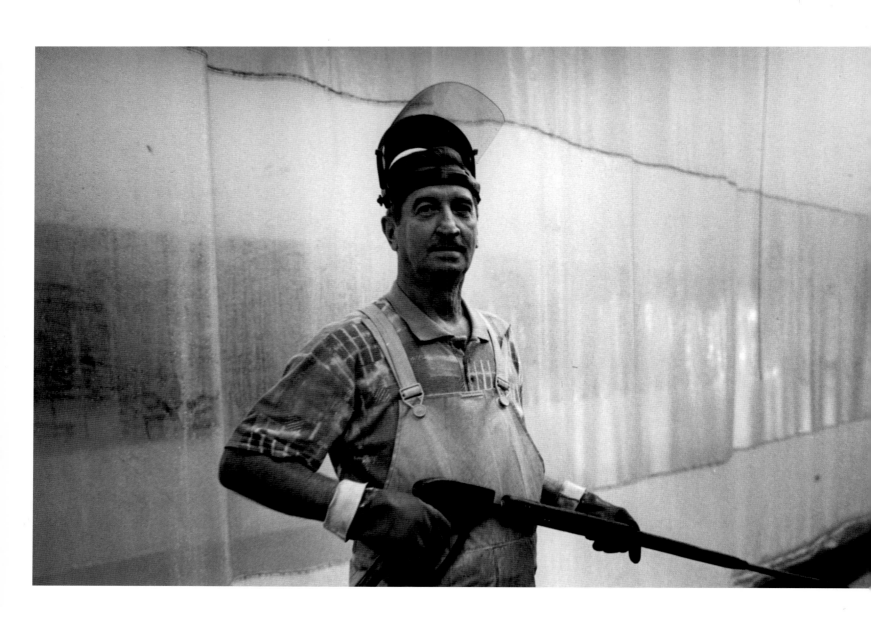

Worker in a fire truck manufacturing plant, Saint-François-du-Lac, Quebec
Previous page: Aircraft maintenance workers, Halifax, Nova Scotia

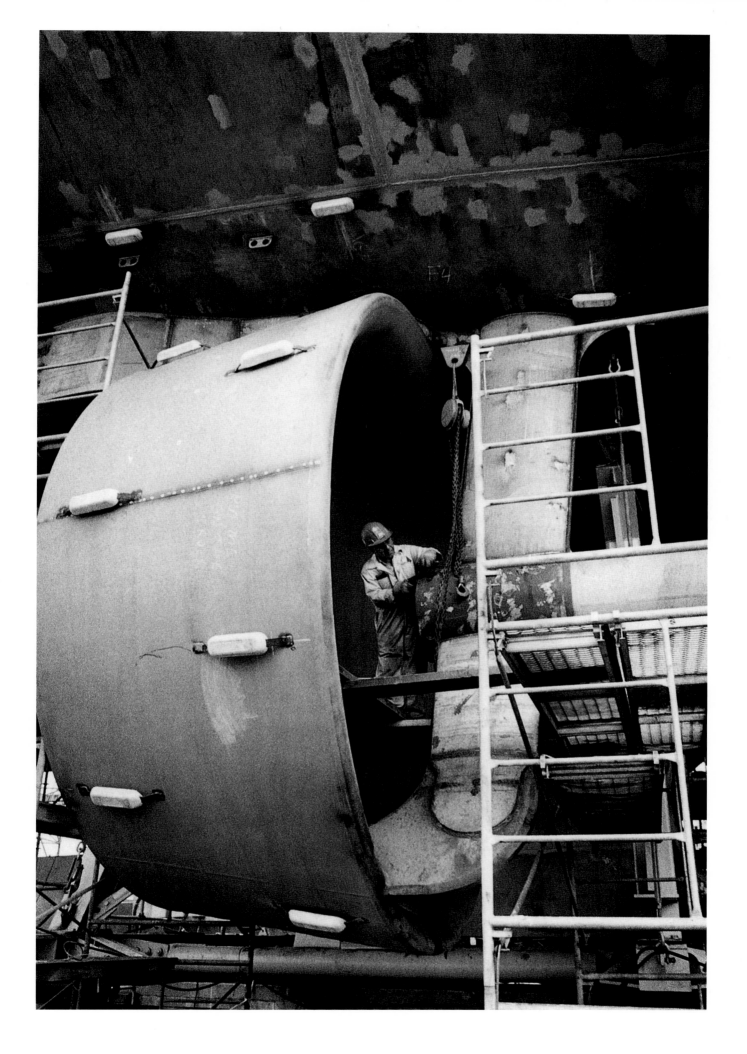

Engine fitter, shipyard, Halifax, Nova Scotia

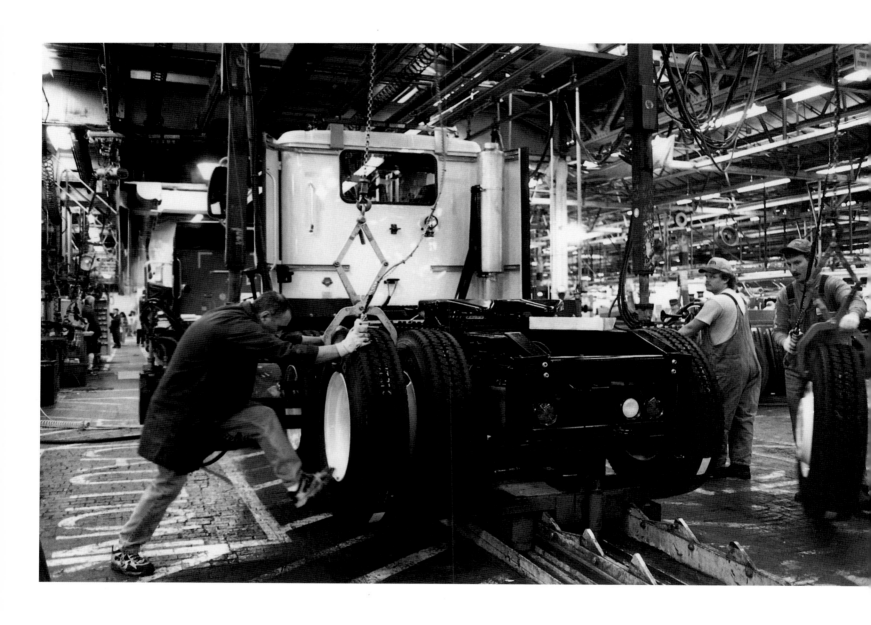

Truck assemblers, Chatham, Ontario

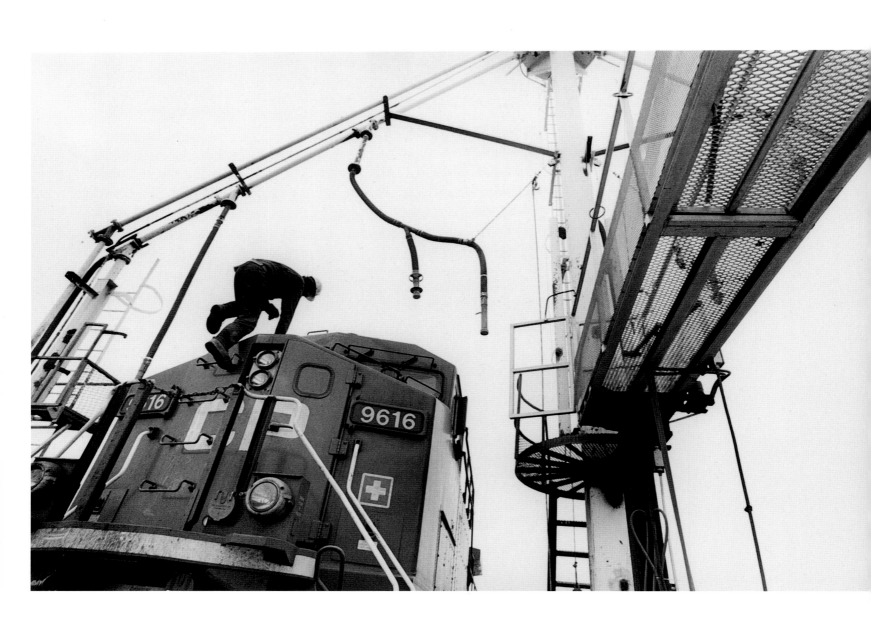

Railway worker, Rogers Pass, British Columbia
Previous page: Cable factory worker, Kingston, Ontario

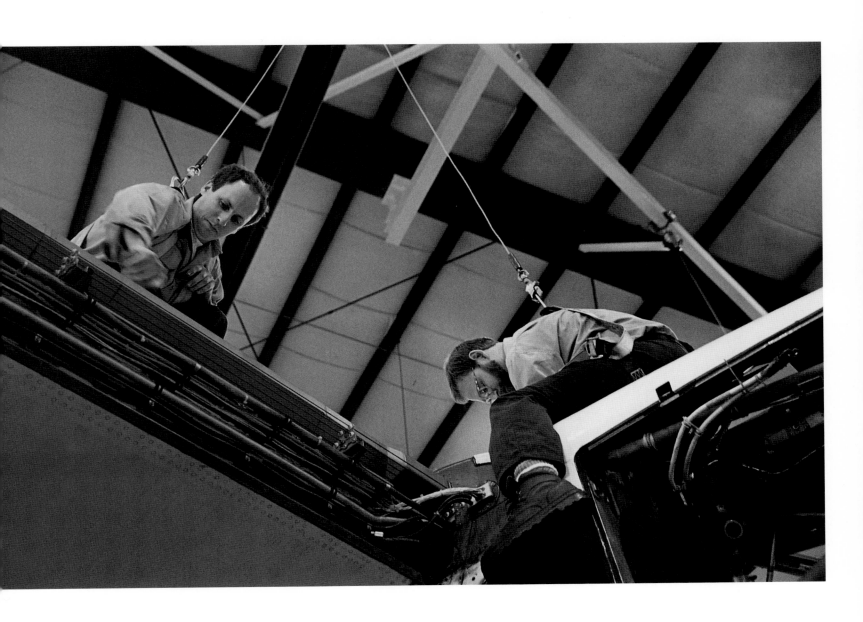

Aircraft mechanics, London, Ontario

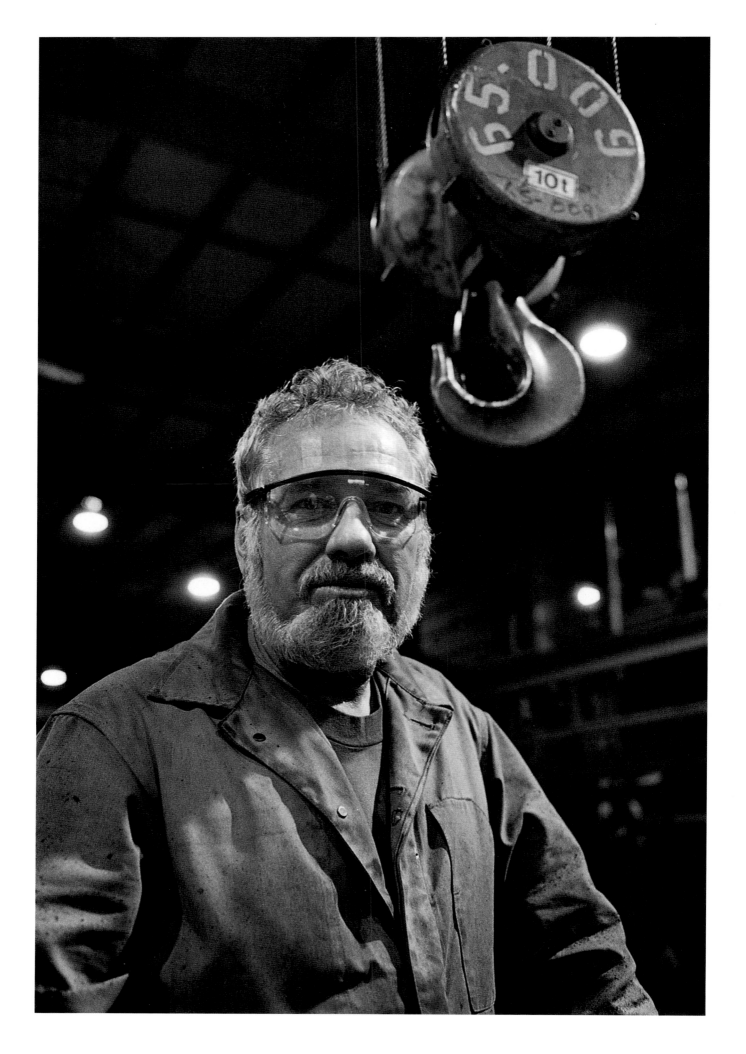

Shipyard welder, Marystown, Newfoundland

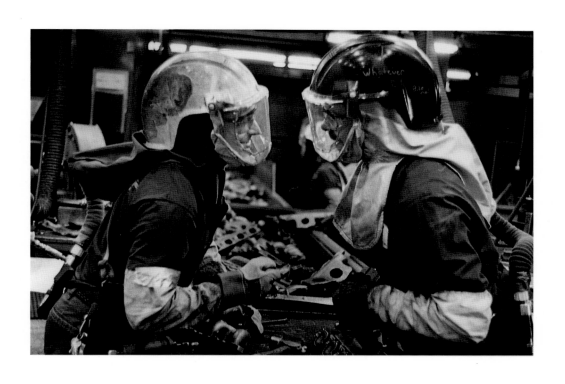

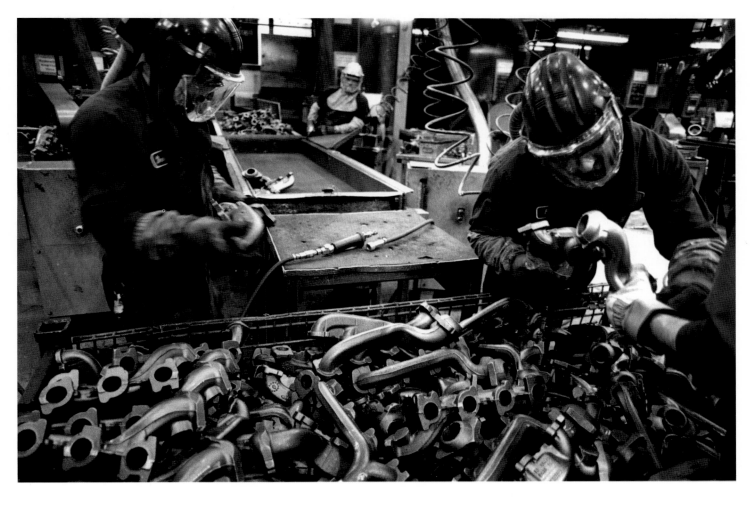

Both: Auto parts workers in a casting plant, Brantford, Ontario

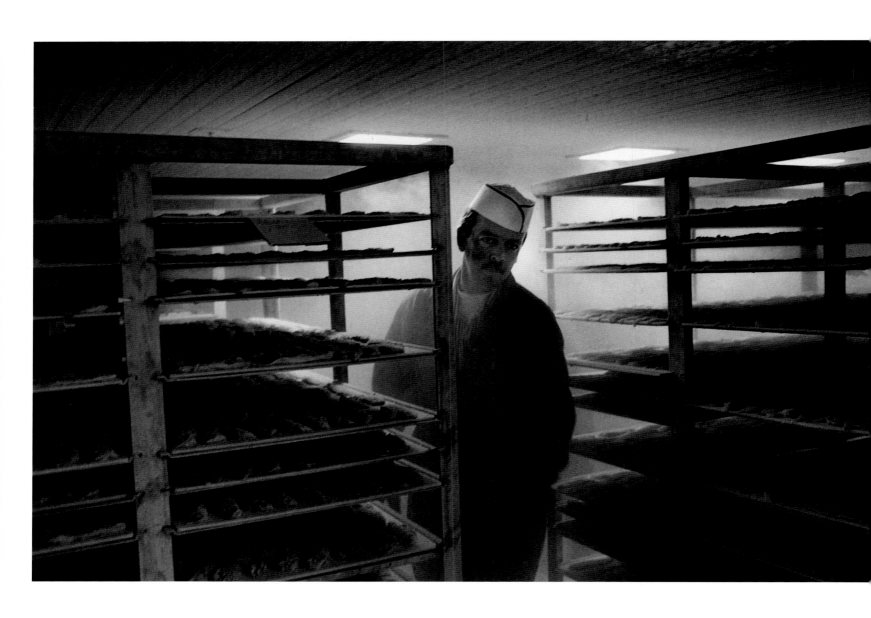

Fish plant worker in a freezer, Marystown, Newfoundland

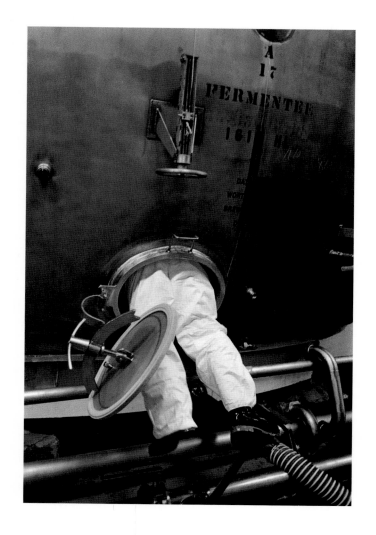

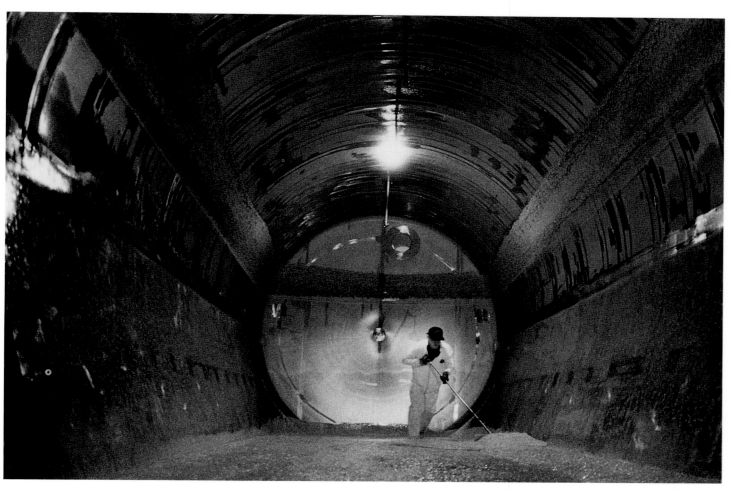

Both: Brewery worker removing yeast inside fermentation tank, Barrie, Ontario

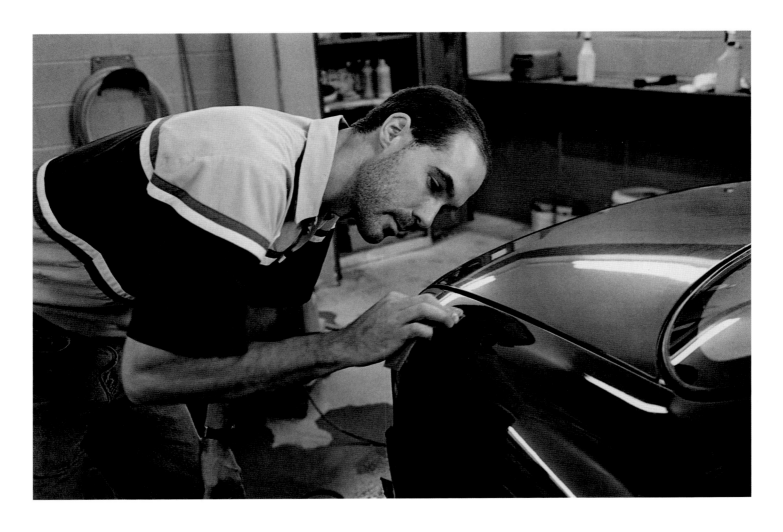

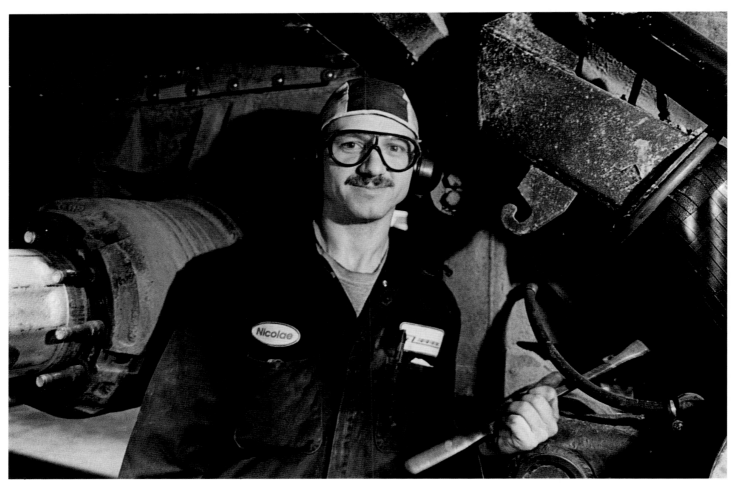

Top: Paint finesse specialist, auto dealership, Moncton, New Brunswick
Bottom: Bus mechanic, Winnipeg, Manitoba

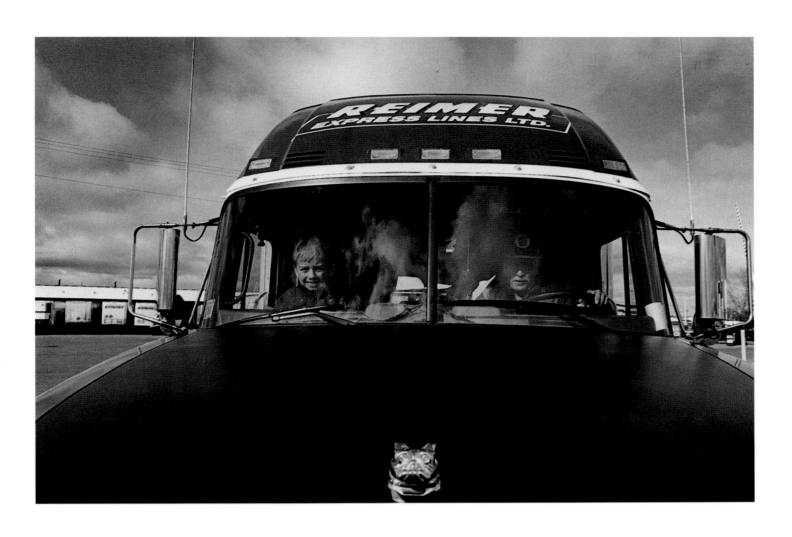

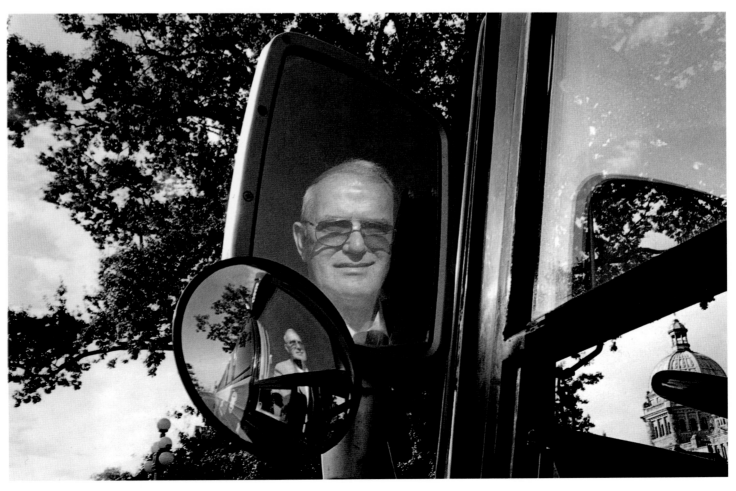

Top: Truck driver, Winnipeg, Manitoba
Bottom: Bus driver, Victoria, British Columbia

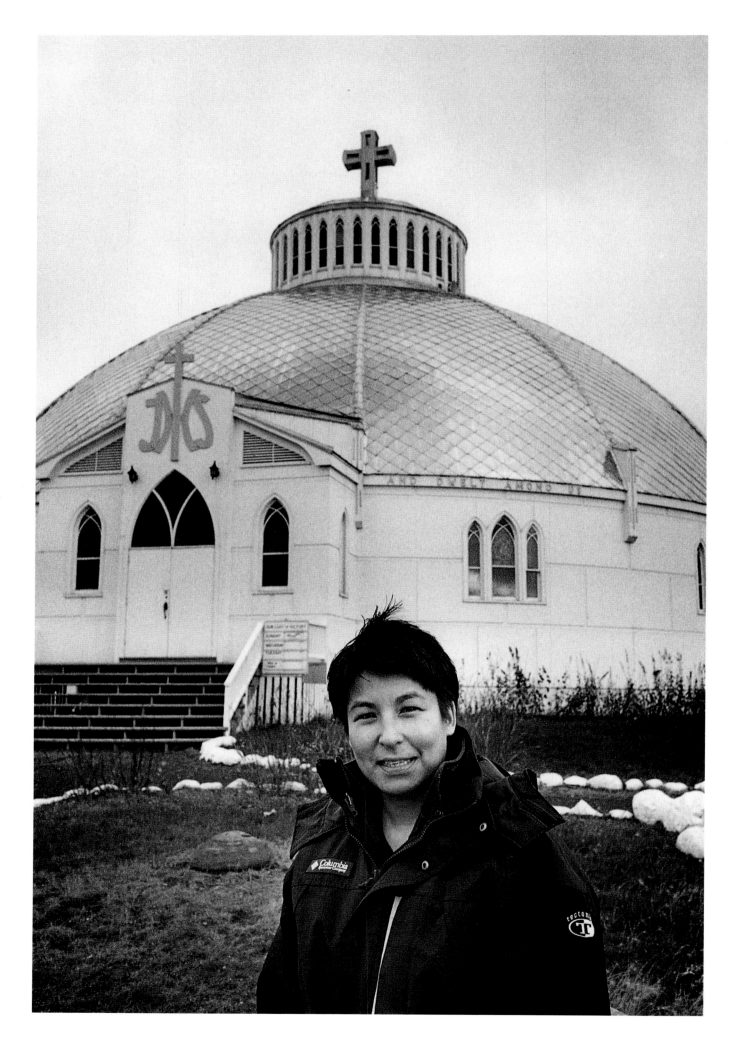

Airline worker on her way home, Inuvik, Northwest Territories

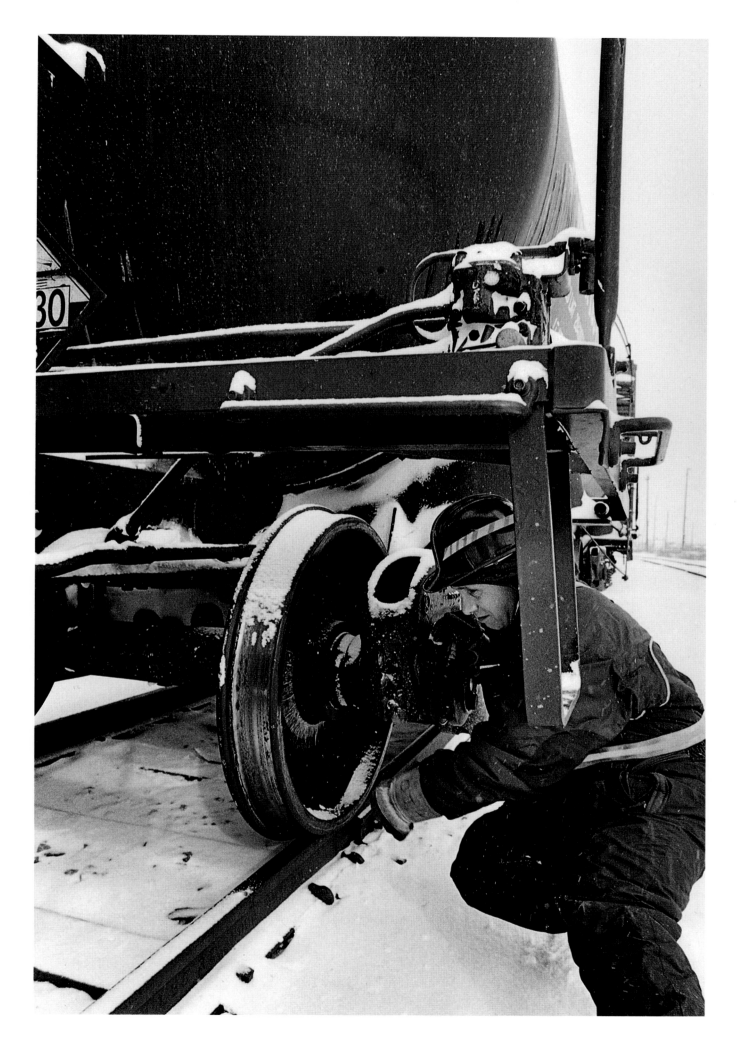

Railway worker, Toronto, Ontario

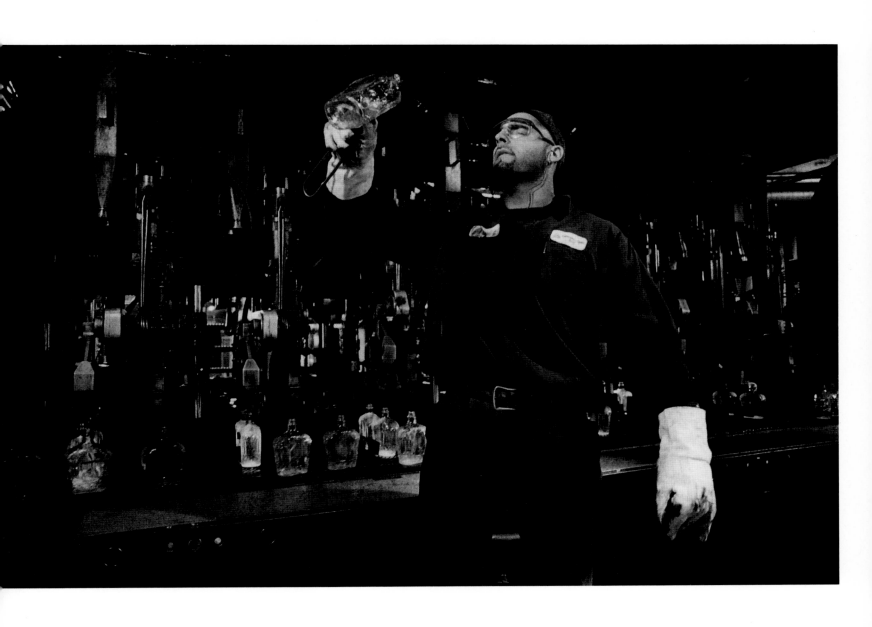

Worker in a glass bottle factory, Toronto, Ontario

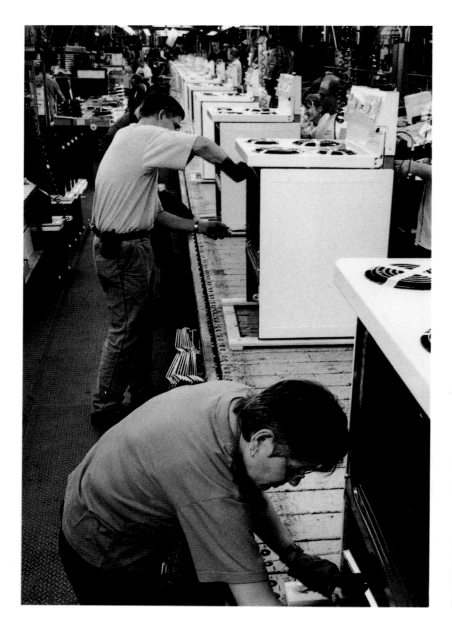
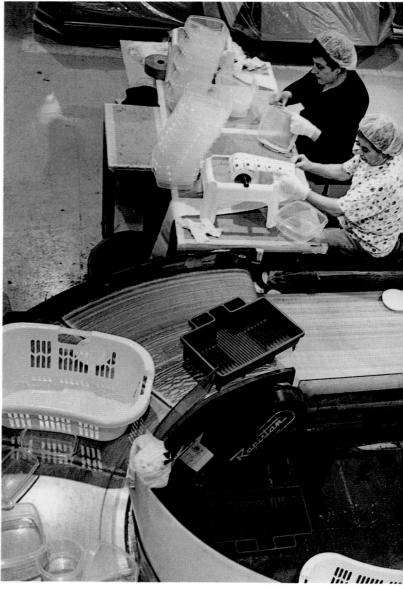

Left: Range assembly workers, Hamilton, Ontario
Right: Plastic container packers, Mississauga, Ontario

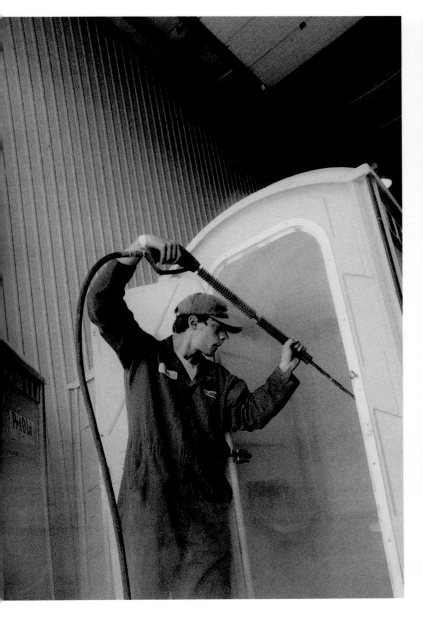
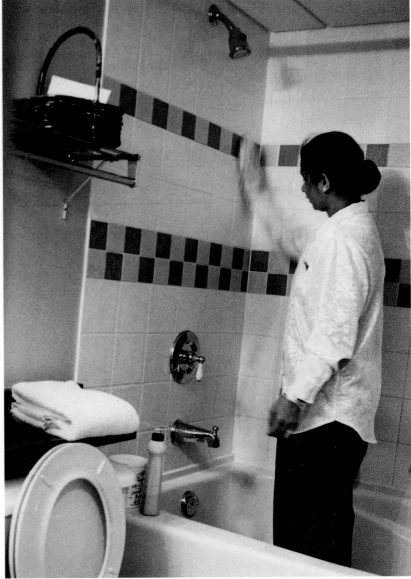

Left: Portable toilet cleaner, Calgary, Alberta
Right: Hotel worker, Whistler, British Columbia

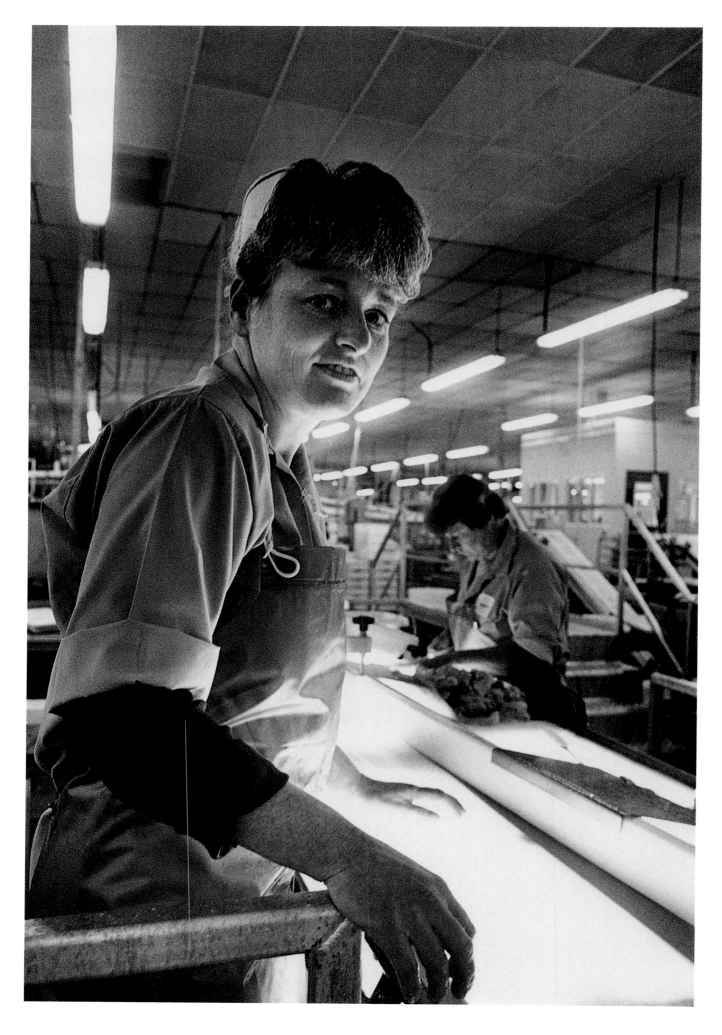

Fish plant worker, Marystown, Newfoundland

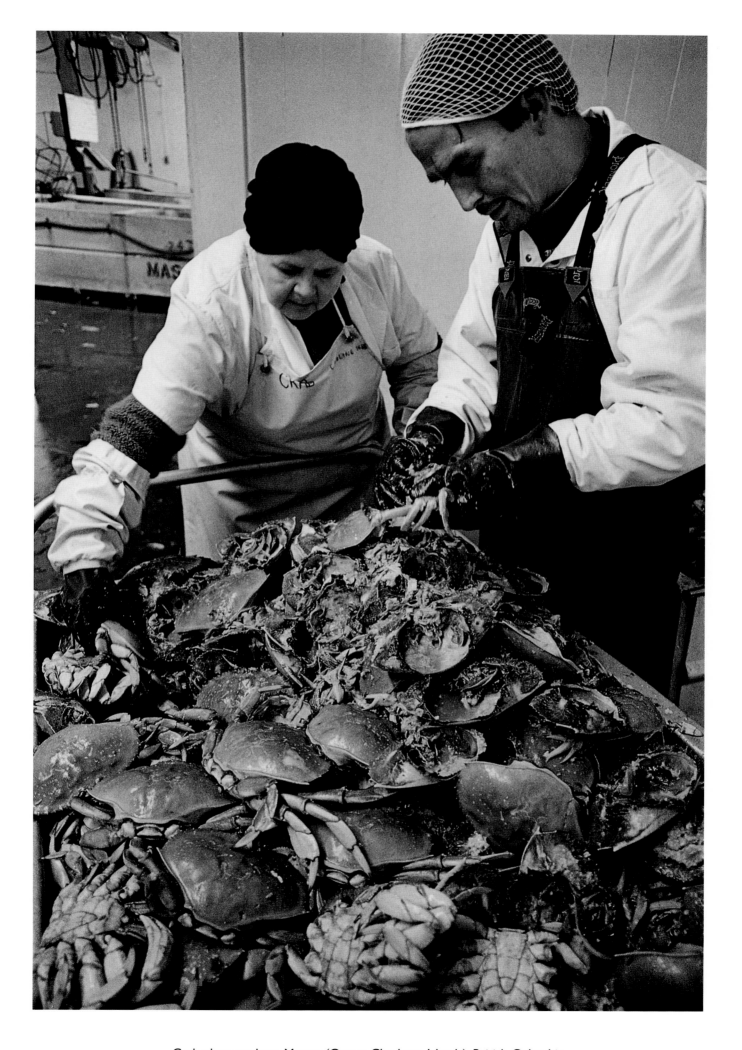

Crab plant workers, Masset (Queen Charlotte Islands), British Columbia

Auto parts stamping plant, Cambridge, Ontario

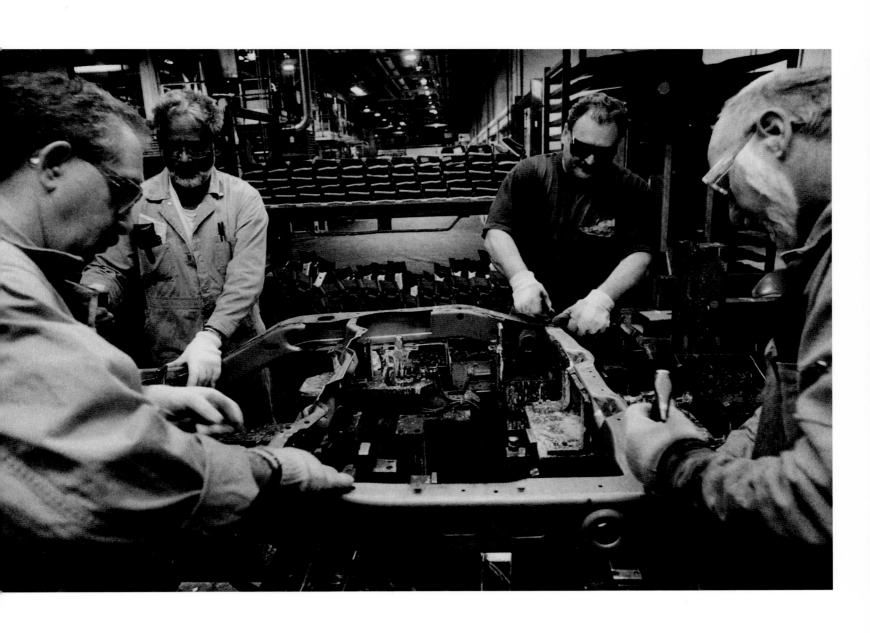

Auto frame assemblers, Kitchener, Ontario

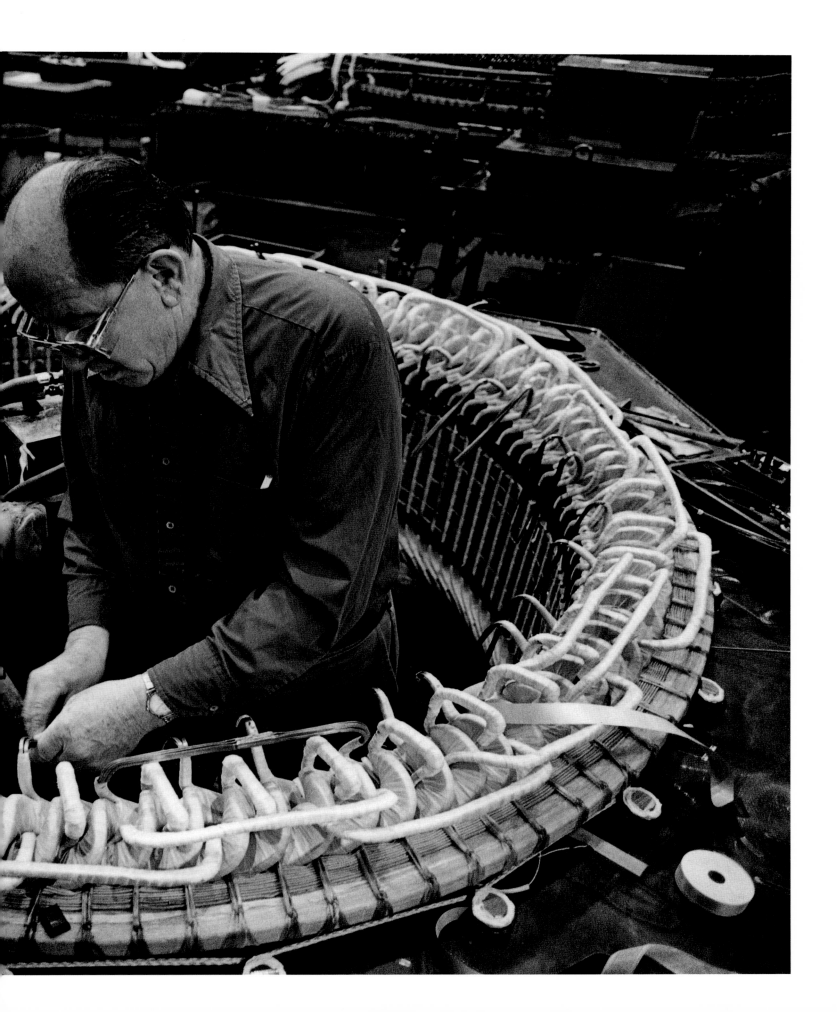

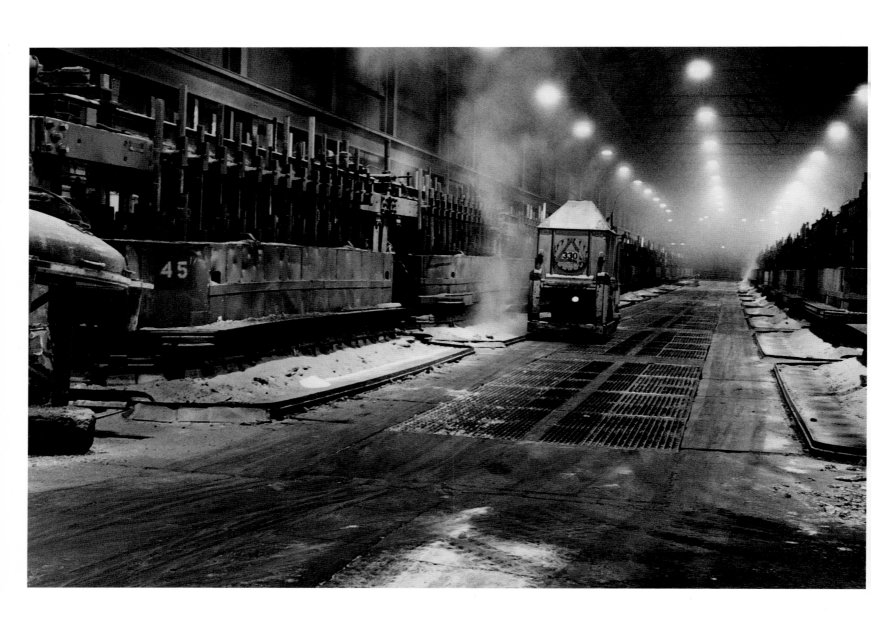

Aluminum smelter, Kitimat, British Columbia
Previous page: Electrical worker, Peterborough, Ontario

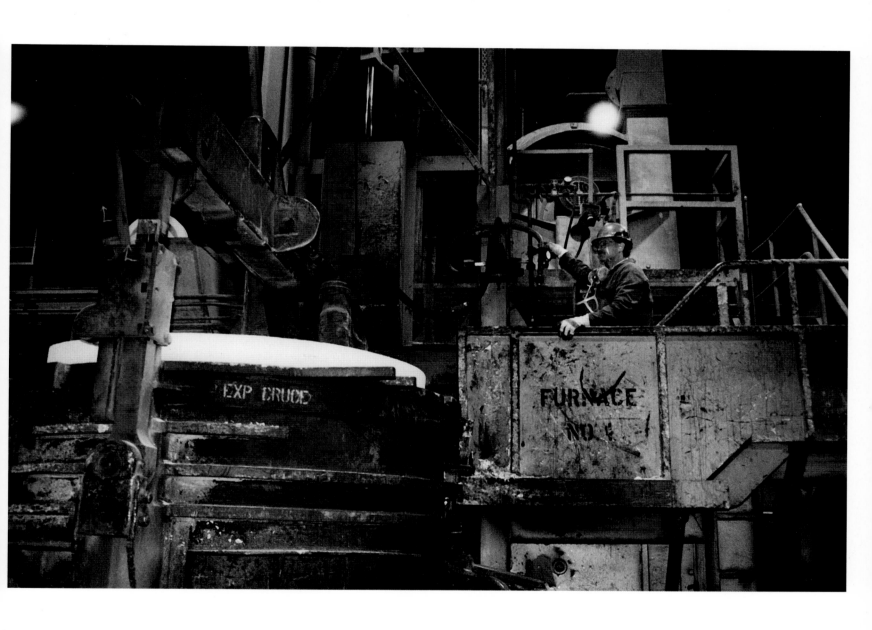

Smelter worker, Kitimat, British Columbia

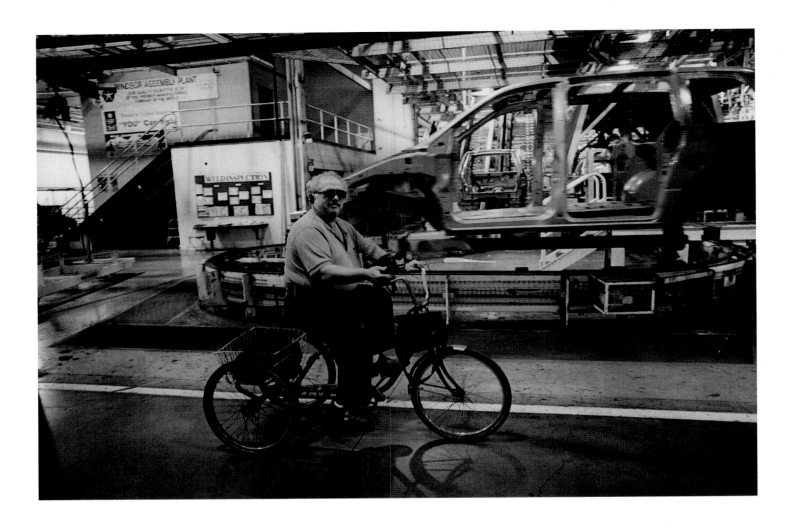

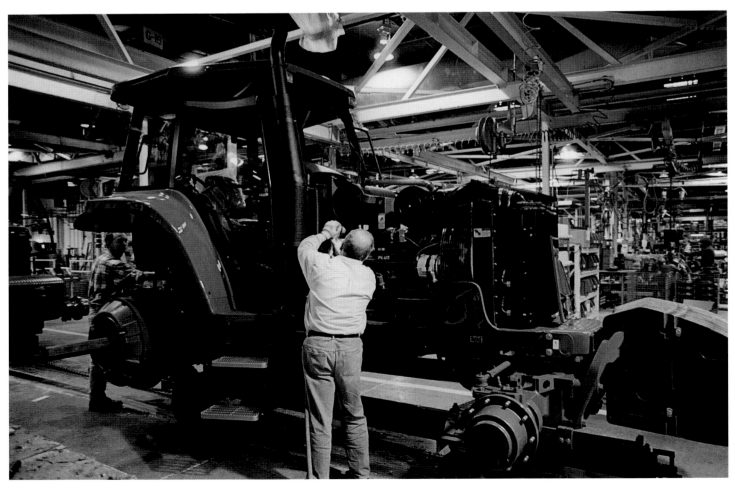

Top: Autoworker, Windsor, Ontario
Bottom: Tractor assembler, Winnipeg, Manitoba

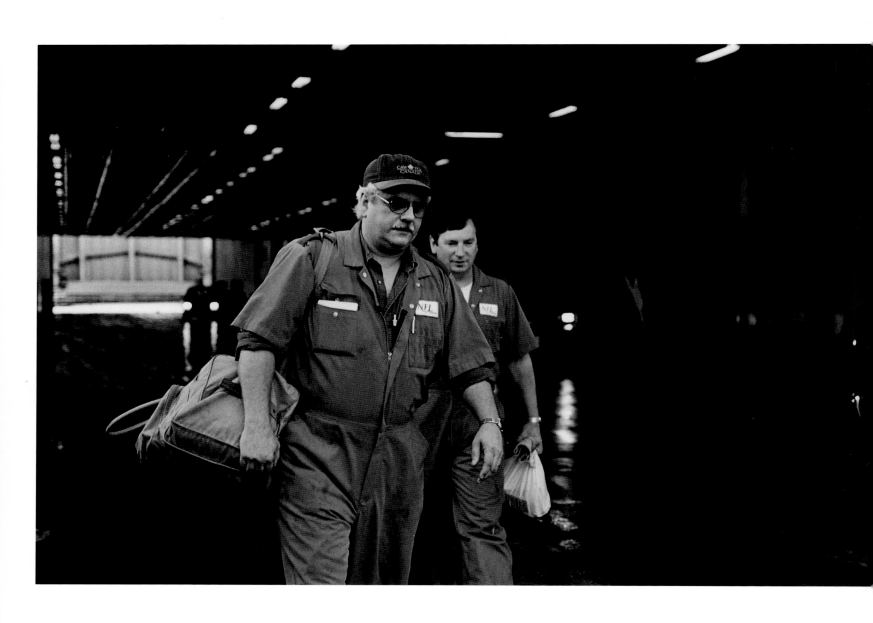

Bosun mate and deck hand aboard the ferry *M.V. Confederation*, Wood Islands, Prince Edward Island
Previous page: Zinc miners, Campbell River (Vancouver Island), British Columbia

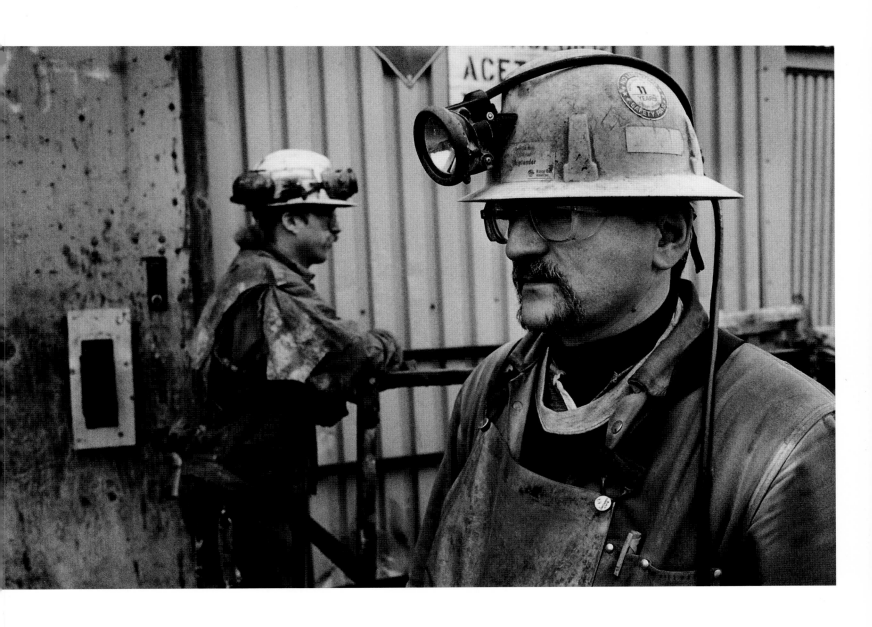

Gold miners (six weeks before plant closure), Yellowknife, Northwest Territories

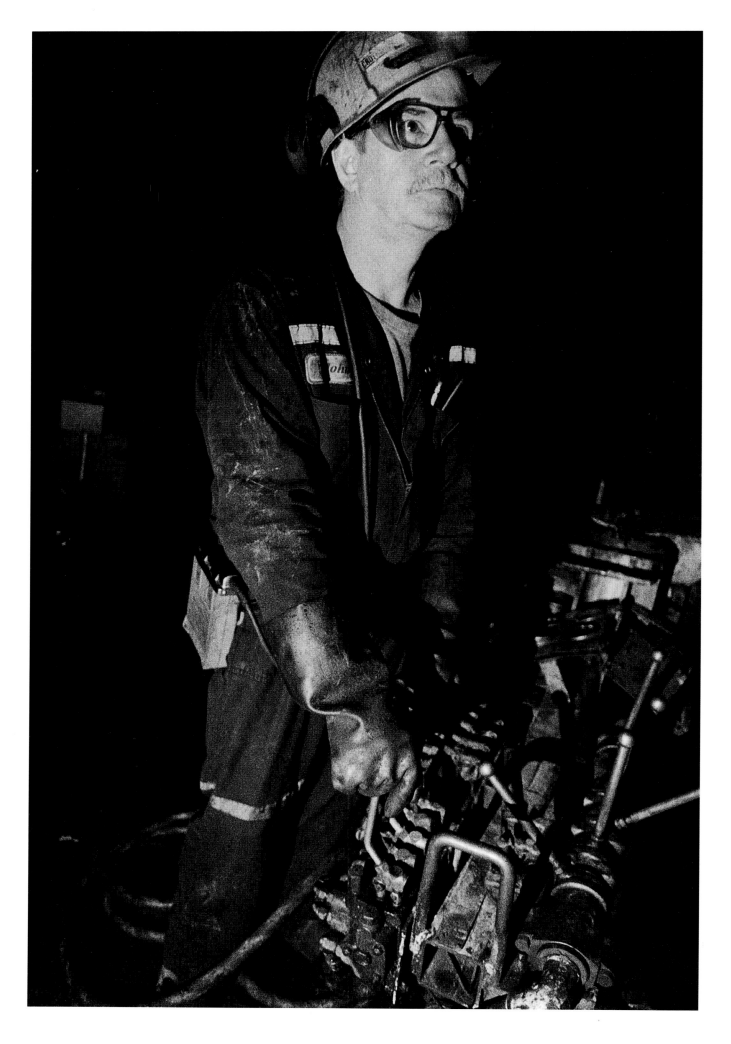

Nickel miner, Sudbury, Ontario

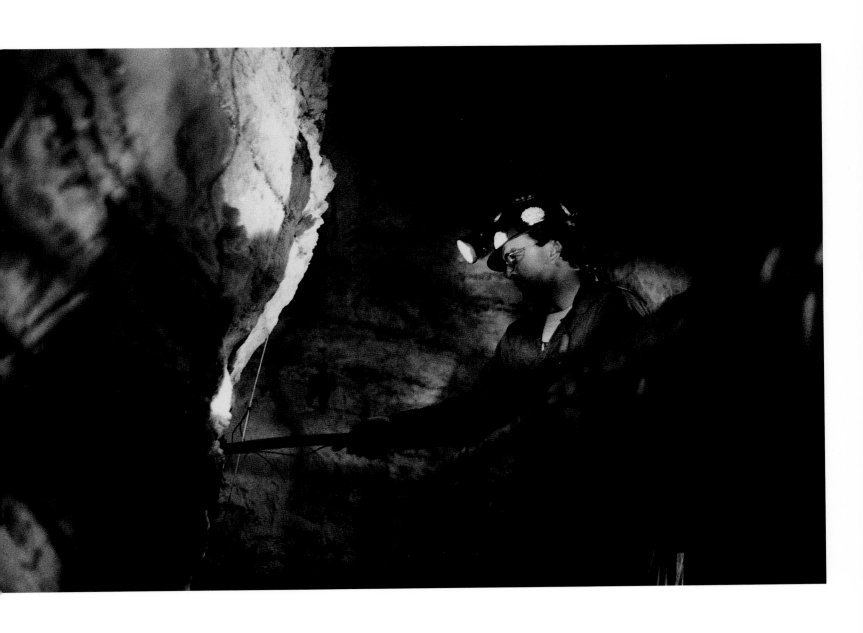

Salt miner, Windsor, Ontario

Scoop tram in a salt mine, Windsor, Ontario

Worker in the international transportation tunnel, Windsor, Ontario

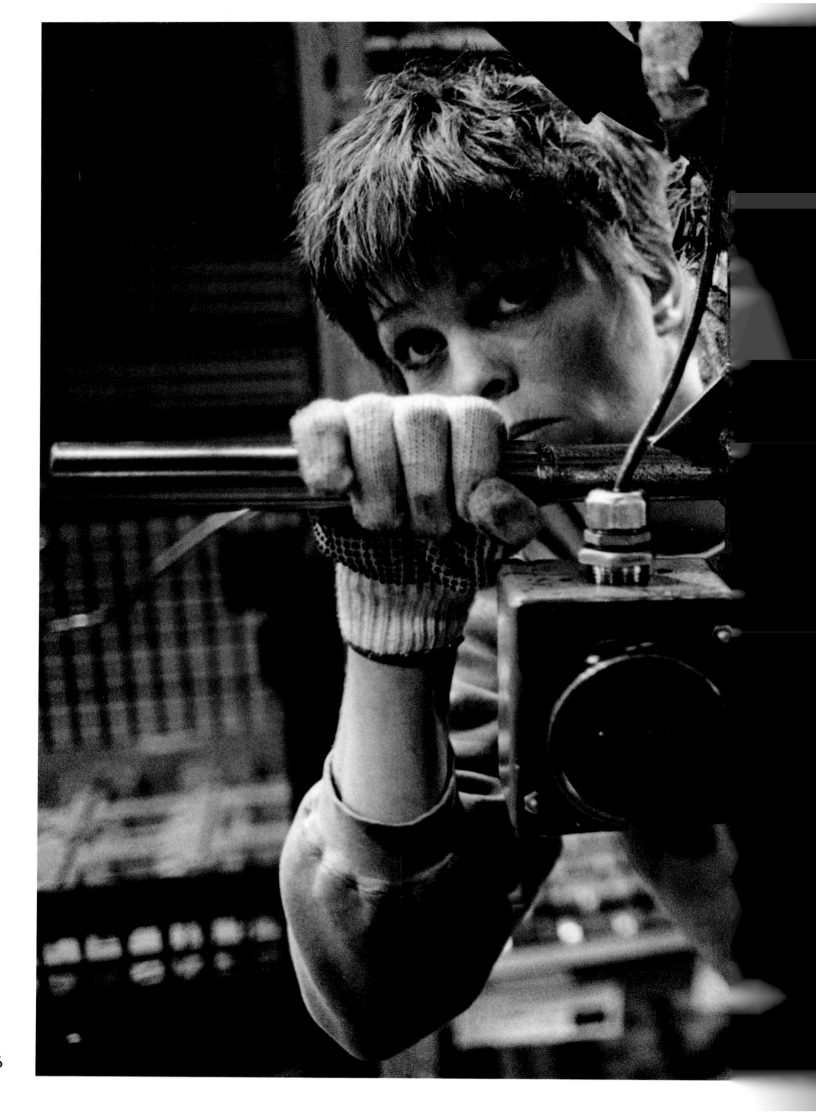

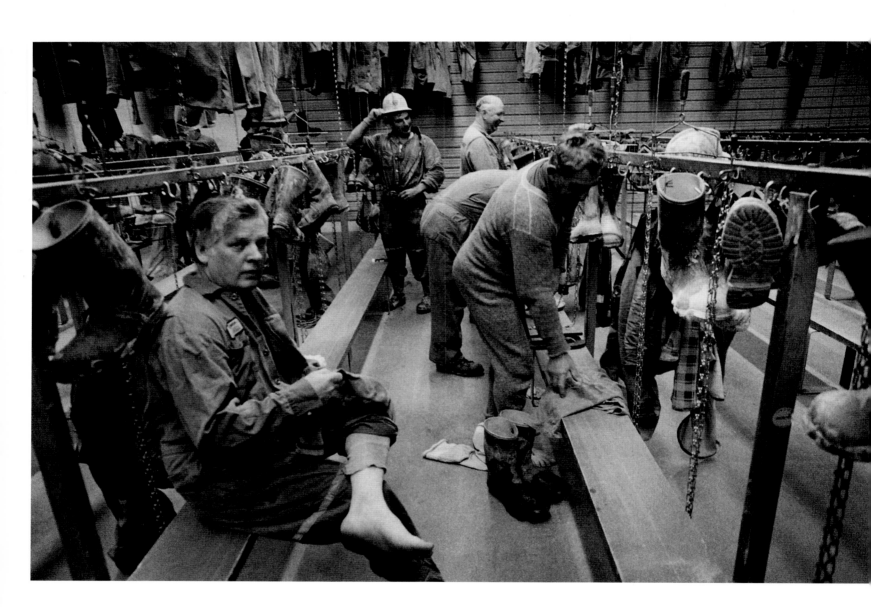

Miners in the change room, Campbell River (Vancouver Island), British Columbia
Previous page: Auto parts worker, Whitby, Ontario

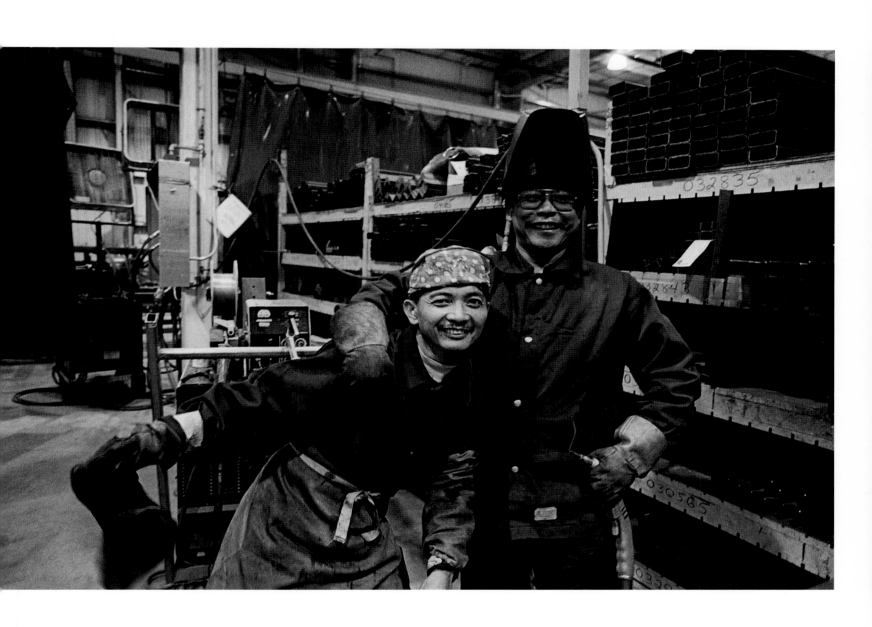

Bus assemblers, Winnipeg, Manitoba

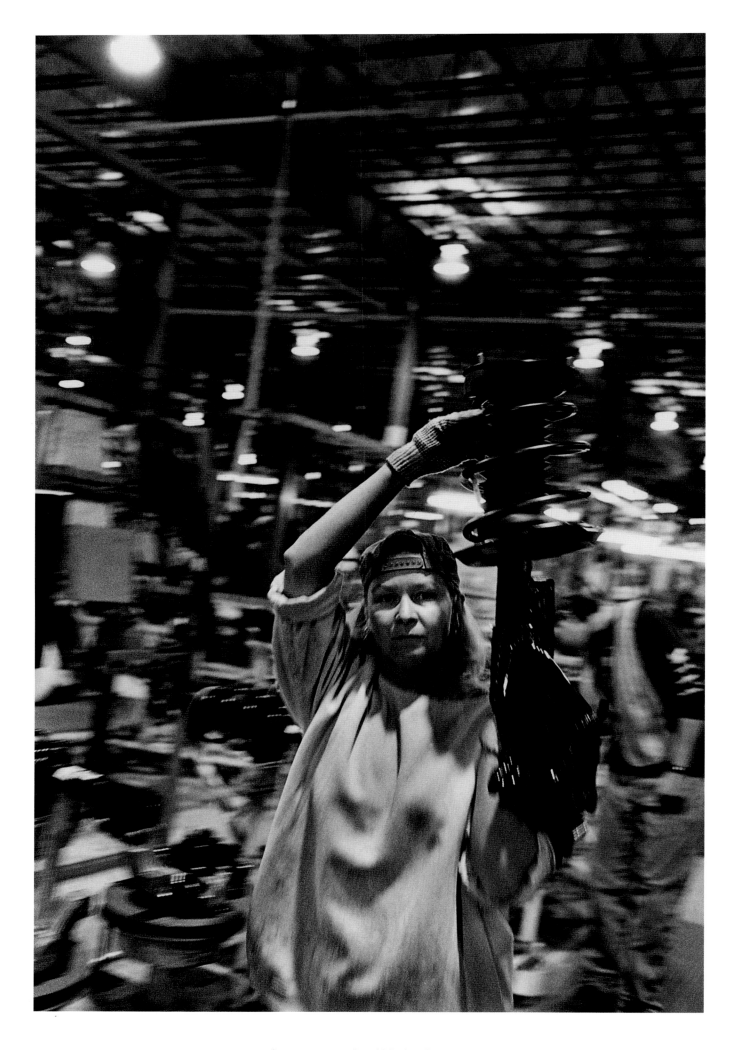

Auto parts worker, Whitby, Ontario

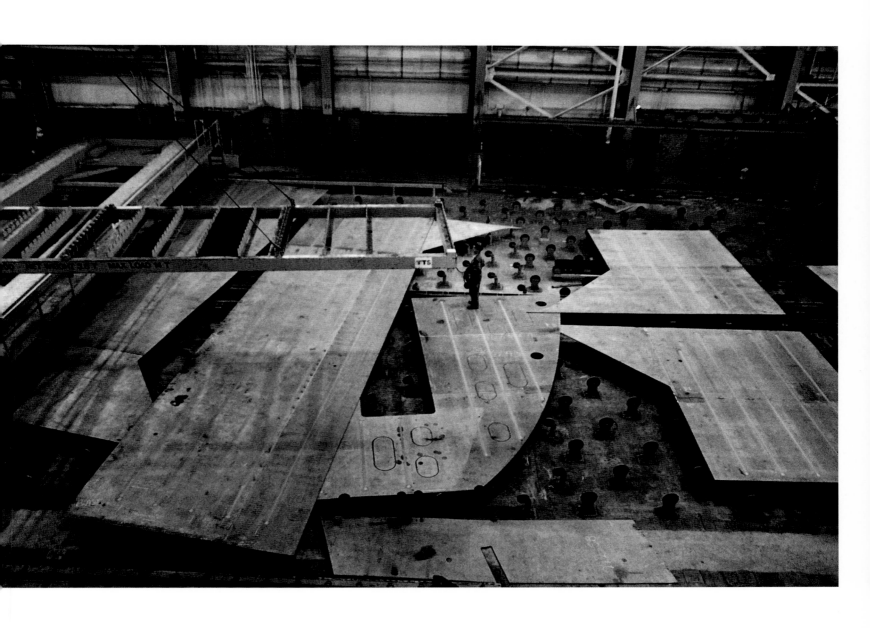

Shipbuilder, Saint John, New Brunswick

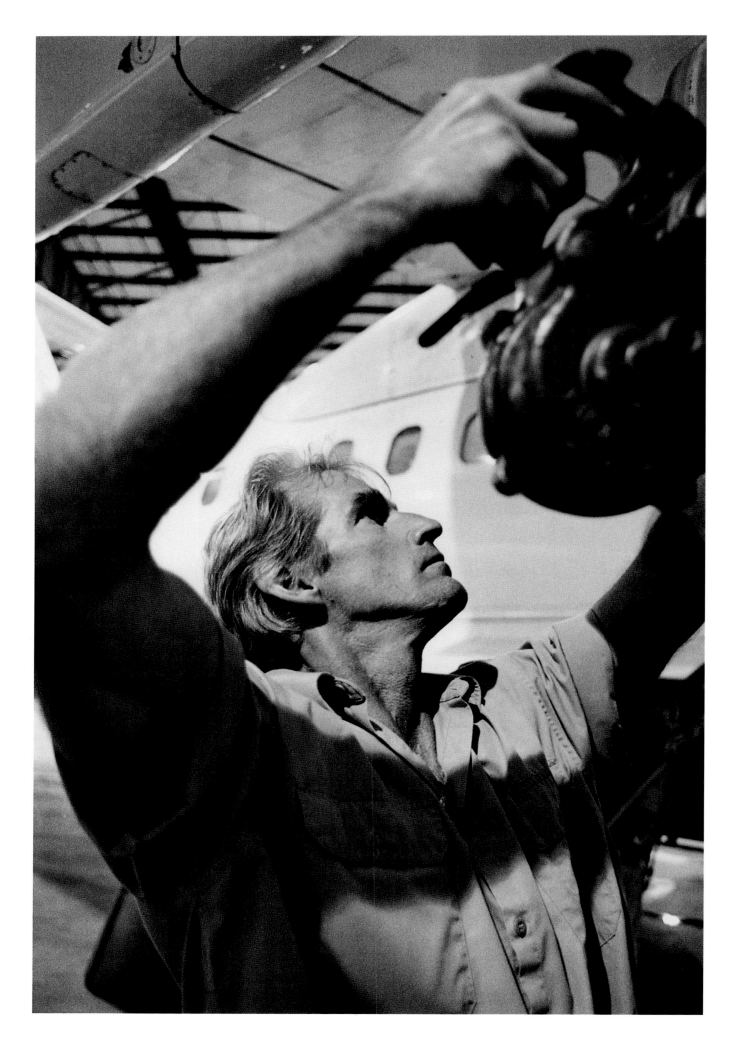

Aircraft mechanic, Halifax, Nova Scotia

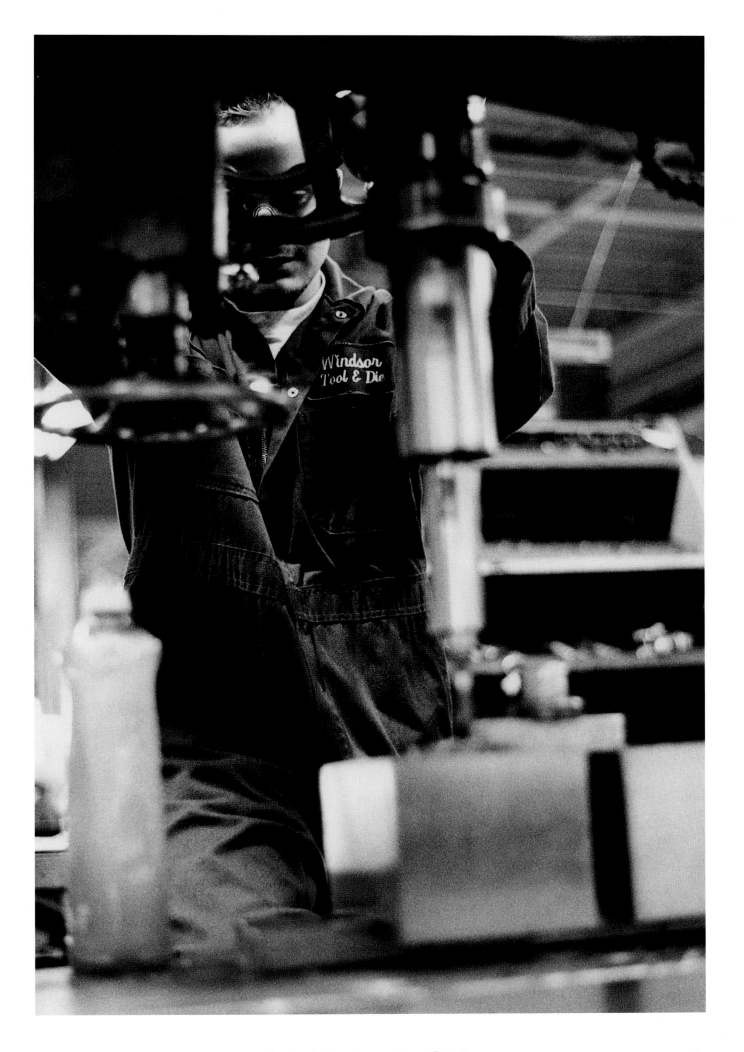

Tool and die maker, Windsor, Ontario

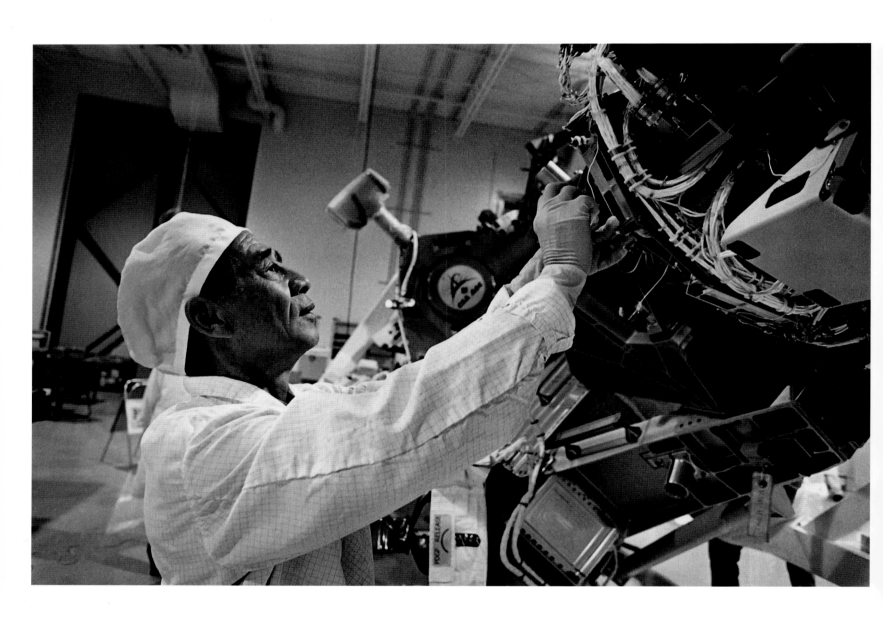

Space systems technician, Brampton, Ontario

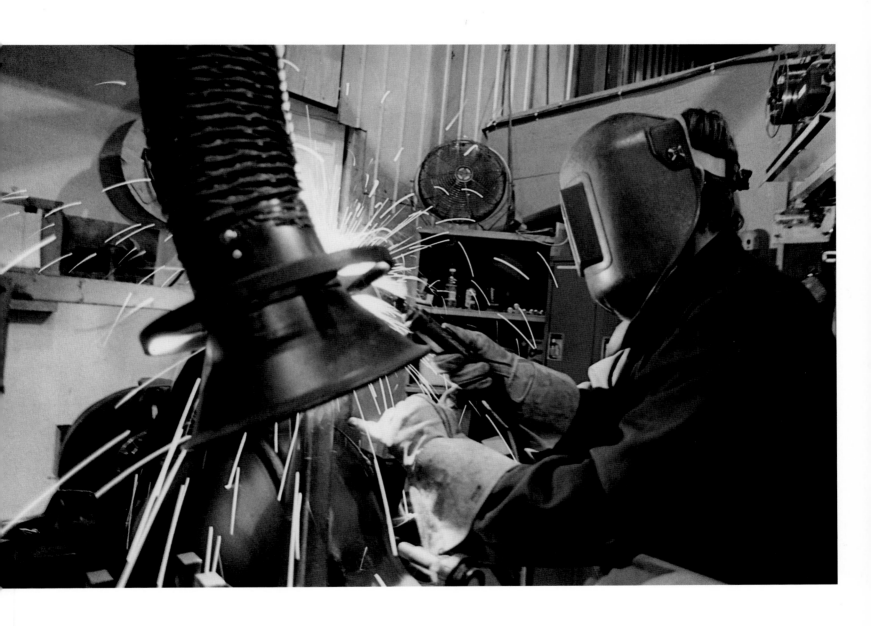

Welder in a bus manufacturing plant, Sainte-Claire, Quebec

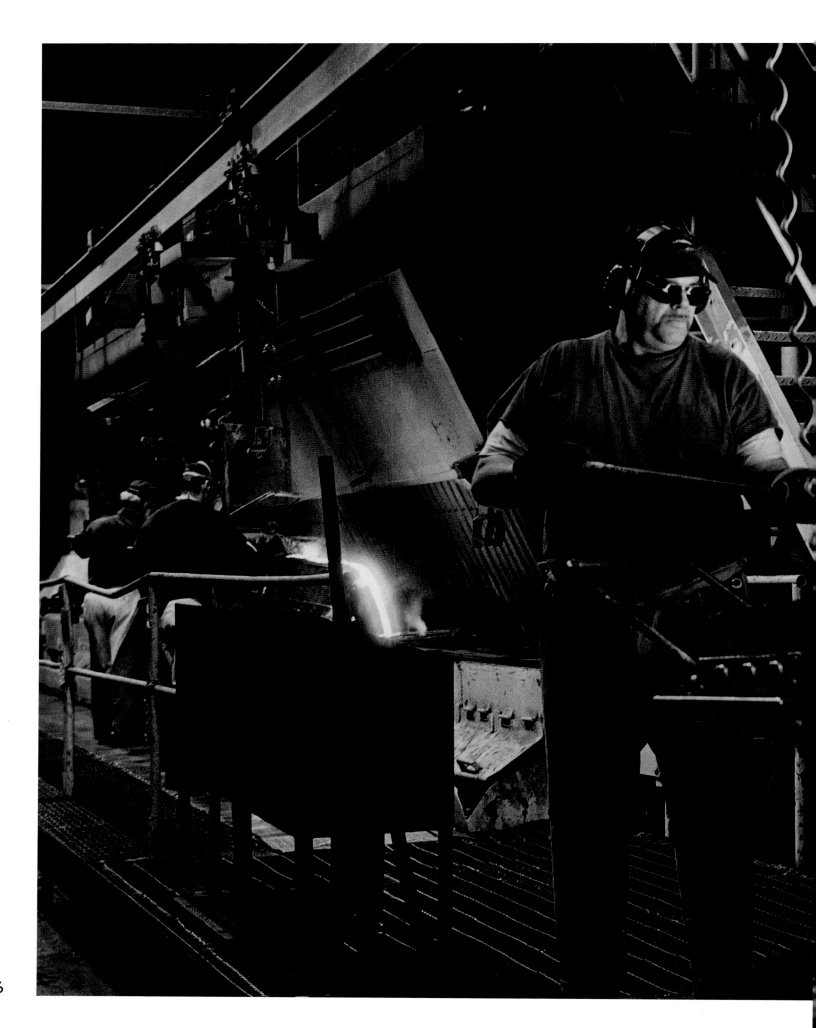

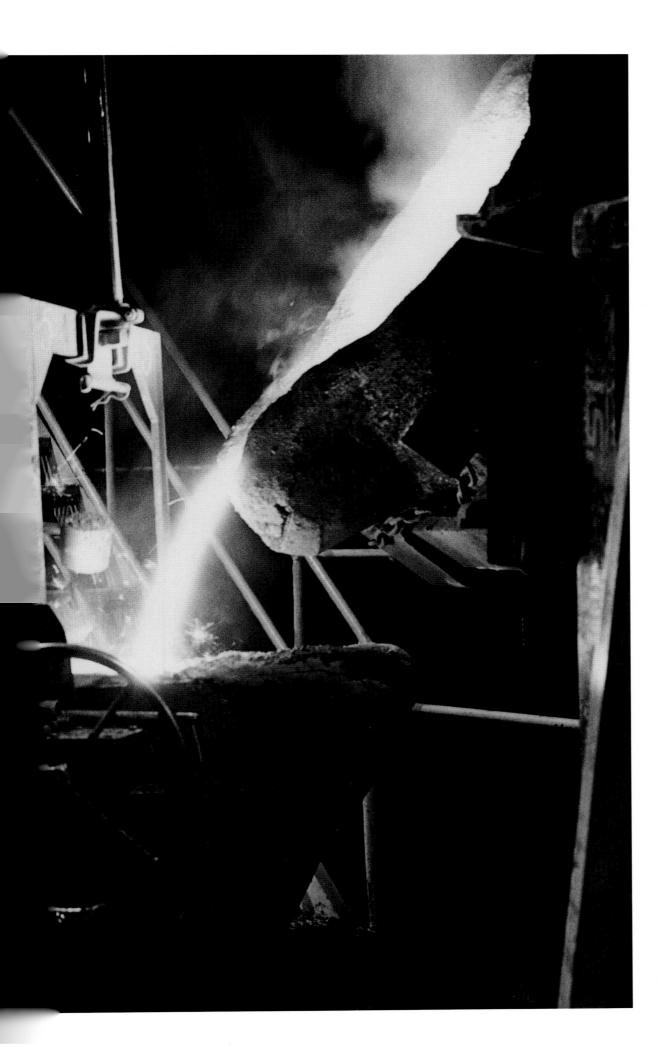

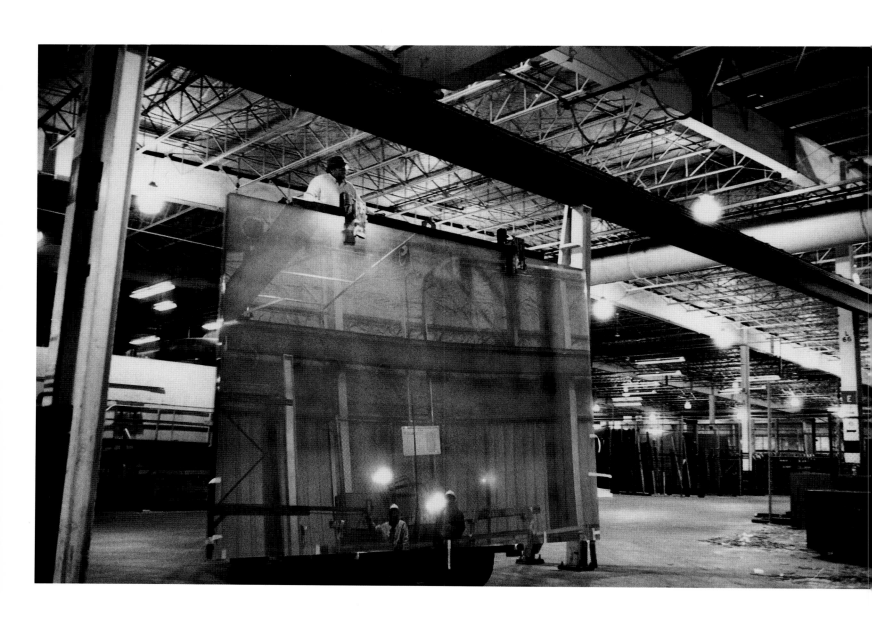

Plate glass workers, Owen Sound, Ontario
Previous page: Iron pourer, Woodstock, Ontario

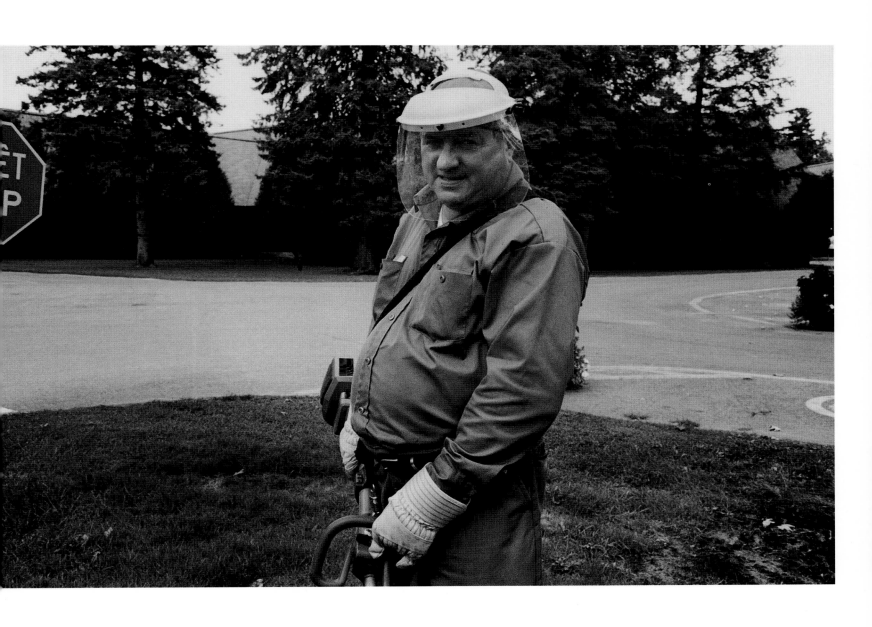

Hotel worker, Montebello, Quebec

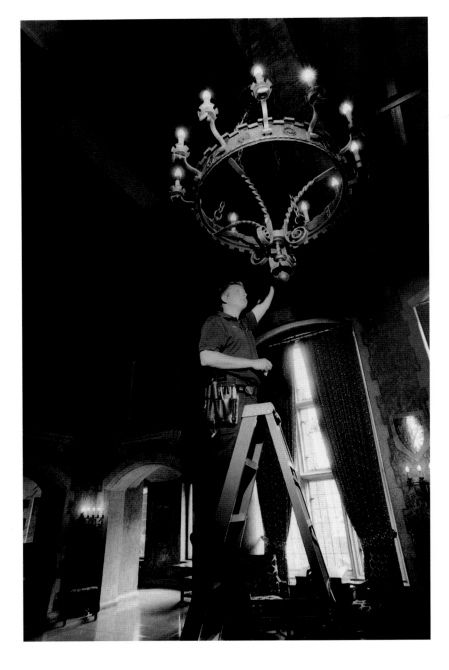

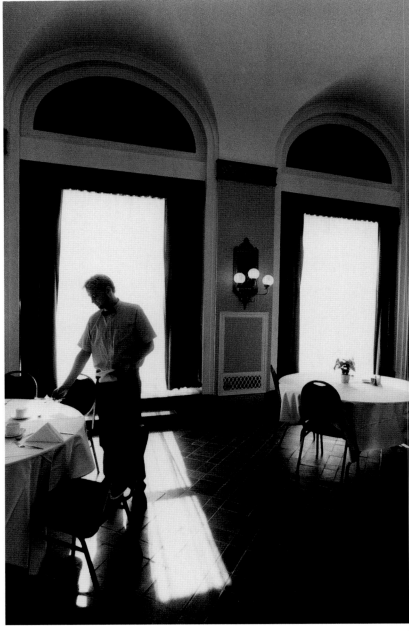

Left: Hotel worker, Banff, Alberta
Right: Hotel worker, Saskatoon, Saskatchewan

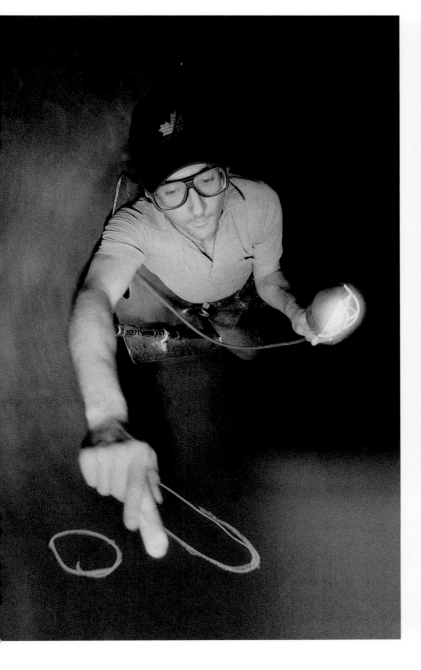

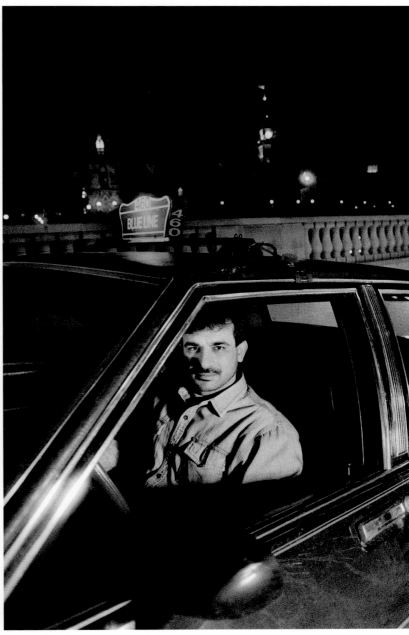

Left: Pipe factory worker, Camrose, Alberta
Right: Taxi driver, Ottawa, Ontario

171

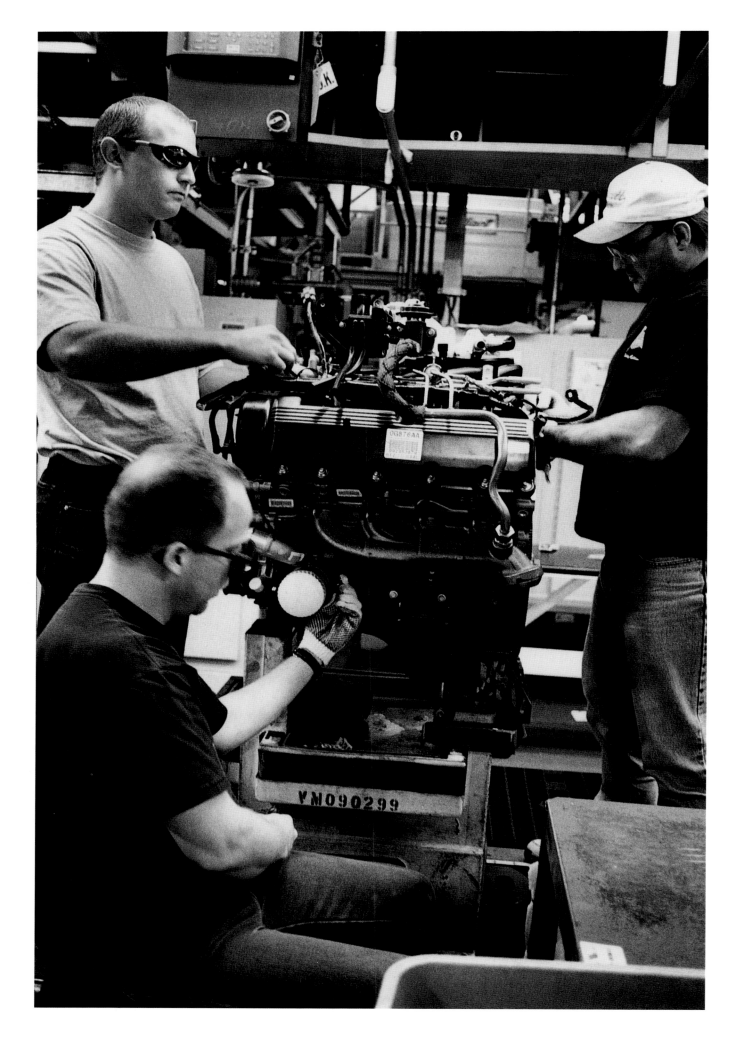

Auto engine assemblers, Windsor, Ontario

Auto brake plant worker, Tilbury, Ontario

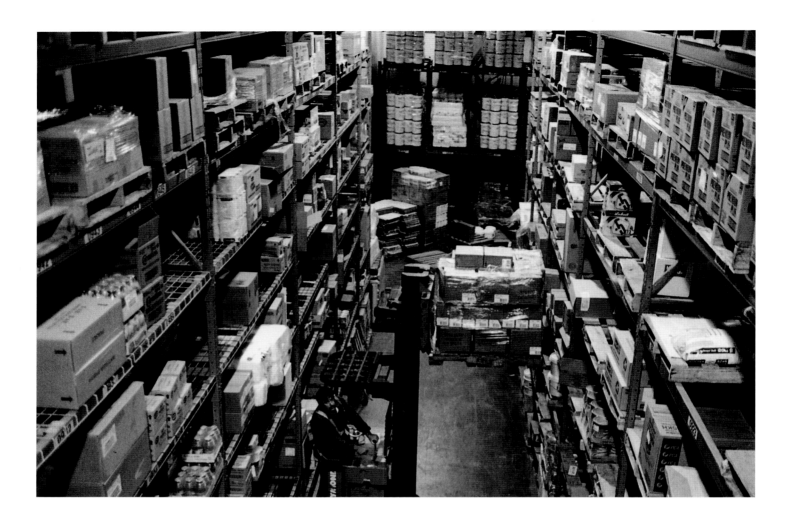

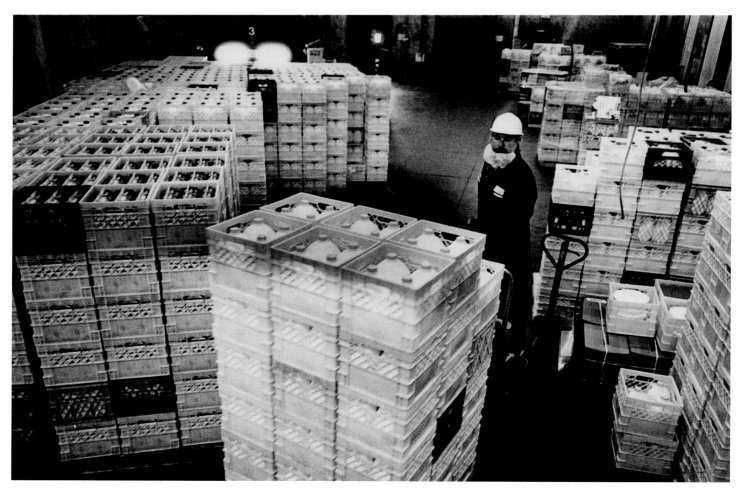

Top: Forklift operator, Sydney, Nova Scotia
Bottom: Milk shipper, Brandon, Manitoba

Hotel workers, Mont-Tremblant, Quebec
Previous page: Aircraft worker, Longueuil, Quebec

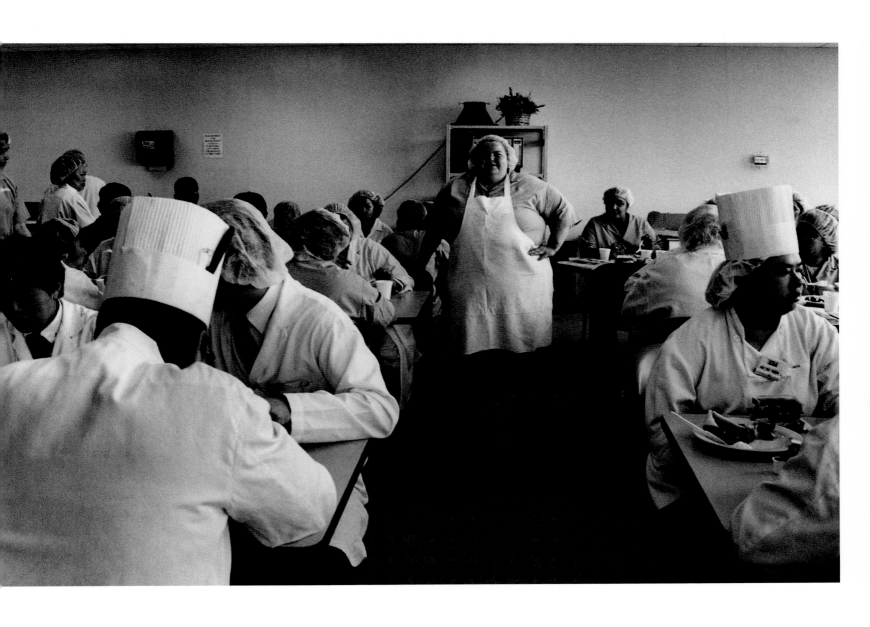

Catering company workers, Richmond, British Columbia

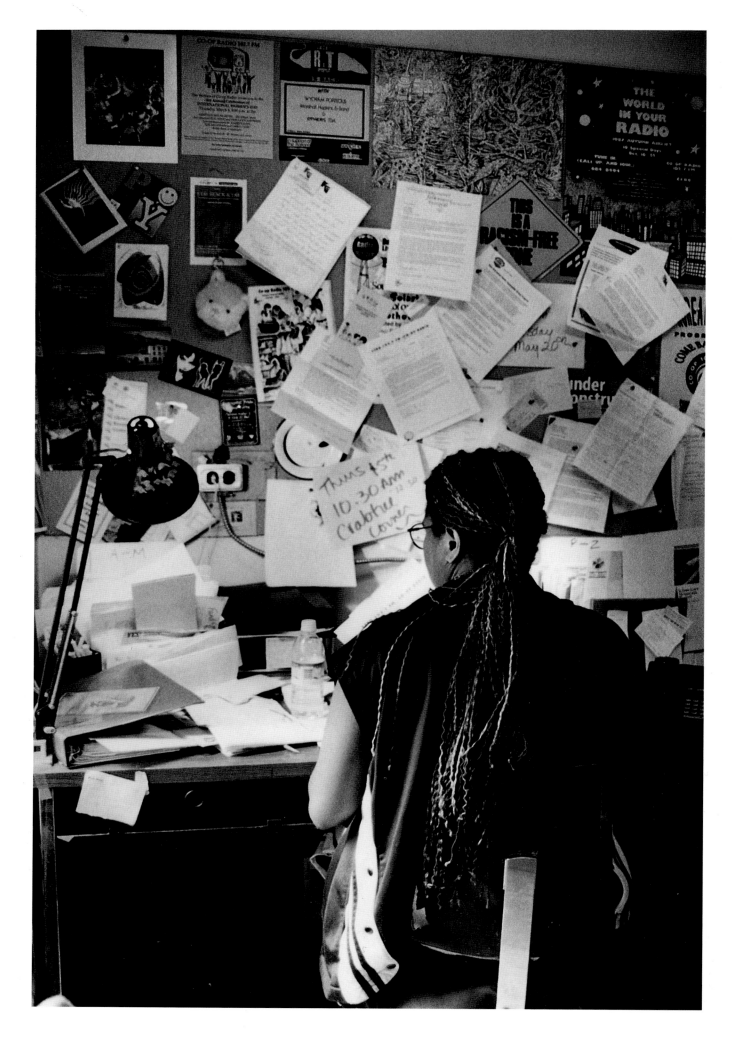

Co-op radio station worker, Vancouver, British Columbia

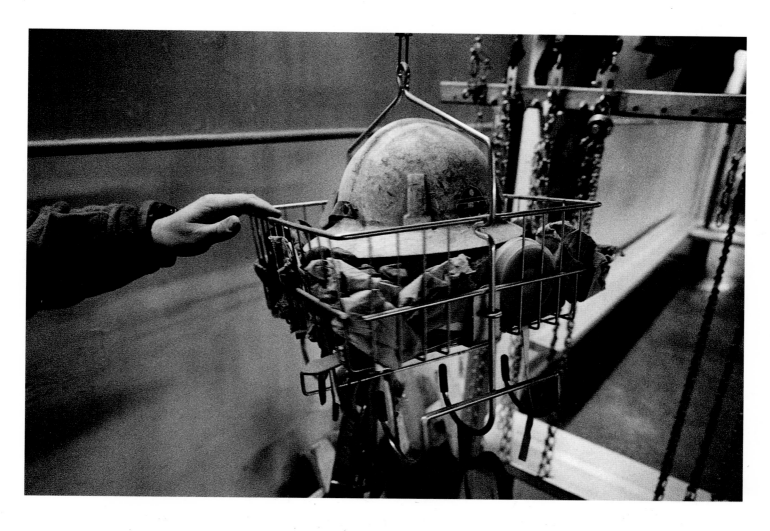

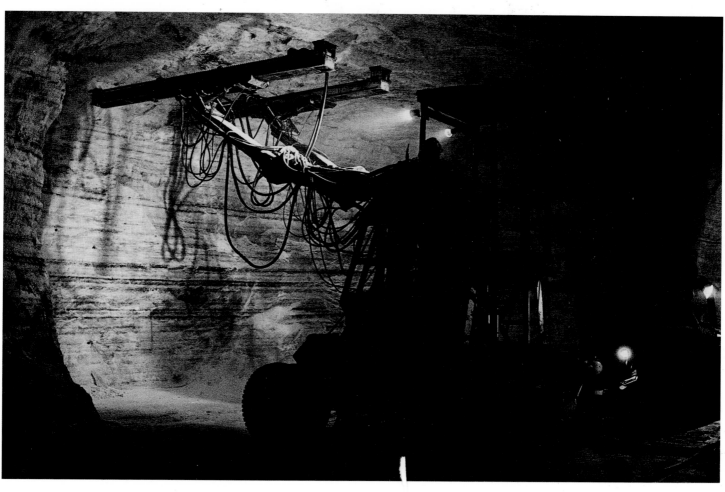

Top: Miner's dry basket, Campbell River (Vancouver Island), British Columbia
Bottom: Jumbo drill, salt mine, Windsor, Ontario

185

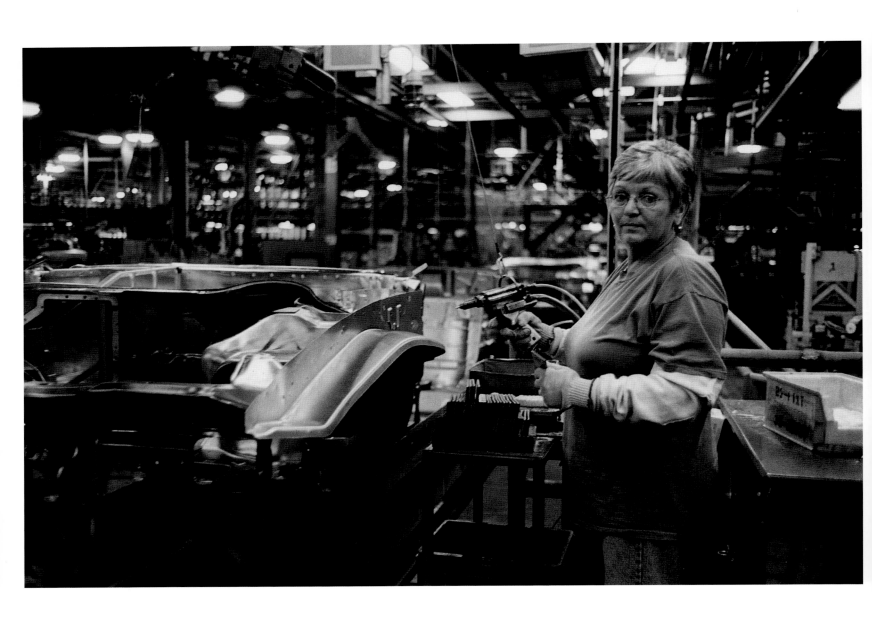

Autoworker, Boisbriand, Quebec

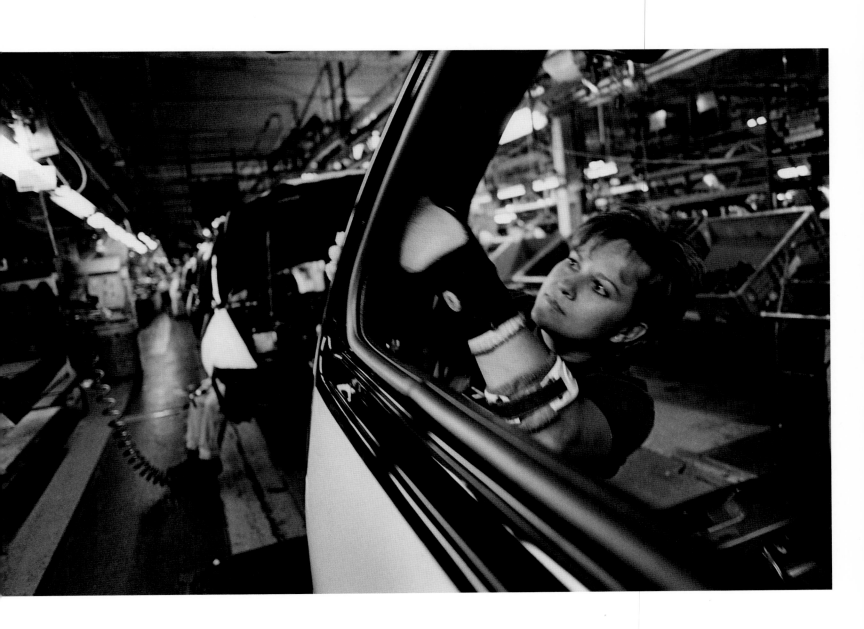

Autoworker, Windsor, Ontario

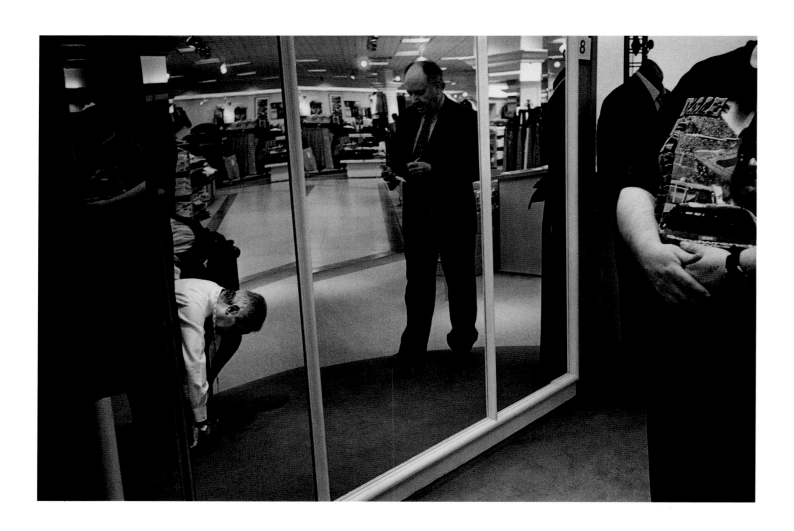

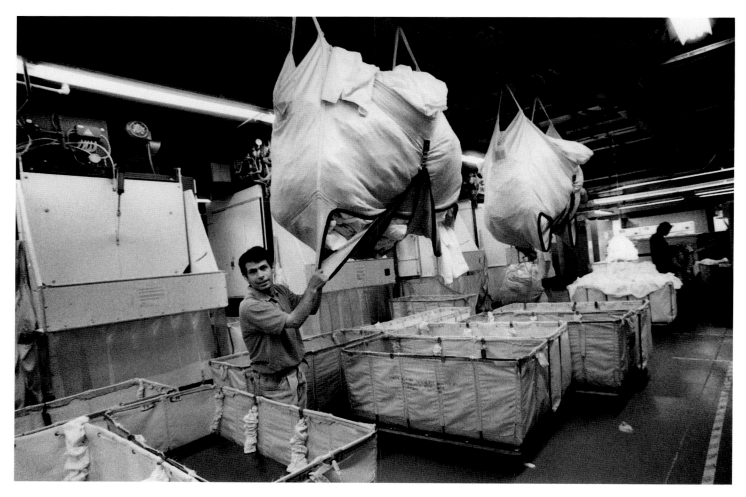

Top: Tailors in a men's shop, Windsor, Ontario
Bottom: Industrial hotel laundry worker, Canmore, Alberta

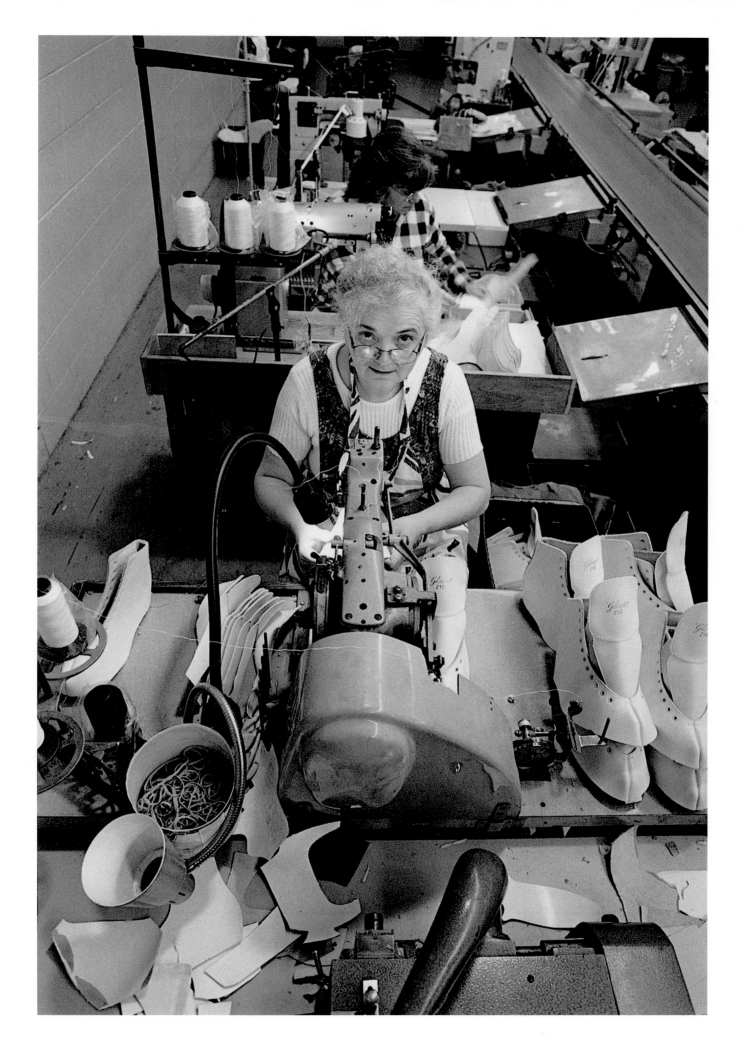

Sewing machine operator in a skate factory, Waterloo, Ontario

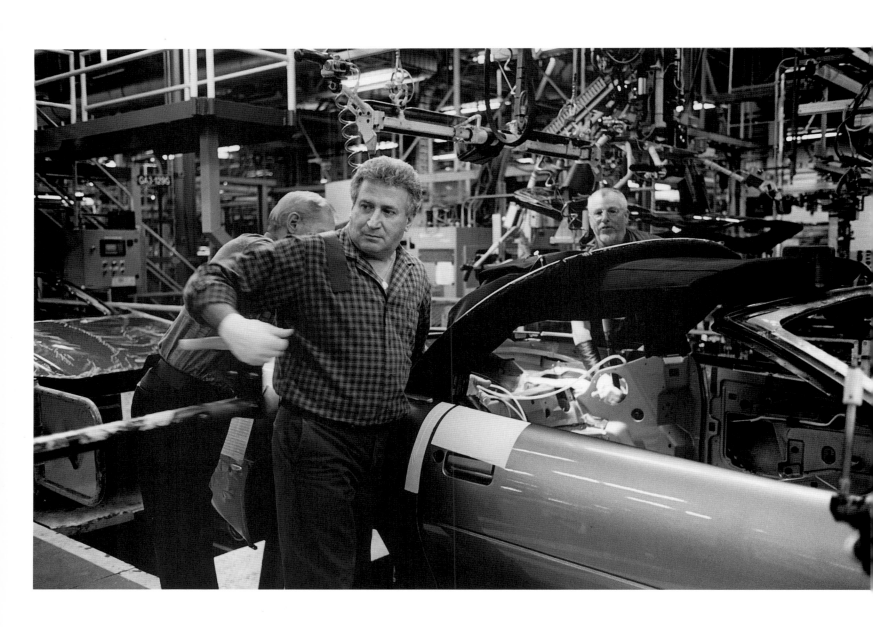

Autoworker, Boisbriand, Quebec

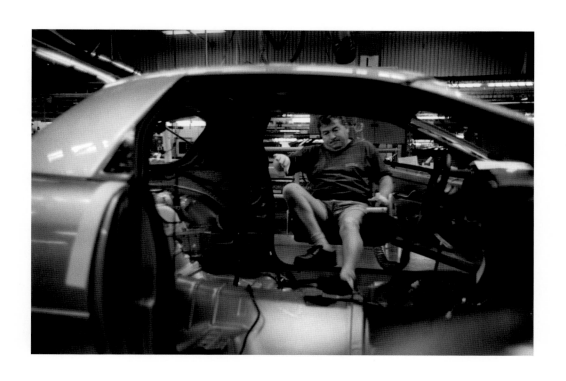

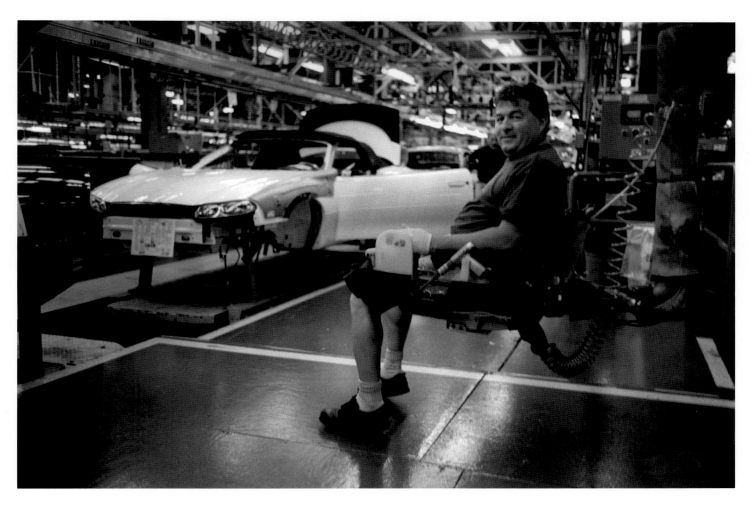

Both: Autoworker with ergonomic chair, Boisbriand, Quebec

191

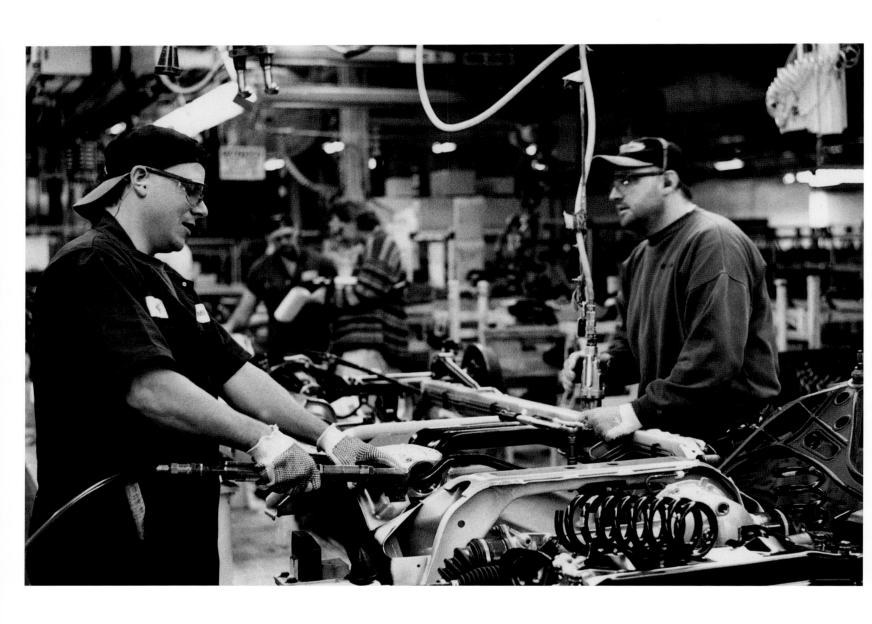

Auto assemblers, Ingersoll, Ontario

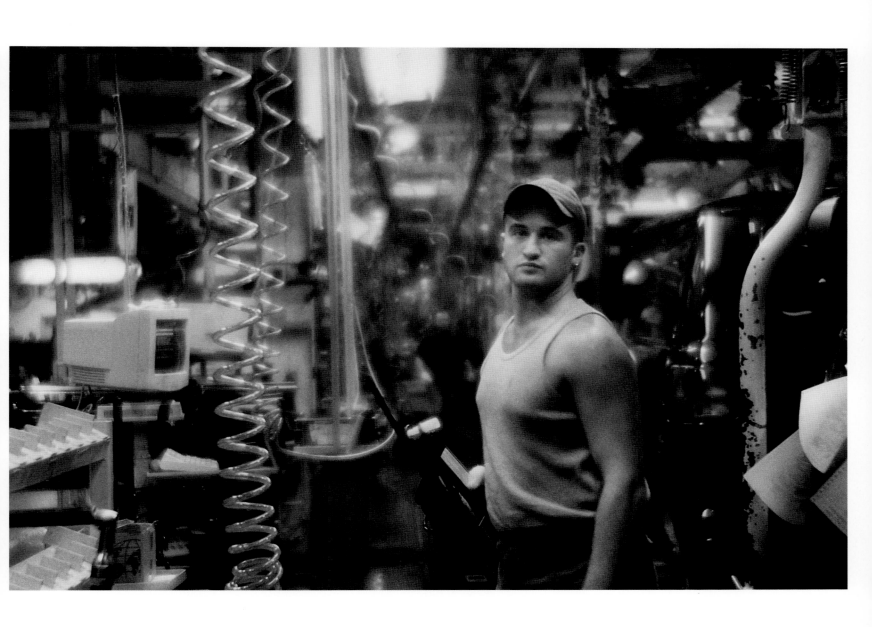

Autoworker, Windsor, Ontario

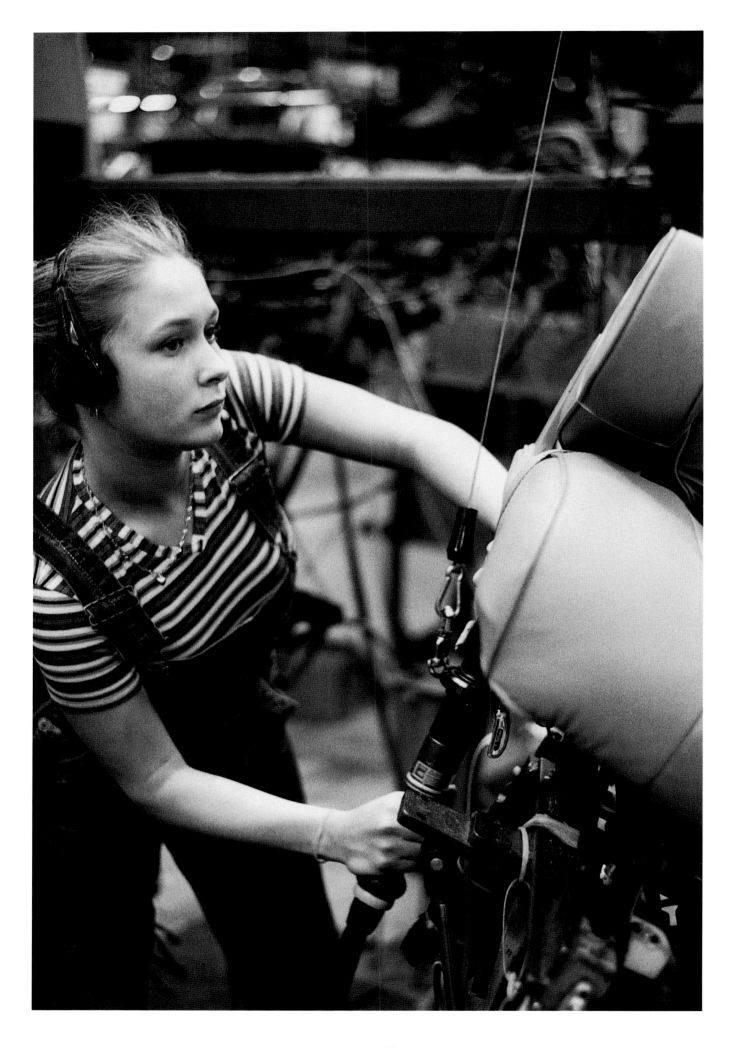

Auto seat assembler, St. Thomas, Ontario

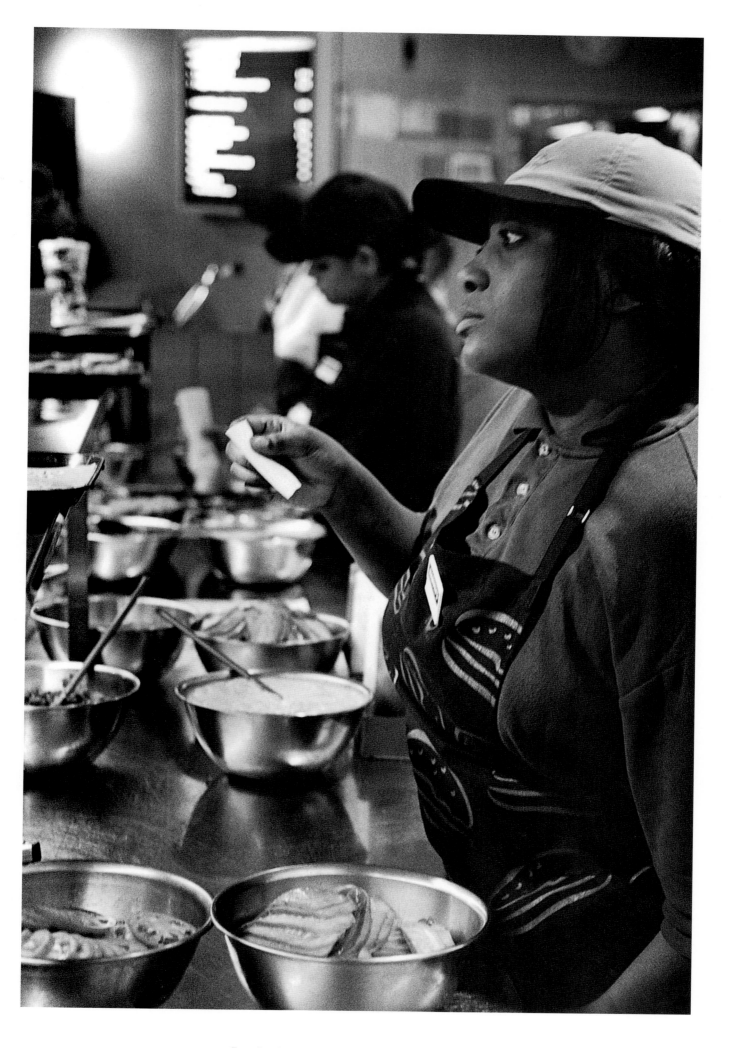

Fast food restaurant worker, Toronto, Ontario

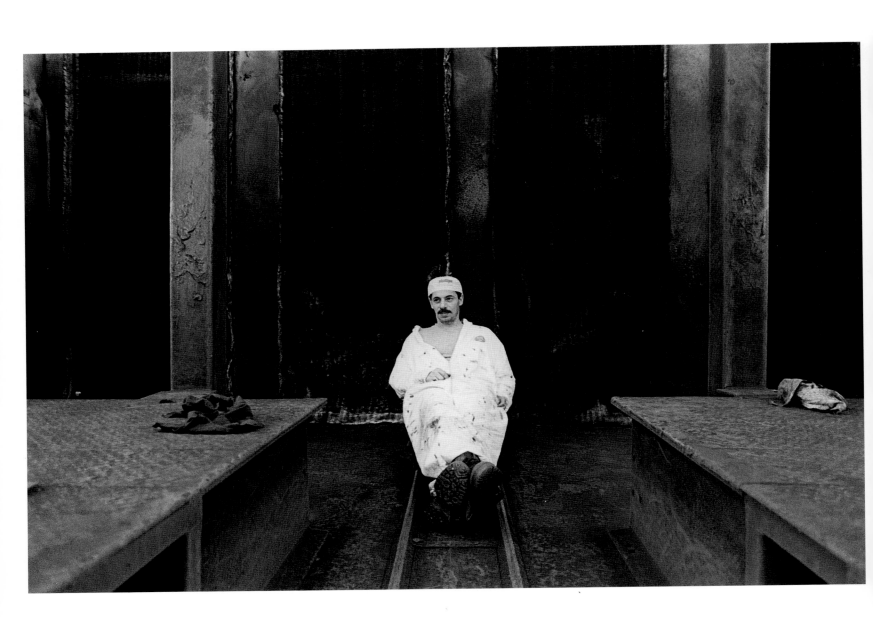

Agricultural machinery worker, Winnipeg, Manitoba

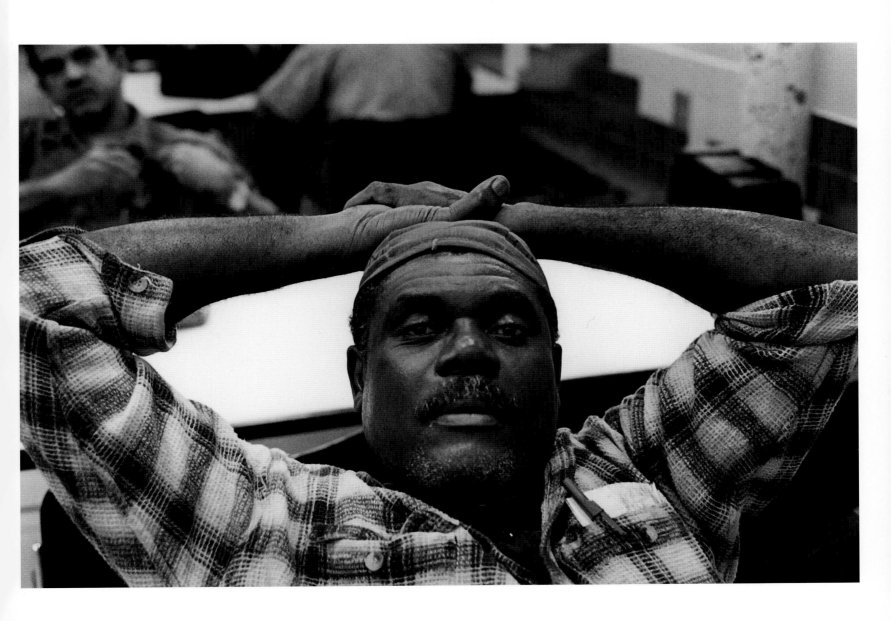

Railway worker, Concord, Ontario

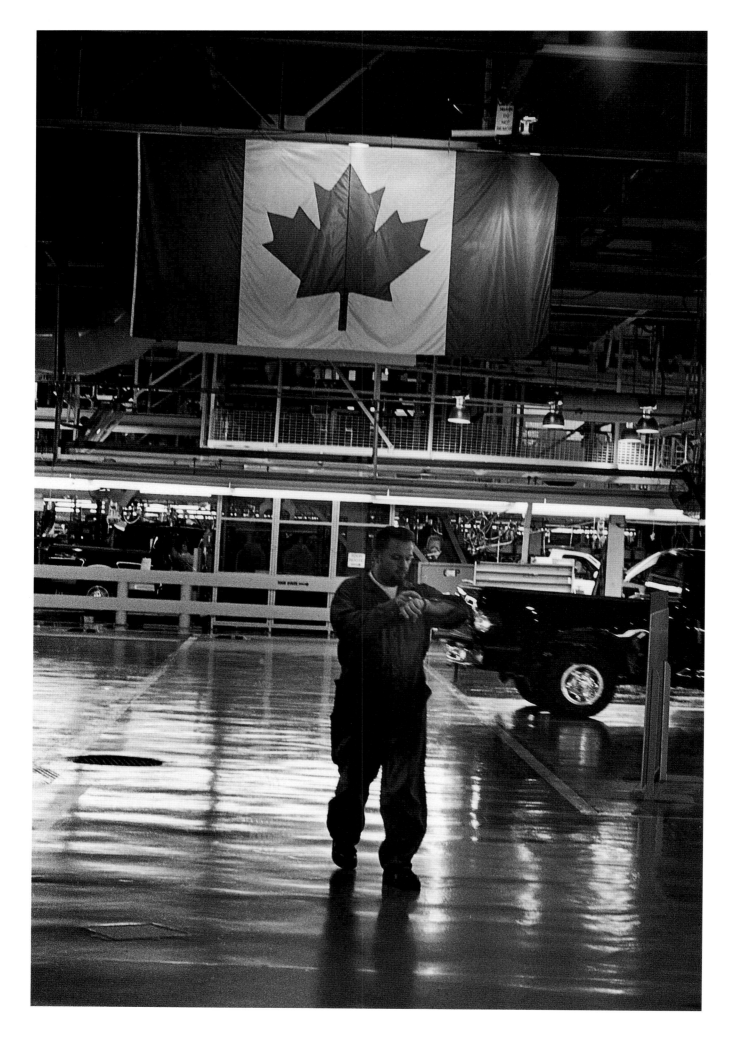

Autoworker at the end of the shift, Oakville, Ontario

Index of
Names, Workplaces, CAW Locals, Locations

Page	Name	Workplace	CAW Local	Location
5	Eric Ruettinger		CAW Retirees	Port Elgin, ON
	Bruno Martinuzzo		CAW Retirees	Port Elgin, ON
	Maria Pia Martinuzzo		CAW Retirees	Port Elgin, ON
22–23	Frank Pellerito	DaimlerChrysler Pillette Road Plant	444	Windsor, ON
24	Dougald Westhaver	Halifax Shipyard	MWF *	Halifax, NS
25 Both	Mike Salsman	Halifax Shipyard	MWF *	Halifax, NS
26	Cindy Learn	Ford Motor Company of Canada –Truck Plant	707	Oakville, ON
27	Andrew Harriet	Mackie Automotive Systems	222	Whitby, ON
	Linda Murphy	Mackie Automotive Systems	222	Whitby, ON
	Tim Find, Ireene Davidson	Mackie Automotive Systems	222	Whitby, ON
	Steven Leith, Steve Salter	Mackie Automotive Systems	222	Whitby, ON
28	Marc Cayouette	EMS Technologies Canada (formerly Spar Aerospace)	188	Ste-Anne-de-Bellevue, QC
29	Rick Adams	Bristol Aerospace	3005	Winnipeg, MB
30–31	auto parts plant	Budd Canada	1451	Kitchener, ON
32 Top	cement plant	Blue Circle Cement	222	Bowmanville, ON
32 Bottom	Ron Bowers	Blue Circle Cement	222	Bowmanville, ON
33	shipping canal	St. Lawrence Seaway Authority – Canada	4320	Brossard, QC
34	Sam Maksoud	Ford Motor Company of Canada – Engine Plant	200	Windsor, ON
35	cable manufacturing plant	NORDX/CDT	1837	Kingston, ON
36	Randy Young	General Motors of Canada – Truck Plant	222	Oshawa, ON
37	John Angi	John Deere Welland Works	275	Welland, ON
38	Betty Ann Lane	General Electric Canada	524	Peterborough, ON
39	John Papadontas	DaimlerChrysler Minivan Assembly Plant	444	Windsor, ON
40	Lucille Bernier	Nabisco	956	Chambly, QC
41	Don Kingbury	NORDX/CDT	1837	Kingston, ON
42–43	Allan Stuart	Crossley Carpet Mills	4612	Truro, NS
44	worker's hands	Bombardier	1075	Thunder Bay, ON
45	Denis Raymond	Goodyear Canada	4511	St-Laurent, QC
46	Stéphanie Levasseur	Château Mont Tremblant	5000	Mont-Tremblant, QC
	Josée Lalande	Château Mont Tremblant	5000	Mont-Tremblant, QC
47	Rhoda Boateng	Woodbridge Foam Corp.	112	Woodbridge, ON
48 Top	Emanuele Farruggia	Goodyear Canada	4511	St-Laurent, QC
48 Bottom	Jagdev Singh Bal	General Motors of Canada – Diesel Division	27	London, ON
49	Stan Botica	Hiram Walker & Sons	2027	Windsor, ON
50–51	Dave Northey	Quaker Oats Company of Canada	1996	Peterborough, ON
52	Linda Tilling	General Motors of Canada – Truck Plant	222	Oshawa, ON
53	Robert S. Lee	Ford Motor Company of Canada – Truck Plant	707	Oakville, ON
54	Debra Amy	Dominion Store	RWC †	Toronto, ON
	Pat Dubrick	Dominion Store	RWC †	Toronto, ON
	Diane O'Brien	Dominion Store	RWC †	Toronto, ON
55	Leonie Metz	Canadian Airlines International	1990	Whitehorse, YK
	Edna Lorenzen	Canadian Airlines International	1990	Whitehorse, YK
56 Top	hands, nursing home	Mahone Bay Nursing Home	1944	Mahone Bay, NS
56 Bottom	Pam Moisman and resident Ella Hints	Mahone Bay Nursing Home	1944	Mahone Bay, NS
57	Jackie Bezanson	Mahone Bay Nursing Home	1944	Mahone Bay, NS
58	Jim Miller	Bombardier	1075	Thunder Bay, ON
59	Frankie Tropea, Jr.	Bombardier	1075	Thunder Bay, ON
60	Fred Dejong	Westmin Resources	3019	Campbell River, BC
61	Bradley Ericson	The Cheesecake Café	4234	Victoria, BC
62–63	Sylvie Rozon	PPG Canada	1661	Hawkesbury, ON
64	Cherie Doan	Dover Corporation (Canada)	27	Strathroy, ON
65	Trinh Hien	Engine Rebuilders	1085	Edmonton, AB
66	Laura Brown	Grand River Hospital	302	Kitchener, ON
67 Top	Karen Cinq-Mars	Nova House	4272	Selkirk, MB
	Inez Mayo	Nova House	4272	Selkirk, MB
67 Bottom	carpentry shop, aluminum plant	Alcan Aluminum	2301	Kitimat, BC
68	Mona Lanteigne and Donald Mercier	L'Association Co-op des Pêcheurs	1727	Lamèque, NB
69 Top	Cécile Roussel	L'Association Co-op des Pêcheurs	1727	Lamèque, NB
69 Bottom	Céline Ferron	L'Association Co-op des Pêcheurs	1727	Lamèque, NB
	Denise Ferron	L'Association Co-op des Pêcheurs	1727	Lamèque, NB
	Chantal Jones	L'Association Co-op des Pêcheurs	1727	Lamèque, NB
70–71	fish plant	L'Association Co-op des Pêcheurs	1727	Lamèque, NB
72	Laura Hill	CAW Oshawa Child Care Centre		Oshawa, ON
73	Marcel Labrecque	Nova Bus – Prévost Car Division	1044	Sainte-Claire, QC
74 Top	Gena di Flavio	Sobeys	1971	Sydney, NS
74 Bottom	Gordon Farewell	FPI	FFAW ‡	Marystown, NF
	David Antle	FPI	FFAW ‡	Marystown, NF

200

Page	Name	Workplace	CAW Local	Location
75 Top	Dave Dickson	The Empress Hotel	4276	Victoria, BC
75 Bottom	Jeff Cook	The Cheesecake Café	4234	Victoria, BC
76	Rosemaria Jenkins	Commercial Bakeries	RWC †	Toronto, ON
	Vilma Pope	Commercial Bakeries	RWC †	Toronto, ON
77	Juliana Ohene Adu	Commercial Bakeries	RWC †	Toronto, ON
78–79	Barry Dillon	Bombardier	1075	Thunder Bay, ON
	Don Green	Bombardier	1075	Thunder Bay, ON
80	Roy Bork	Canadian National Railway	100	Concord, ON
81	Mark Kish	Eureka Foundry	636	Woodstock, ON
82	Paul Snow	Hotel Newfoundland	4550	St. John's, NF
83	Paul Bourque	Atlantic Sleep Products	4529	Scoudouc, NB
84	Barry Willshaw	Quaker Oats Company of Canada	1996	Peterborough, ON
85	Alicia Hall	Nestlé Canada	252	Toronto, ON
	Beverley Wright	Nestlé Canada	252	Toronto, ON
86–87	Keith Sullivan	independent crab harvester	FFAW ‡	off St. John's, NF
	Lloyd Sullivan	independent crab harvester	FFAW ‡	off St. John's, NF
88 Top	Cathy Oram	FPI	FFAW ‡	Marystown, NF
	Hazel Prior	FPI	FFAW ‡	Marystown, NF
	Marie Hatcher	FPI	FFAW ‡	Marystown, NF
88 Bottom	Sophie Larocque	Pêcheries FN Fisheries	1717	Shippagan, NB
89 Top	inside Lloyd Sullivan's storage shed	independent crab harvester	FFAW ‡	Calvert, NF
89 Bottom	fishing boats	independent crab harvesters	FFAW ‡	off St. John's, NF
90	fish plant	Pêcheries FN Fisheries	1717	Shippagan, NB
91	Keith Sullivan	independent crab harvester	FFAW ‡	off St. John's, NF
92	Firmin Mallet	VIA Rail Canada	4005	Halifax, NS
93	Oscar Ifurung	CN Tower	4271	Toronto, ON
94 Top	Joanne Wells	The Windsor Star	240	Windsor, ON
	Linda Crawford	The Windsor Star	240	Windsor, ON
94 Bottom	S. Vimalan	AT&T Canada	2000	Toronto, ON
95 Top	name unknown	Air Canada – Call Centre	2213	Saint John, NB
95 Bottom	Carolyn Saunders	Green Shield Canada	240	Windsor, ON
96–97	Nancy Pella	Casino Windsor	444	Windsor, ON
98	Teja Kalsi	AlliedSignal	1849	Montreal, QC
99	Fred Dejong	Westmin Resources	3019	Campbell River, BC
100 Top	Shirley Kisoun	Canadian Airlines International	1990	Iqaluit, NT
100 Bottom	Kristine Copland	Canadian Airlines International	1990	Whitehorse, YK
101 Top	Ron Jones	Air Canada	2213	Charlottetown, PE
	Juanita Glenn-Hughes	Air Canada	2213	Charlottetown, PE
101 Bottom	Maria Puster	Air Transat A.T.	1990	Toronto, ON
102	(clockwise)	Budd Canada	1451	Kitchener, ON
	Howard Miller	Budd Canada	1451	Kitchener, ON
	Junior Riggan, Gladstone Ingram	Budd Canada	1451	Kitchener, ON
	Rohan Riggan	Budd Canada	1451	Kitchener, ON
	Dean Bridgewater	Budd Canada	1451	Kitchener, ON
103	(clockwise)	Hotel Newfoundland	4550	St. John's, NF
	Louise Tobin	Hotel Newfoundland	4550	St. John's, NF
	Madonna Cave	Hotel Newfoundland	4550	St. John's, NF
	Carmel Dunne	Hotel Newfoundland	4550	St. John's, NF
	Hilda Hibb	Hotel Newfoundland	4550	St. John's, NF
	Gerard McDonald	Hotel Newfoundland	4550	St. John's, NF
	Joanne Russell	Hotel Newfoundland	4550	St. John's, NF
104 Left	Mel Shortland with passenger, Robert Fraser	City of Moose Jaw	4187	Moose Jaw, SK
104 Right	Jason Ridinger	Clipper Navigation	4234	Victoria, BC
105 Left	Eden Gebreslasic	KFC	3000	Vancouver, BC
105 Right	Kenny Poon	Rosie's on Robson	3000	Vancouver, BC
106–107	aircraft maintenance plant	IMP Group International	2215	Halifax, NS
108	Randy Glover	Air Nova	2213	Halifax, NS
109	Lino Scrivo	Boeing Canada	1967	Toronto, ON
	Manuel Siervo	Boeing Canada	1967	Toronto, ON
110	(clockwise)	Bombardier Aerospace (formerly deHavilland)	112	Toronto, ON
	Merlyn Stewart	Bombardier Aerospace (formerly deHavilland)	112	Toronto, ON,
	Roberto Poce	Bombardier Aerospace (formerly deHavilland)	112	Toronto, ON
	Mike Lam	Bombardier Aerospace (formerly deHavilland)	112	Toronto, ON
	Jack Lee	Bombardier Aerospace (formerly deHavilland)	112	Toronto, ON
	Frank Maida	Bombardier Aerospace (formerly deHavilland)	112	Toronto, ON
	Jack Slaughter	Bombardier Aerospace (formerly deHavilland)	112	Toronto, ON
111	hands and instruments, aircraft plant	Boeing Canada	2169	Winnipeg, MB

Page	Name	Workplace	CAW Local	Location
112–113	James Griggs	IMP Group International	2215	Halifax, NS
	Martin Day (inside engine)	IMP Group International	2215	Halifax, NS
114	André Courchesne	Nova Fabtech	1362	Saint-François-du-Lac, QC
115	mattress factory	Atlantic Sleep Products	4529	Scoudouc, NB
116	Ray Summerton	Air Ontario	2213	London, ON
117	Babooram Magmaught	Halifax Shipyard	MWF *	Halifax, NS
118	Sergio Simms	Navistar International Corporation Canada	127	Chatham, ON
	Dwayne Blonde	Navistar International Corporation Canada	127	Chatham, ON
	Kevin Galbraith	Navistar International Corporation Canada	127	Chatham, ON
119	Vicki Bennet	Navistar International Corporation Canada	127	Chatham, ON
120–121	Eric Schneider	NORDX/CDT	1837	Kingston, ON
122	Doug Croft	Canadian Pacific	101	Rogers Pass, BC
123	Paul Davis	Air Ontario	2213	London, ON
	Jack Selinger	Air Ontario	2213	London, ON
124	Wilburt Goodridge	Freide Goldman Newfoundland	MWF *	Marystown, NF
125 Top	Dale Strachan	Wescast Industries	397	Brantford, ON
	Roger Frigault	Wescast Industries	397	Brantford, ON
125 Bottom	Deodato Reis	Wescast Industries	397	Brantford, ON
	Karl Slowka	Wescast Industries	397	Brantford, ON
	Steve Leslie	Wescast Industries	397	Brantford, ON
126	Charlie Parsons	FPI	FFAW ‡	Marystown, NF
127 Both	Rick Rowell	Molson Breweries	306	Barrie, ON
128 Top	Gilles Breau	MacDonald Pontiac Buick GMC	4501	Moncton, NB
128 Bottom	Nicolae Iacobcivc	Grey Goose Bus Lines	4210	Winnipeg, MB
129 Top	John Dyck	Reimer Express World	4209	Winnipeg, MB
129 Bottom	Peter A. Haima	Pacific Coach Lines	4234	Victoria, BC
130	Joy Lemieux	Air NorTerra	1990	Inuvik, NT
131	Oswald Junior Henry	Canadian Pacific	101	Toronto, ON
132–133	Joe Doutra	Toronto Terminals Railway	4003	Toronto, ON
	Frank Quinto	Toronto Terminals Railway	4003	Toronto, ON
134	Agnes Hayes	Cape Breton Regional Hospital	4600	Glace Bay, NS
135	Paul Lepore	Consumers Glass	29	Toronto, ON
136 Left	Peter Temko	Camco	504	Hamilton, ON
	Cindy Macpherson	Camco	504	Hamilton, ON
	Paula Francour	Camco	504	Hamilton, ON
136 Right	Josie Mancinelli	Rubbermaid Canada	252	Mississauga, ON
	Alvarina Patricio	Rubbermaid Canada	252	Mississauga, ON
137 Left	Ken Grant	Canadian Waste Services	4050	Calgary, AB
137 Right	Daljit Kavr Bajwa	Powder Property Management	3000	Whistler, BC
138	Charlotte Mitchell	FPI	FFAW ‡	Marystown, NF
139	Caroline Bell	Omega Packing	UFAWU §	Masset, BC
	Doug Edgars	Omega Packing	UFAWU §	Masset, BC
140	stamping plant	A G Simpson	1986	Cambridge, ON
141	Jim Knowles	Budd Canada	1451	Kitchener, ON
	Ron Ramsaroop	Budd Canada	1451	Kitchener, ON
	Doug Brett	Budd Canada	1451	Kitchener, ON
	Allan Mackinnon	Budd Canada	1451	Kitchener, ON
142–143	Gerry (Gerhard) Kluge	General Electric Canada	524	Peterborough, ON
144	aluminum smelter	Alcan Aluminum	2301	Kitimat, BC
145	Jody McHale	Alcan Aluminum	2301	Kitimat, BC
146 Top	Nello Quaglia	DaimlerChrysler Minivan Assembly Plant	444	Windsor, ON
146 Bottom	Camilo Droguett	New Holland Canada (formerly Versatile)	2224	Winnipeg, MB
147 Top	Nathaniel Rogic	Eight Rinks Hockey Complex	3000	Burnaby, BC
147 Bottom	Jean Marc Latour	Paccar Inc. (formerly Kenworth)	728	Ste-Thérèse, QC
	Jacques Paquette	Paccar Inc. (formerly Kenworth)	728	Ste-Thérèse, QC
148–149	Al Sankey	Westmin Resources	3019	Campbell River, BC
	Norman Warren	Westmin Resources	3019	Campbell River, BC
150	Bob Ross	Northumberland Ferries	4508	Wood Islands, PE
	Lester MacPherson	Northumberland Ferries	4508	Wood Islands, PE
151	Glenn Murray	Royal Oak Mines	2304	Yellowknife, NT
	Mike Stockdale	Royal Oak Mines	2304	Yellowknife, NT
152	John Rankin	Falconbridge (Sudbury Division)	598	Sudbury, ON
153	John Concannon	Canadian Salt	1959	Windsor, ON
154	salt mine	Canadian Salt	1959	Windsor, ON
155	Bill Jones	Detroit & Canada Tunnel	195	Windsor, ON
156–157	Sue Carley	Mackie Automotive Systems	222	Whitby, ON
158	Terry Mountan	Westmin Resources	3019	Campbell River, BC

Page	Name	Workplace	CAW Local	Location
159	Domingo Ilagah	New Flyer Industries	3003	Winnipeg, MB
	Enrique Ramos	New Flyer Industries	3003	Winnipeg, MB
160	Wendy Vandermeulen	Mackie Automotive Systems	222	Whitby, ON
161	Winston Ritchie	Saint John Shipbuilding	MWF *	Saint John, NB
162	Dick Alden	Air Nova	2213	Halifax, NS
163	Roderick Fonseca	Windsor Tool & Die	195	Windsor, ON
164	Chen-Hua Huang	MacDonald Dettwiler Space and Robotics	673	Brampton, ON
165	Jocelyn Couture	Nova Bus – Prévost Car Division	1044	Sainte-Claire, QC
166–167	Rick Osborne	Eureka Foundry	636	Woodstock, ON
168	Burt Buckton	PPG Canada	248	Owen Sound, ON
169	Carroil Janusauskas	Château Montebello	4281	Montebello, QC
170 Left	Andrew Prentice	Banff Springs Hotel	4325	Banff, AB
170 Right	Paul Spriggs	Delta Bessborough	4278	Saskatoon, SK
171 Left	Trace Mutehler	Camrose Pipe	551	Camrose, AB
171 Right	Laith Hasek	Blue Line Taxi	RWC †	Ottawa, ON
172	(clockwise)	Ford Motor Company of Canada – Engine Plant	200	Windsor, ON
	Greg Booker	Ford Motor Company of Canada – Engine Plant	200	Windsor, ON
	Roy Dufresne	Ford Motor Company of Canada – Engine Plant	200	Windsor, ON
	Sid Bell	Ford Motor Company of Canada – Engine Plant	200	Windsor, ON
173	Dave Martindale	Meritor Automotive Canada	1941	Tilbury, ON
174 Top	Paul Foley	Clover Produce	1971	Sydney, NS
174 Bottom	Bill Lischka	Dairyworld	RWC †	Brandon, MB
175	Danny R. Briand	National Sea Products	1944	Lunenburg, NS
176–177	Robert Preville	Pratt & Whitney Canada	510	Longueuil, QC
178	Adam Mayhew	Château Mont Tremblant	5000	Mont-Tremblant, QC
	Marc Tourigny	Château Mont Tremblant	5000	Mont-Tremblant, QC
179	Teresa Barnwell	C.L.S. Catering Services (Cathay Pacific)	2213	Richmond, BC
180	April Sumter	Co-op Radio	3000	Vancouver, BC
181	Michael Kletka	Jasper Park Lodge	4534	Jasper, AB
182	D.R. Asirk	Hotel Vancouver	4275	Vancouver, BC
183	Danielle Etienne	Delta Montreal	5000	Montreal, QC
184 Top	refuge station, zinc mine	Westmin Resources	3019	Campbell River, BC
184 Bottom	salt mine	Canadian Salt	1959	Windsor, ON
185 Top	miner's dry basket, zinc mine	Westmin Resources	3019	Campbell River, BC
185 Bottom	salt mine	Canadian Salt	1959	Windsor, ON
186	Suzanne Canuel	General Motors of Canada	1163	Boisbriand, QC
187	Deborah Easter	DaimlerChrysler Minivan Assembly Plant	444	Windsor, ON
188 Top	Sam Ferraro	Freed's Menswear	RWC †	Windsor, ON
	Ken Thompson	Freed's Menswear	RWC †	Windsor, ON
188 Bottom	Sharif Alhassan	Canadian Pacific Hotels and Resorts Regional Laundry	4050	Canmore, AB
189	Georgina Liuba	Jackson Skate Co.	1524	Waterloo, ON
190	André Ciré	General Motors of Canada	1163	Boisbriand, QC
	Camille Fortier	General Motors of Canada	1163	Boisbriand, QC
	Richard Rancourt	General Motors of Canada	1163	Boisbriand, QC
191 Both	Normand Assselin	General Motors of Canada	1163	Boisbriand, QC
192	Jeff Morgan	CAMI Automotive	88	Ingersoll, ON
	Dan Evans	CAMI Automotive	88	Ingersoll, ON
193	Tim Arslan	DaimlerChrysler Pillette Road Plant	444	Windsor, ON
194	Amy Colwell	Lear Canada	2168	St. Thomas, ON
195	Jennifer Banton	Cara Operations (Harvey's Union Station)	4003	Toronto, ON
196	Durval Medeiros	New Holland Canada (formerly Versatile)	2224	Winnipeg, MA
197	Lionel L. Williams	Canadian National Railway	100	Concord, ON
198	Michael Frlan	Ford Motor Company of Canada – Truck Plant	707	Oakville, ON

* MWF = Marine Workers Federation/CAW

† RWC = RetailWholesale Canada/CAW

‡ FFAW = Fish, Food, Allied Workers/CAW

§ UFAWU = United Fishermen and Allied Workers' Union/CAW

Photo Credits

Denyse Gérin-Lajoie: pp. 33, 114, 169, 183, 186, 190, 191 (both).

Schuster Gindin: pp. 34, 35, 41, 47, 62-63, 72, 93, 95 (bottom), 101(bottom), 118, 119, 120-121, 136 (left), 153, 155, 163, 168, 172,173, 192, 194.

Ursula Heller: pp. 67 (bottom), 105 (both), 137 (right), 144, 145, 147 (top), 179, 180, 182.

Vincenzo Pietropaolo: pp. 5, 22-23, 24, 25 (both), 26, 27, 30-31, 32 (both), 36, 37, 38, 39, 42-43, 44, 48 (bottom), 49, 50-51, 52, 53, 54, 55, 56 (both), 57, 58, 59, 60, 61, 64, 66, 68, 69 (both), 70-71, 74 (both), 75 (both), 76, 77, 78-79, 80, 81, 82, 83, 84, 85, 86-87, 88 (both), 89 (both), 90, 91, 92, 94 (both), 95 (top), 96-97, 99, 100(both), 101 (top), 102, 103, 104 (right), 106-107, 108, 109, 110,112-113, 115, 116, 117, 123, 124, 125 (both), 126, 127 (both), 128(top), 129 (bottom), 130, 131, 132-133, 134, 135, 136 (right), 138,139, 140, 141, 142-143, 146 (top), 148-149, 150, 151, 152, 154, 156-157, 158, 160, 161, 162, 164, 166-167, 171 (right), 174 (both), 175, 184 (both), 185 (both), 187, 188 (top), 189, 193, 195, 197, 198

George Webber: pp. 65, 104 (left), 122, 137 (left), 170 (both), 171 (left), 181, 188 (bottom).

Iva Zímová: pp. 28, 29, 40, 45, 46, 48 (top), 67 (top), 73, 98, 111, 128 (bottom), 129 (top), 146 (bottom), 147 (bottom), 159, 165, 176-177, 178, 196.

Photographers

Denyse Gérin-Lajoie, born in Montreal, Quebec, has worked for over 25 years as a photographer, photo editor, and conservator in Canada, the United States, and Europe. As co-director and editor of *OVO Magazine* for fifteen years, she made a significant contribution to photography in Quebec and the rest of Canada. She was also co-founder and co-director of the Photographic Documentation Centre, and of Espace OVO. She has had numerous solo and group exhibitions, and her forthcoming book on Sesimbra, a fishing town in Portugal, will be published by Editorial Caminho, Lisbon.

Schuster Gindin, born in Racine, Wisconsin (U.S.A.), immigrated to Canada in 1970. Her documentary photographs and visual art have been featured in solo and group exhibitions at A Space, Harbourfront Centre, Ontario Science Centre, and various other Toronto galleries. Her work has also been on tour in North America. Her book *pasta/rasta: A Year in the Life of a Neighbourhood Theatre*, was published in 1983. Her photographs have appeared in Toronto dailies. She is based in Toronto, where she lives with her short husband and two tall sons.

Ursula Heller was born in Eglisau, Switzerland, and studied photography at the Zurich Art School. Her specialty of community reportage, whereby she produces photo essays in strict collaboration with the communities where she lives, has been included in many international exhibitions and publications. She has photographed in Switzerland, Greece, Italy, Israel, and Mexico, and has published three books of photographs, including *Village Portraits* (Methuen Publications, Toronto, 1981). She lives with her family in Harrop, B.C., where in addition to freelancing in photography, she is also a full-time caregiver of a handicapped person.

Vincenzo Pietropaolo was born in Maierato, Italy, and grew up in Toronto. Self-taught as a social documentary photographer, for the past 25 years he has been documenting the immigrant experience in Canada, working class culture, and the labour movement. His work has been exhibited widely across Canada, and also in the United States, Mexico, Italy, the Netherlands, and the Caribbean. He has taught at the Nova Scotia College of Art and Design, Halifax, Nova Scotia. His most recent book is *Celebration of Resistance* (BTL Press, Toronto, 1999) which documented the Ontario Days of Action.

George Webber is a documentary photographer living in Calgary. Self-taught, he is now employed as a photographer and instructor at the Southern Alberta Institute of Technology. For a period of 20 years he documented the people and landscape of the Canadian west, culminating with the publication of his book, *Requiem: The Vanishing Face of the Canadian Prairie* (Folio Gallery, Calgary, 1995). In 1992 he won the grand prize in the Faces of Canada photography competition. His contribution to Canadian visual art was recognized with his induction into the Royal Canadian Academy of Arts in 1999.

Iva Zímová was born in the former Czechoslovakia and has been living in Montreal since 1982. A graduate of Concordia University's photography program and the Dawson Institute of Photography, Iva has had several group and solo exhibitions, including Le Mois de la Photo Festival in Montreal, Harbourfront in Toronto, Prague, and the World Conference on Women in Beijing. She has produced a major body of work on women in Ukraine, commissioned by the Canadian International Development Agency (CIDA). In 1996 she published *The Forgotten Czechs of the Banat*, (Köcher & Köcher, Prague). She is currently documenting the rebuilding of Chechnya.

Writer

Sam Gindin has lived with the history of the CAW for the past 25 years (and with a photographer even longer). He recently retired after 25 years as Head of Research and Assistant to the President of the CAW. A renowned economist, he has written extensively on working class issues. In 1996 he wrote *The Canadian Auto Workers: the History and Transformation of a Union* (JLC, Publishers, Toronto). In September 2000 he resumed his teaching career with a course on Social Justice, designed for both students and activists at York University in Toronto.